AMERICAN WATERS

"Water is the driving force of all nature"

Leonardo da Vinci

AMERICAN WATERS

ALEX KIRKBRIDE

foreword by Jean-Michel Cousteau

D&C
David and Charles

This book is dedicated to Patricia, Christina and Hazel

A DAVID & CHARLES BOOK
Copyright © David & Charles Limited 2007

David & Charles is an F+W Publications Inc. company
4700 East Galbraith Road
Cincinnati, OH 45236

First published in the US in 2007

Text and illustrations copyright
© Alex Kirkbride

Alex Kirkbride has asserted his right to be identified as author
of this work in accordance with the Copyright, Designs and
Patents Act, 1988.

Names of manufacturers, paper ranges and other products are
provided for the information of readers, with no intention to
infringe copyright or trademarks.

A catalogue record for this book is available from the British Library.

ISBN-13:978-0-7153-2751-7
ISBN-10: 0-7153-2751-8

Printed in Singapore by KHL
for David & Charles
Brunel House, Newton Abbot, Devon

Commissioning Editor: Neil Baber
Head of Design: Prudence Rogers
Editor: Emily Pitcher
Assistant Editor: Demelza Hookway
Project Editor: Constance Novis
Production Controller: Beverley Richardson

Visit our website at www.davidandcharles.co.uk

David & Charles books are available from all good bookshops;
alternatively you can contact our Orderline on 0870 9908222
or write to us at FREEPOST EX2 110, D&C Direct, Newton Abbot,
TQ12 4ZZ (no stamp required UK only); US customers call
800-289-0963 and Canadian customers call 800-840-5220.

contents

by Jean-Michel Cousteau

HUMAN BEINGS ARE GEOGRAPHICALLY challenged about their planet's water system. Earth is covered nearly three-quarters by water. Yet, ask anyone to describe what this brings to mind and they will likely mention the vast oceans of the world.

As someone who has been raised since the age of seven on the ocean, you may believe I would readily agree. But, to the contrary, I see our water planet everywhere. From snow-packed mountain tops, to rivers, streams, and lakes, down to small puddles and even droplets of water on a leaf. It's all connected. One water system inextricably woven from fresh water to saltwater, circling the globe.

Altering our perception of water—what lives in it, how we contain it, or what is deposited in it—is just what Alex Kirkbride has done in *American Waters*. By providing us images of water in all 50 of the United States, he is challenging us to rethink what water means in

our lives. He asks us to look beyond the coastal habitats of the world and see beauty and utility in parts of America few people associate with bodies of water. How refreshing this is.

Anyone who picks up this volume expecting to see pretty travel photos is in for a surprise and a welcome one. Alex has the audacity to lead us into ponds and swimming pools and a variety of otherwise mundane places to show us art and nature framed by water.

Sometimes the water itself is the subject. Other photos show us the fanciful or frightening species that lurk in the deep and not so deep. Of particular interest to me are many photos which show those things which we discard in our society, lying on the water's bottom. Ships, shoes, trucks, and other debris are the topography of the silt down below. At once, I am saddened by the objects that reflect how we use bodies of water as our garbage can. I also see Nature's resilience

as plants and animals make "homes" out of this debris and alter it to become one with the environment. Does the object change the water or does the water change the object? Through Alex's lens, I believe it is both.

This book changes us as well. Whether a photo of a dog standing partially submerged in a swimming pool makes you laugh or scratch your head in puzzlement, it makes you contemplate the power of water to transform and reshape our vision of everyday things. Nothing is exactly as you would perceive it to be...or is it?

The riddles of water are apparent in some of my favorite photos in *American Waters*. Several of Alex's most unique images are of the water's surface and what is beyond it. As a diver, I have spent a significant portion of my life staring up at the surface as I emerge from the water realm. The surface is the point at which all my dives begin and end. But, think for a moment about how profound the surface of water truly is. The surface is Nature's great divide. It is where the elemental change occurs that transform components of the hydrogen and oxygen that make water into the atmosphere around us.

We take this for granted everyday from a glass of water to a pool to a lake or ocean. The chemical composition changes and so does the prism through which we see the world at this level.

The image of a cottonwood tree through the light shimmer of the water's surface becomes a pointillist painting. Cranberries, floating to the surface for harvesting, appear as colliding planets or circus balls. Texas wild-rice is a racing explosion of leaves. Mangroves spun in a fish-eye view subdivide the photo. Even an aging Minuteman missile rises above the surface like a Spanish religious shrine.

The water's edge transforms and plays an optical trick that takes our minds in new directions. This begs the question, is this a book of "underwater photography" or "Nature photography"? What Alex has done is blur the line and educate us that it is all connected. He dares us to think outside categories, labels, or convention. He has reinvented the medium and we thank him for that.

Although this book is entitled *American Waters*, it speaks far beyond borders. While we may be entertained, amused, or enchanted by these images, the message for me is much greater. Alex has pushed us to appreciate all water on Earth, no matter how simple or small. He shows us grandeur in the easily overlooked.

Water is a medium and a material to the photographer who crafts his shot to embrace a vision. For all of us, water is a vision we must embrace for our very survival. Think about water...everywhere...and you contemplate all life on Earth.

American waters: oceans, lakes, rivers, streams, and creeks

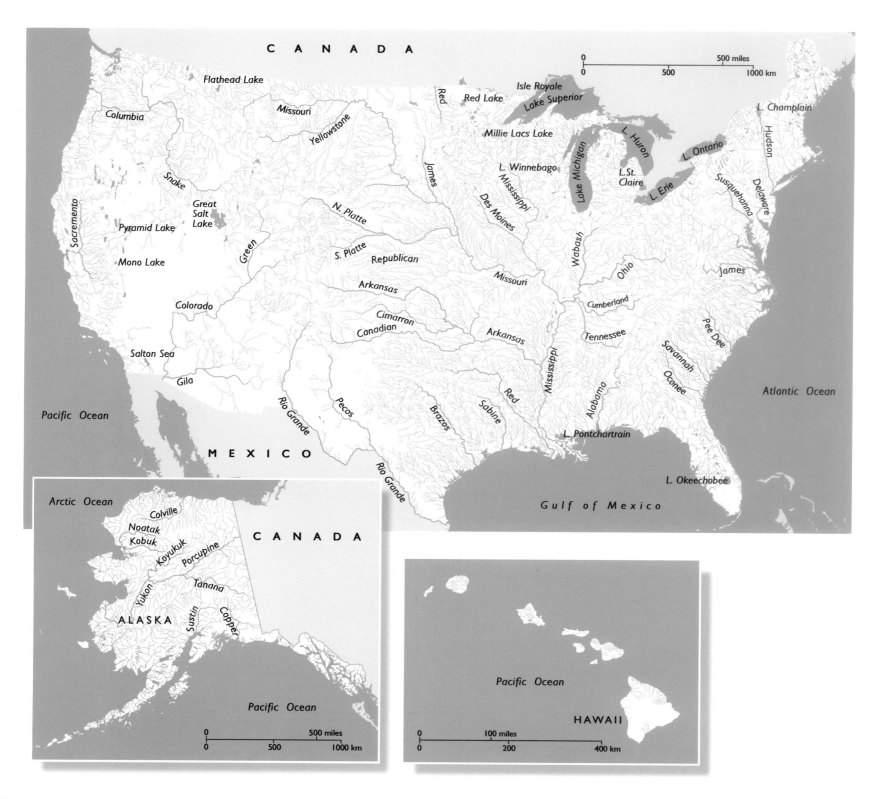

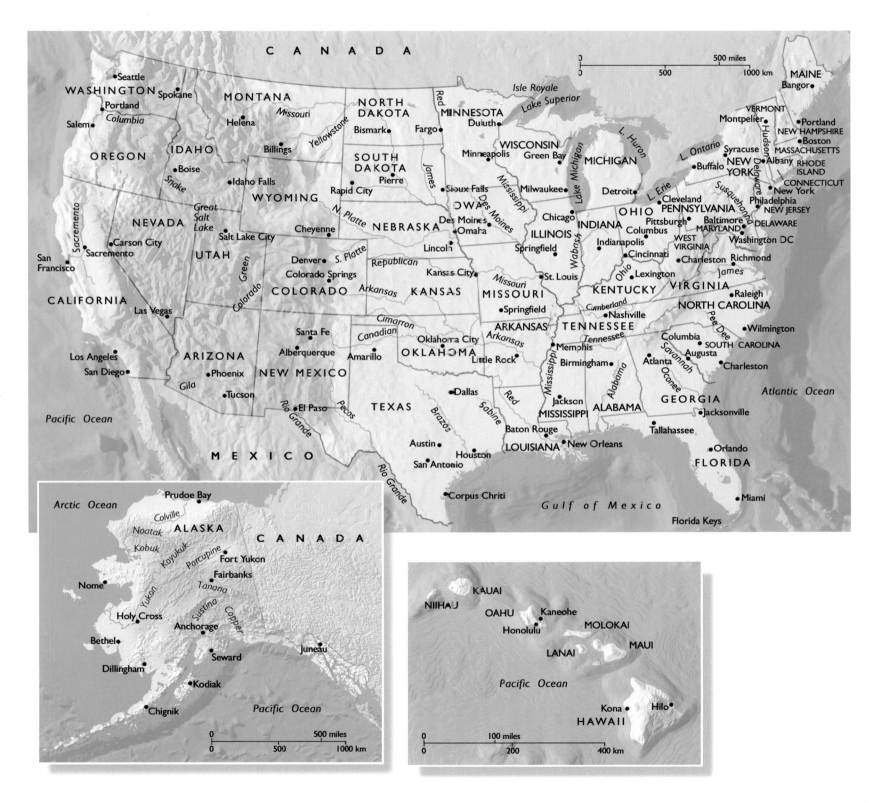

CANADA

Seattle
WASHINGTON Spokane
Portland MONTANA
Salem Columbia Helena
Missouri

OREGON IDAHO Billings
Boise
Idaho Falls
Snake

NORTH DAKOTA
Bismark Fargo
Red

Isle Royale
Lake Superior

MINNESOTA
Duluth

MAINE
Bangor

VERMONT
Montpelier Portland
NEW HAMPSHIRE
Boston

WISCONSIN
Minneapolis Green Bay
MICHIGAN
L. Huron

Syracuse MASSACHUSETTS
Albany RHODE
Buffalo NEW ISLAND
YORK CONNECTICUT

SOUTH DAKOTA
Pierre
Rapid City
WYOMING
James
Sioux Falls
Milwaukee
Lake Michigan
Detroit
L. Erie
L. Ontario

New York
Cleveland Philadelphia
PENNSYLVANIA NEW JERSEY
Pittsburgh Baltimore DELAWARE
Columbus MARYLAND
Washington DC

NEVADA
Carson City
Sacramento Sacramento
San Francisco
Great Salt Lake
Salt Lake City
UTAH Green

Cheyenne
Denver S. Platte
Colorado Springs
COLORADO
Republican
Lincoln
Des Moines
Omaha
IOWA
Des Moines
ILLINOIS
Springfield
INDIANA
Indianapolis
OHIO
Cincinnati
WEST VIRGINIA
Lexington
Charleston Richmond
James
VIRGINIA
Raleigh
NORTH CAROLINA

CALIFORNIA
Las Vegas
Colorado
Kansas City
KANSAS
Arkansas
MISSOURI
Springfield
St. Louis
Missouri
Ohio
KENTUCKY
Nashville
Cumberland
TENNESSEE
Tennessee
Pee Dee
Columbia
SOUTH CAROLINA
Augusta

Los Angeles
San Diego
ARIZONA
Phoenix
Gila
Tucson
Santa Fe
Albérquerque
NEW MEXICO
Canadian
Amarillo
Cimarron
Oklahoma City
OKLAHOMA
Arkansas
Little Rock
ARKANSAS
Memphis
Birmingham
Atlanta
Oconee
Savannah
Charleston

El Paso
Rio Grande
Pecos
TEXAS
Dallas
Brazos
Sabine
Red
Jackson
MISSISSIPPI
Alabama
ALABAMA
GEORGIA
Jacksonville

Pacific Ocean

Atlantic Ocean

MEXICO
Austin
San Antonio
Houston
Baton Rouge
LOUISIANA
New Orleans
Tallahassee
Orlando
FLORIDA

Rio Grande
Corpus Chriti
Gulf of Mexico
Miami
Florida Keys

500 miles
500 1000 km

Arctic Ocean
Prudoe Bay
Colville
Noatak
Kobuk Koyukuk
ALASKA
Porcupine Fort Yukon
CANADA
Nome
Yukon
Tanana Fairbanks
Holy Cross
Sustina Copper
Bethel
Anchorage
Dillingham
Seward
Juneau
Kodiak
Chignik
Pacific Ocean

0 500 miles
0 500 1000 km

KAUAI
NIIHAU
OAHU Kaneohe
Honolulu
MOLOKAI
LANAI
MAUI

Pacific Ocean

Kona Hilo
HAWAII

0 100 miles
0 200 400 km

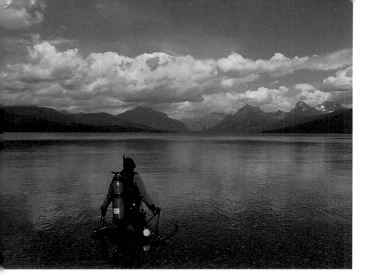

Diving Lake McDonald, Montana

the grand idea

At the age of twelve, I walked into a second-hand bookstore. Knowing that my grandfather Ronald was a writer, I looked around the old-fashioned shop to see if any of his books were on the shelves. Lo and behold there were three of them. I pulled out the first one and to my surprise discovered that he had dedicated the paperback to my brother, my sister, and me. I remember feeling profoundly gratified, and challenged by that legacy, and ever since I have had a burning desire to create my own book.

IN JULY 1997 *Aqua* magazine commissioned a "Diving across America" story. My assistant Sebastian, the writer Jim, and I traveled 4,000 miles in nine days in a motorhome from Long Island, New York to Los Angeles, California. It was a gloriously mad, intense shoot and I've never been more exhausted after a job. For example, in one day I photographed the Sheriff of Santa Rosa, New Mexico, went diving in the nearby Blue Hole and adjacent creek, and then drove 900 miles to Las Vegas, Nevada. We arrived in Vegas at 1 a.m. and were up and moving by 6 a.m. Then we drove to the Colorado River, went diving in an eight to 10 knot current, and afterward flogged on all the way to Santa Barbara, California. I feel tired just thinking about it.

The results demonstrated how extraordinarily diverse underwater images could be. There was an impressionistic image of a cottonwood tree from New Mexico, an antique dentist's chair from Indiana, and an ore cart from a flooded mine in Missouri. I began to think about what else I might find on a lengthy trip around the country and how it might make a unique collection of images—a portrait of America from a fish's point of view, or a crocodile's, or a turtle's eye in a desert spring. It would be an enormous challenge to capture images expressive of American waters from coast to coast—a feat no one had ever attempted before.

Work began on the project in 1998, but twenty-four hours after a summer dive off the East Coast, I began to have tingling symptoms in my left arm. Any life-long diver knows what tingling can mean: It's a possible symptom of decompression sickness, a potentially life-threatening diving-related illness. I had every reason to believe my ailment wasn't "the bends" because my dive profile for that day was well within the diving tables and the tingling did not begin within six to 12 hours after my dives. Even so, I immediately went to a recompression chamber, but to my dismay, the tingling persisted after treatment. I then visited a variety of doctors, had MRIs on my head and back, but nothing unusual appeared and nobody could tell what was wrong. As you can imagine, this was frustrating, and frightening. I was waking up in the middle of the night unable to move my left arm, and during the day I just couldn't concentrate on anything. After a few months the symptoms did not subside, and I was forced to put my underwater career and the book on hold.

A year later a friend of mine told me about rolfing, a holistic system of soft-tissue manipulation, and I decided to give it a try. I explained to the doctor what had happened and she said

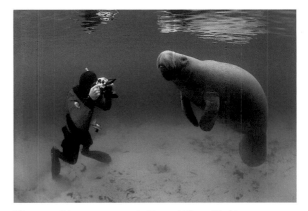

Photographing a manatee in Crystal River, Florida

that the tingling might be caused by some type of neck injury. She lay me down on her worktable and probed into my flesh. Her sensitive fingers soon made a diagnosis. "Yes, your neck has been damaged," she said. "Have you ever been in a car accident?" Did ramming a car into a telephone pole count? I'd made that tactical error when I was 22 in Jamaica. "Yes, that would do it," she said. Finally, I had an answer.

The rolfing treatment was for 10 sessions over the course of five months. After two years the tingling died down to where I could barely notice it, and I felt ready to give scuba a go again. The first dive aggravated my symptoms a little, but I felt confident I would be able to return to my underwater work. A month later, in September 2000, I recommitted to the project. When your passion is denied, you tend to reevaluate and question your life's path. My illness was like a long period of gestation, and when at last I had a green light, I was fueled with even greater determination and desire.

Initially, the project was planned on the basis of a few months a year, but once I began making calculations, it became apparent it could take more than ten years. Plus, during that time I would have to continue my commercial work, which would only delay the book even further. It was clear the only way to

accomplish this feat was to go all out and just focus on the project for three years without interruption. It was time to jump off the deep end.

At the beginning of 2001 there was no one to make the journey with me. Then in April I met Hazel, and once our relationship had become more secure, I asked her if she would share the trip of a lifetime with me. When she signed on for the odyssey, with all its potential joys and pitfalls, the project became not only plausible but delightful. Hazel left her job in London and moved to New York City in April 2002 to become my producer. Now all we needed was a mobile home. By chance, my friends Stuart and Susanne were selling their Airstream, which was my ideal choice. A used one wasn't too expensive, it would be reliable and extremely aerodynamic in high winds. It was 35 feet long with plenty of space for everything. The back of our SUV became the equipment area, while my camera housings sat on the back seat ready at all times.

My criteria for the images were simple but stringent: at least one from every state; each had to be partly underwater; each entirely original in subject and treatment, or, if a subject had been photographed before, I had to try and find a new

perspective if possible, one which would uniquely illustrate the extraordinary American aquatic landscape. And finally I decided to include man-made objects, and not limit myself just to the natural world, since a great deal of tangible American history is underwater.

Ideally, there would've have been a crew of three: Hazel, my producer and girlfriend (now my wife); myself; and a full-time assistant. However, with inadequate sponsorship funds, I had to give up on the idea of that handy third person, who was also going to be the main driver. I honestly did not know if Hazel and I would be able to keep up with the daunting schedule, but we had no choice, and so went for it. Hazel took on the job of my assistant, among many other duties, and I picked up the slack in the driving department. The combination of constantly moving, driving an average of 3,300 miles a month, diving, and only having one day off a month took its toll. Exhausting? Absolutely! But I was living my dream three ways at once—as a photographer, as a diver, and as a traveler—with my loved one at my side. Despite lapses into insanity, one of us could always be counted on to remind the other how extremely fortunate we were to be enjoying the freedom of the road and the surprises of each new day.

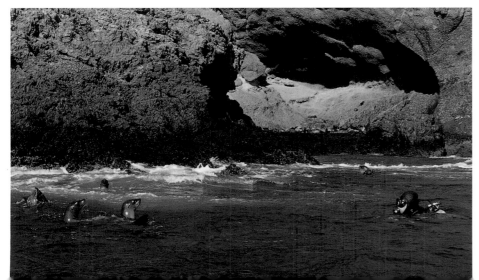

With the sea lions at Santa Barbara Island, California

Mangrove snappers, The Three Sisters, Crystal River, Florida February 15, 2001 / Depth 1ft. / Temp. 72°F / Vis. 100ft.+

This image was taken in the channel, or "run," which connects Crystal River to a complex of springs called The Three Sisters. It was the first site I photographed after recommitting myself to the *American Waters* project. I felt relieved and elated to be back in the game, especially in this beautiful and peaceful place, where manatees lazily graze and mangrove snappers school in teeming clusters. Such Florida springs, with their superb clarity and year-round mild water temperatures (controlled by the giant limestone cistern of the Floridian Aquifer) are like natural spas—for the soul as much as the body. No wonder they have long been associated with the myth of the Fountain of Youth. That day, in the richness of the color and light, the plentitude of the Sisters brimming over and gushing through the run, I felt their rejuvenating power—a wonderful way to start the journey.

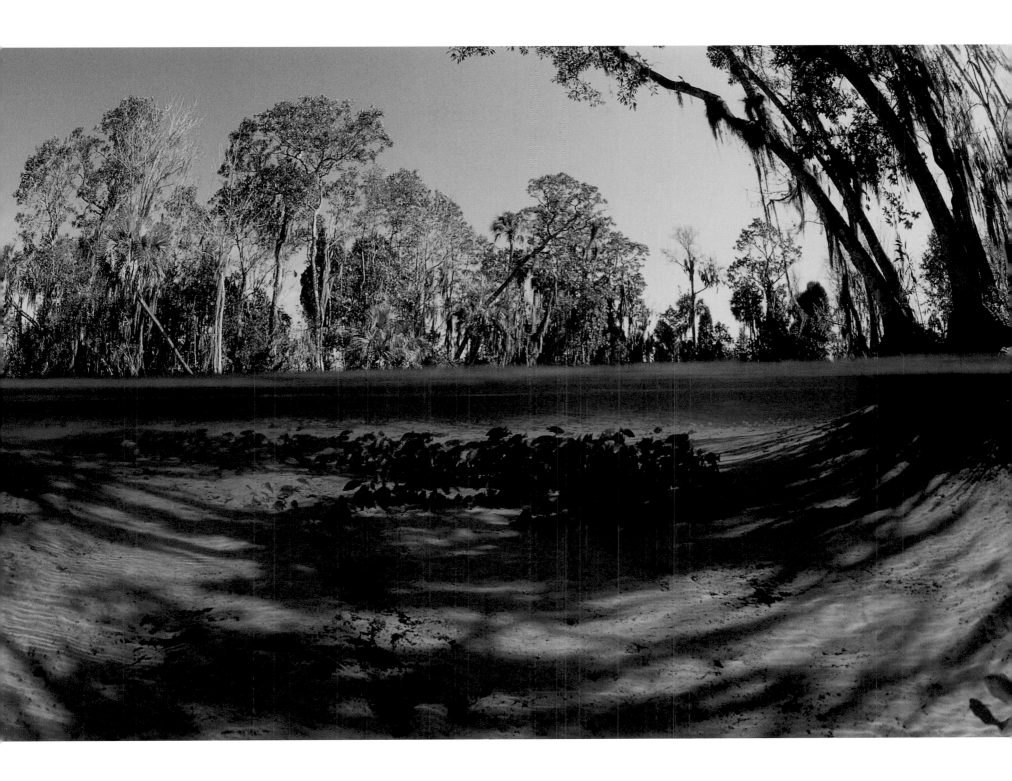

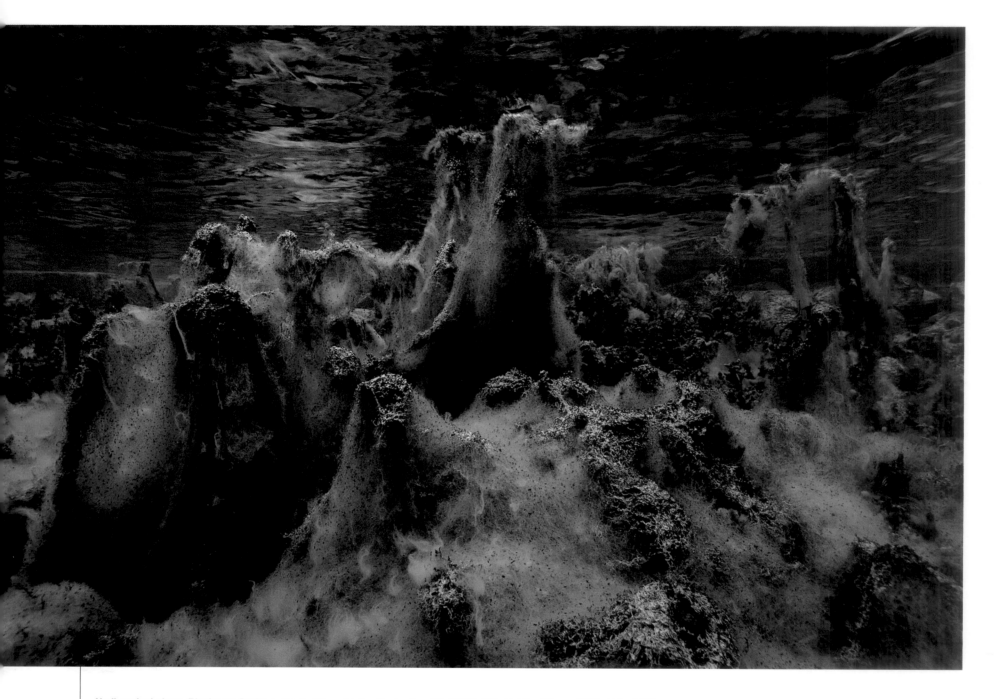

Undisturbed algae, Blueheart Springs, Snake River, Idaho September 13, 2003 / Depth 5ft. / Temp. 58°F / Vis. 100ft.+

Blueheart Springs on the Snake River bubbles up from underneath a 200-feet-high cliff, and can only be reached by boat. The spring was formed by a monster whirlpool spawned by the Bonneville Flood 15,000 years ago. The whirlpool eroded the basalt rock and tunneled all the way down to the aquifer, forcing underground water upward. Jim, a local farmer, kindly took us to see the spring before harvest time. On the river we passed dozens of white pelicans. As we turned into the entrance of Blueheart, a couple of muskrats were swimming on the surface and an otter lounged on the rocks. It lifted its head and blinked sleepily, willing to share in the spirit of the springs, which were named after algae had formed the shape of a heart in the sand. Sadly, the 1988 earthquake diminished the amount of water bubbling out of the sand, allowing the algae to spread and conceal the heart.

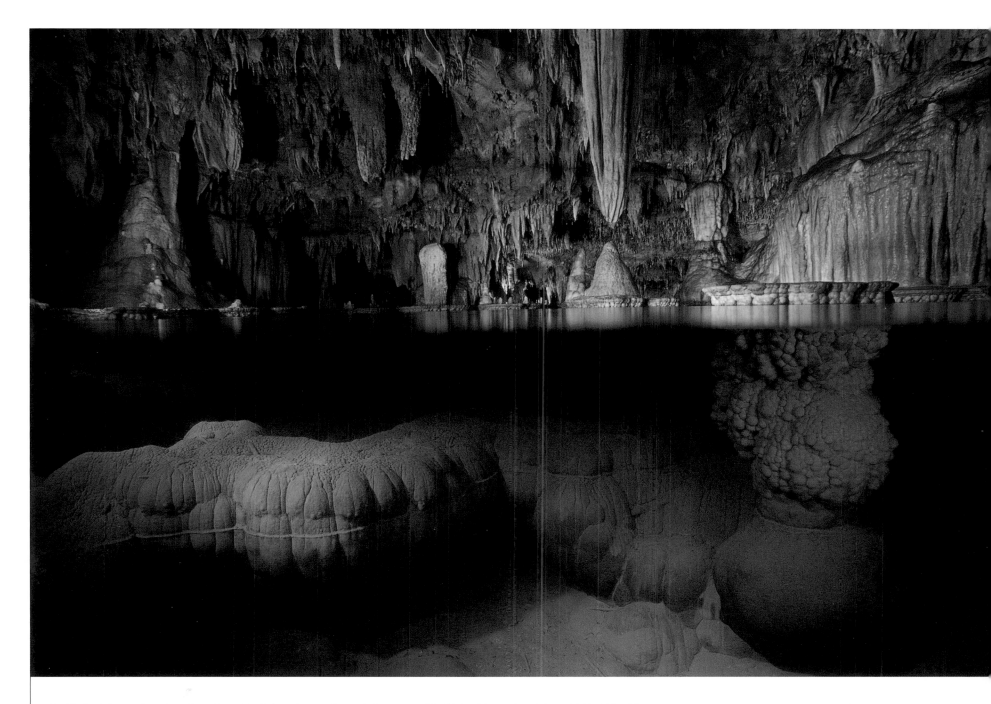

The Lily Pad Room, Onondaga Cave State Park, Leasburg, Missouri September 21, 2004 / Depth 1ft. / Temp. 55°F / Vis. 20ft.

There are more than 6,000 caves in Missouri, the Cave State, and none is more entrancing than Onondaga. As we walked through the underground cavern, I marveled at the artistry of geology. Highly soluble limestone and dolomite, deposited as layers of sediment eons ago when a shallow sea covered the Ozark region, gradually gave way under water's persistent influence, becoming passages for underground streams. Over the ages these underwater tunnels grew bigger, setting the stage for Missouri's spectacular air-filled caves once the sea withdrew. Water's tireless work continues, drop by drop, depositing dissolved carbonates that resolidify as speleotherms—stalactites, stalagmites, draperies, and shelf stones. All these never-finished forms decorate the lavish Lily Pad Room, where flowstone built up on one side, thus creating a natural pool. It's breathtaking to see.

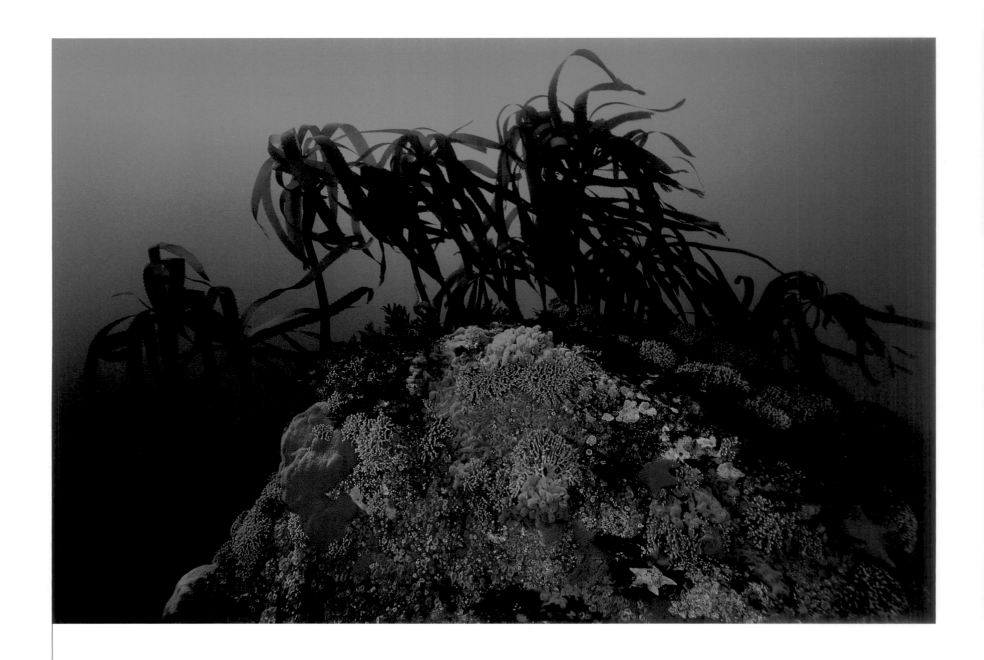

Mono Lobo, Carmel Bay, California July 22, 2005 / Depth 75ft. / Temp. 48°F / Vis. 60ft.

It was early when we left Monterey Bay, the boat silently slipping along in the morning fog, passing the old buildings of Cannery Row. Risso dolphins escorted us out of the bay and a flock of cormorants flew by in single file just above the gently undulating swells. The fog cleared and the sun appeared as we approached the Mono Lobo dive site. A sea otter, lying on his back, watched me eagerly jump in. I glided down through the magnificent kelp forest and past multitudes of plankton-nibbling blue rockfish. I reached the maze of huge granite outcroppings and made my way along one of the many colorful interconnecting passageways and out to a vertical wall covered in strawberry anemones, orange volcano sponges, and hard corals. I followed the wall around and found myself at the edge of a spectacularly vertical canyon, 130 feet deep —the first of a series of steep steps dropping all the way down to the 6,000-feet-deep Monterey Submarine Canyon, which provides the area with a cold water upwelling rich in nutrients. I relished the view as long as my air lasted before reluctantly returning to the surface.

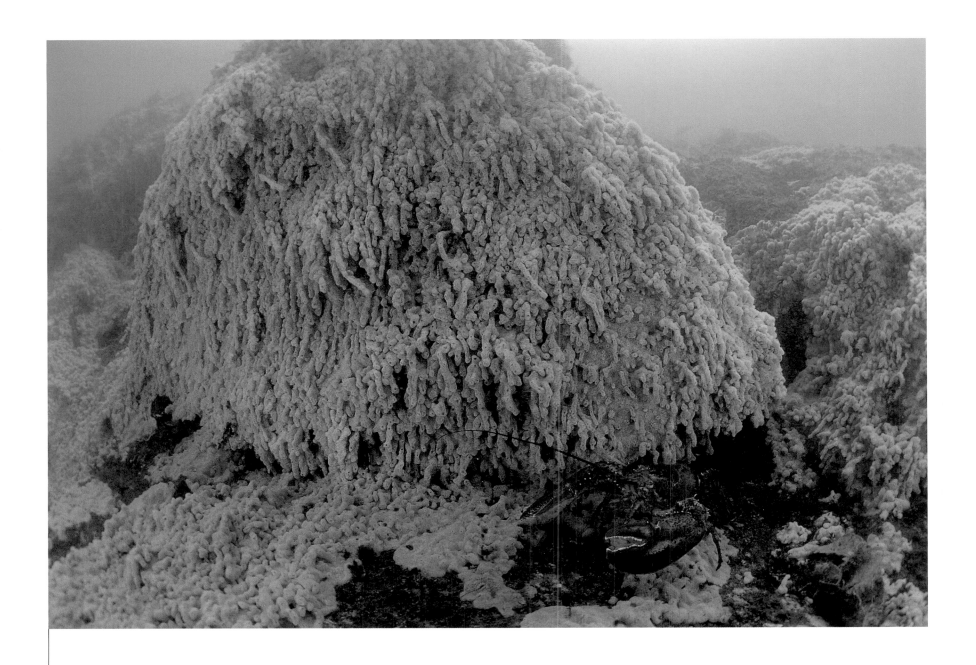

American lobster amidst colonial tunicate, Monhegan Island, Maine September 21, 2002 / Depth 25ft. / Temp. 49°F / Vis. 20ft.

After a morning of playing hide and seek with gray seals, seeing only the occasional ghostlike shadow in the distance, I was ready to try something different. This time we anchored in a small cove on the north side of Monhegan Island, a small, rocky island ten miles off the coast. There, slipping through the murky water, I entered a completely foreign terrain: an expansive meadow of the invasive colonial tunicate (a marine invertebrate) that stretched far and wide across the submerged granite rocks. Lobsters calmly walked over this soft yellow canvas, showing no fear of my presence. The sea gods must have told them they inhabit the only lobster-conservation area in Maine where, from June through November, they are free from the threat of the lobster pot.

Crocodile snake eel, Manuka Bay, Hawaii
February 2, 2005 / Depth 36ft. / Temp. 78°F / Vis. 60ft.

I could have spent hours looking for the eel if Brian, a local divemaster, hadn't helped me. Even with his knowledge of the dive site, we searched the sand by the reef for some time before he found the admirably camouflaged creature. Only the four-inch head of the "puhi" (as they are called in Hawaiian) can be seen after it burrows into the sand with its pointed tail. There it lies in wait for prey until small fish and crustaceans pass within striking range. Then with lightning speed the formidable predator attacks.

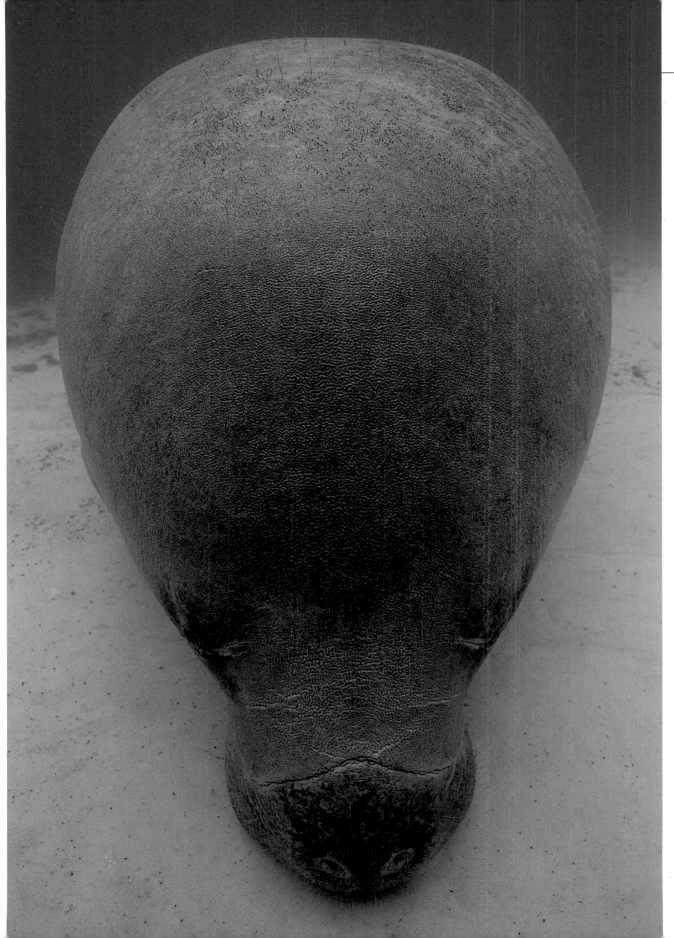

West Indian Manatee, Crystal River, Florida
January 1998 / Depth 12ft. / Temp. 72°F /
Vis. 45ft.

It is thought that sailors created the myth of the
mermaid by mistakenly believing manatees to
be half fish, half human. I was a rookie diver in
Jamaica the first time I saw one. Passing over a
coral head, I came face to face with a creature
I had never seen before, even in a photograph.
I really felt I had encountered a monster of the
deep. We scared the life out of each other,
and it took off, leaving me in shock. A local told
me afterward, "You seen a sea cow, mon!" My
naïve fear seems ludicrous now, because this
endangered, slow-moving, 10-feet-long gentle
giant is unquestionably the most docile animal
I've ever experienced underwater.

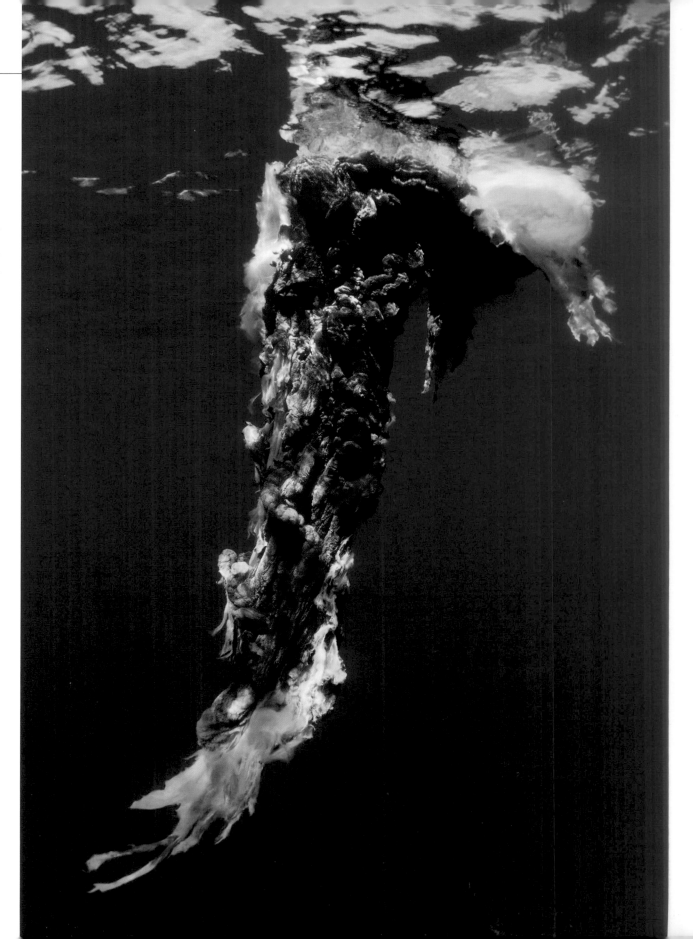

Humpback whale placenta, Manele Bay, Lanai, Hawaii February 15, 2005 / Depth 7ft. / Temp. 72°F / Vis. 80ft.

A floating placenta is a rarely glimpsed feature of humpback life. In his thirty-three years of observing cetaceans, Mark Ferrari, Director of the Center for Whale Studies, had never seen one until that afternoon, when a tip from a fellow researcher sent us zipping across the Auau Channel to southern Lanai. One reason for the scarcity of sightings, Ferrari speculated, was that the expelled birth sacs would be like caviar to the 16-foot tiger sharks that share these waters with the calving whales. With that in mind, I worked especially quickly to capture this image.

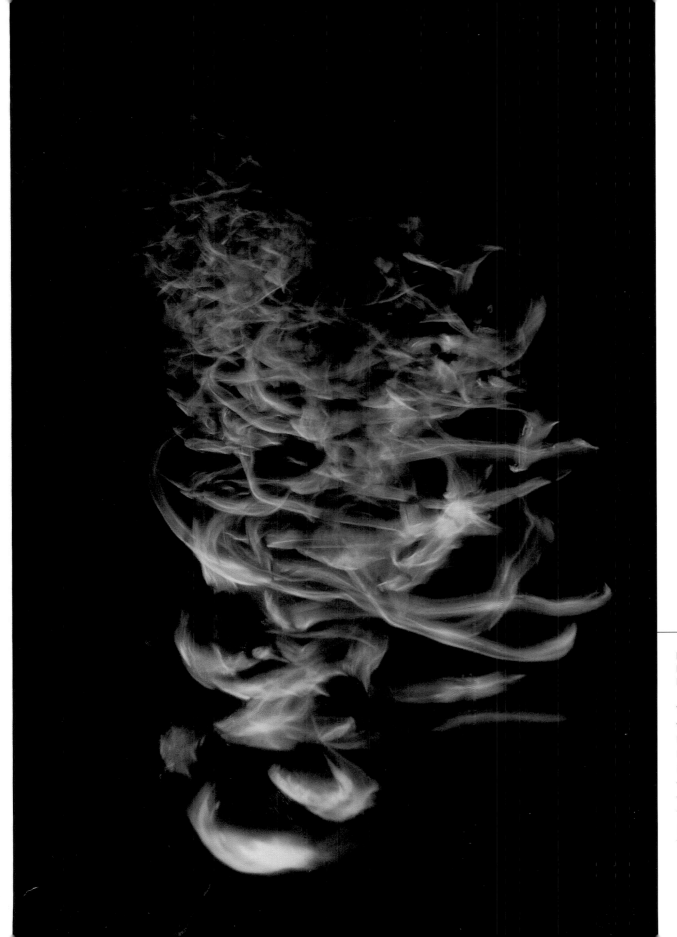

Flagtailfish, Garden Eel Cove, Nr. Kona, Hawaii February 6, 2005 / Depth 37ft. / Temp. 78F / Vis. 20ft.

When it comes to photographing wildlife, you naturally don't always find what you're looking for. When this happens, I feel Mother Nature is telling me to use my imagination. So while the manta rays were otherwise engaged, I experimented with a long exposure on the endemic flagtailfish, who were busy munching plankton, attracted by the lights set up by the local dive shop.

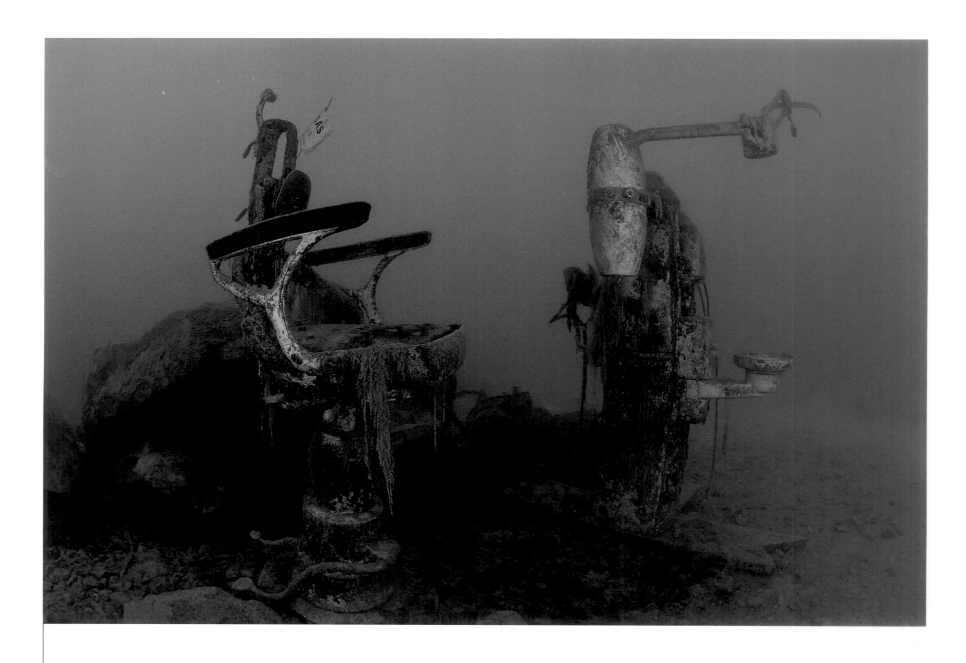

The dentist's chair, Blue Springs, Waldron, Indiana July 1997 / Depth 40ft. / Temp. 53°F / Vis. 25ft.

How and why did an old dentist's chair end up at the bottom of a man-made lake in the middle of Indiana? The park's owner knew the whole story. It was a vintage model, circa 1935. Doc White used it in the Shelby County jail when he worked on the inmates' teeth, and sometimes the sheriff tied the drunk and disorderly to it when they became unruly. Starting from the early 1960s onward, prisoners with medical problems were sent out to the local hospital, and the chair was no longer useful. In 1965 Sheriff Edgil Moore was cleaning out the basement and came across the dentist's chair. He believed it would make a comfortable seat while he fished the old limestone quarry, his favorite way of relaxing. Sometime later vandals thought it would be a better idea to push it into the water and divers completed the surrealistic scenario by dragging the chair to center stage and standing it upright.

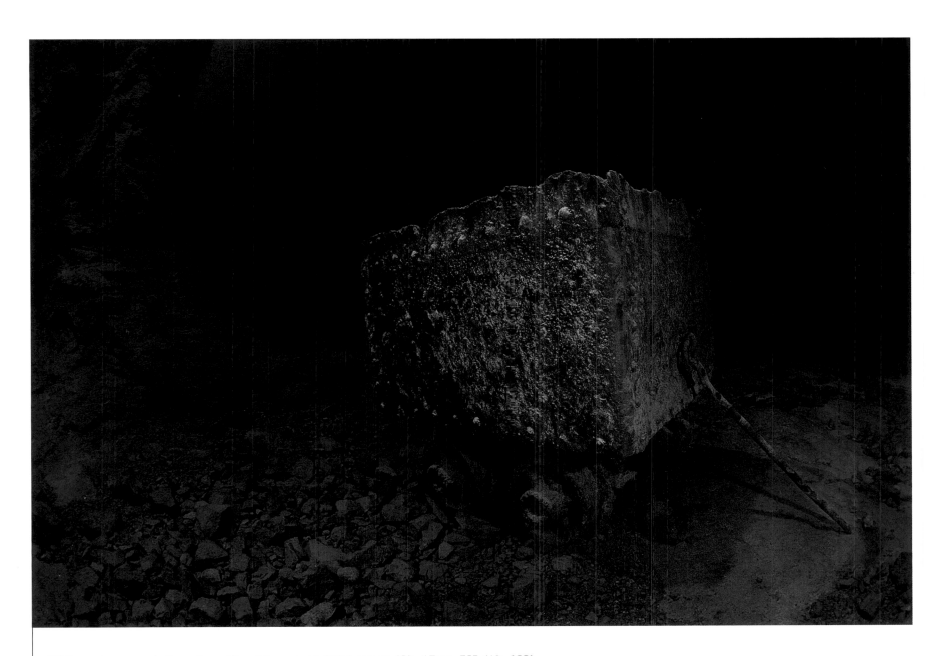

1920s one-ton ore cart, Bonne Terre Mine, Missouri July 1997 / Depth 48ft. / Temp. 58F / Vis. 100ft.

One of the most bizarre places to dive lies hidden underground in the heartland of the Midwest beneath the rolling foothills of the Ozark Mountains. In the middle of the small town of Bonne Terre, there is a defunct mine that filled with a billion gallons of groundwater after it was abandoned in 1961. In its heyday, circa 1900, it was the world's largest lead producer. These days it's a popular scuba-diving site. To enter you walk down the long, steep tunnel, once traveled by teams of mules, which then opens up into an enormous, magnificent cavern. The vista reminded me of the old movie *Journey to the Center of the Earth*. The dive guide gave me the tour of the historic artifacts. We cruised mine shafts, passed over small locomotives and around gigantic stone pillars, and up into the main elevator shaft, before we came across the solitary ore cart. The lights from my strobes made it glimmer like gold. I felt ecstatic, like an old prospector who'd just struck it rich.

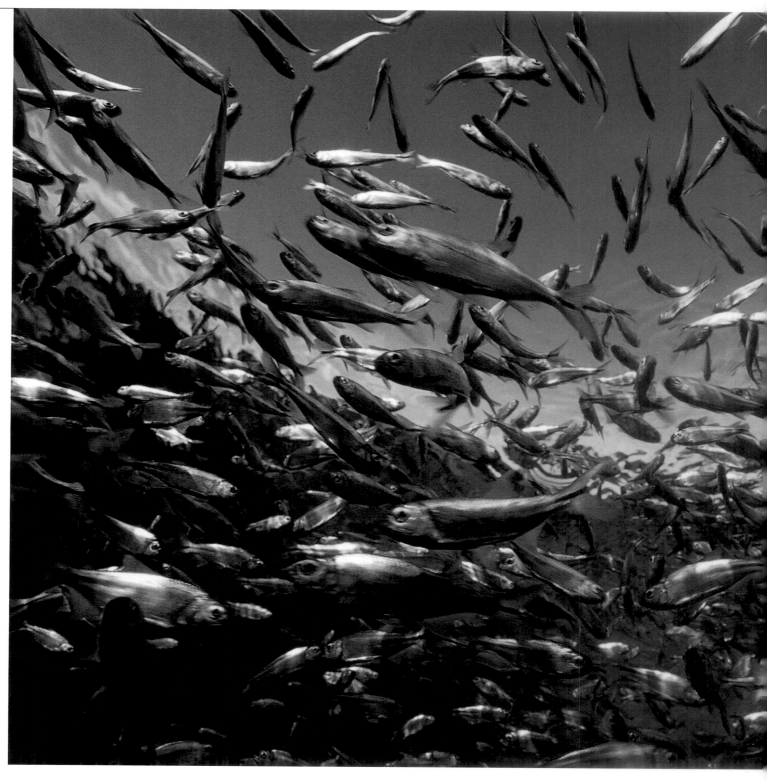

Mexican tetras, San Solomon Springs, Balmorhea State Park, Toyahvale, Texas
February 16, 2003 / Depth 4ft. / Temp. 78°F / Vis. 100ft.

One of the most successful structures built during the Great Depression by the Civilian Conservation Corps is a 1.75-acre natural swimming pool through which nearly 30 million gallons of spring water still flow every day. Designed to preserve an ancient watering hole, it looked like any other really big pool until I dunked my mask underwater. Then the genius of the design was revealed where the man-made limestone walls gave way gracefully to a natural bottom of rocks and aquatic plants. I was the only person in the water, and the resident school of Mexican tetras swarmed all around me. When I swam to the shallow end to photograph a Texas spiny soft-shell turtle, the tetras blocked my view until a group of divers jumped in and diverted their attention. Free of my fishy entourage, I could photograph the accommodating turtle. Just when I thought the morning dive couldn't get any better, a group of migratory scaup ducks landed on the surface and began diving down looking for food. I savored the moment, thinking of all the past desert nomads, such as the Mescaleros, who must have felt just as content as I was to stop at this extraordinary oasis.

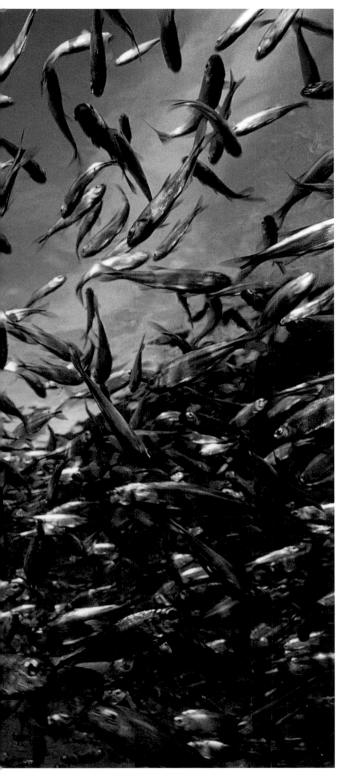

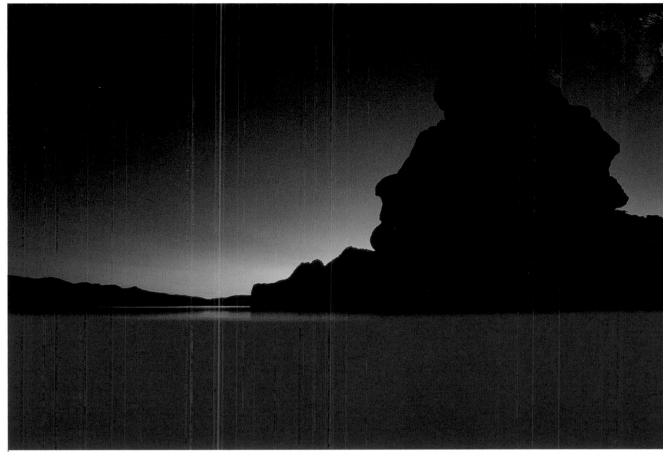

Stone Mother, Pyramid Lake, Paiute Tribe Reservation, Nevada October 27, 2003 / Depth 1ft. / Temp. 70°F / Vis. 30ft.

The Native American People who lived around Pyramid Lake called themselves Kooyooe tukadu, an ancestral name, meaning "cui-ui eaters." The endemic cui-ui fish, now an endangered species, served as the main staple of their diet. In the middle of the nineteenth century, when settlers crossed the Nevada desert on their way to California, they asked the friendly tribe where they could find water. "Paa'a yootoo" was the reply, which meant 'water this way," hence the now more familiar name Paiute. According to Paiute tradition, the sacred Pyramid Lake—source of their livelihood and identity—was formed when Stone Mother sat down with her burden basket and wept because her children had been dispersed across the land. Before her heart went cold and she turned to stone, her tears were so plentiful they formed the great body of water that would then sustain the people. I met an elderly tribal woman who told me offerings of food are still placed in the stone-burden basket in thanks for the gift of water in the desert.

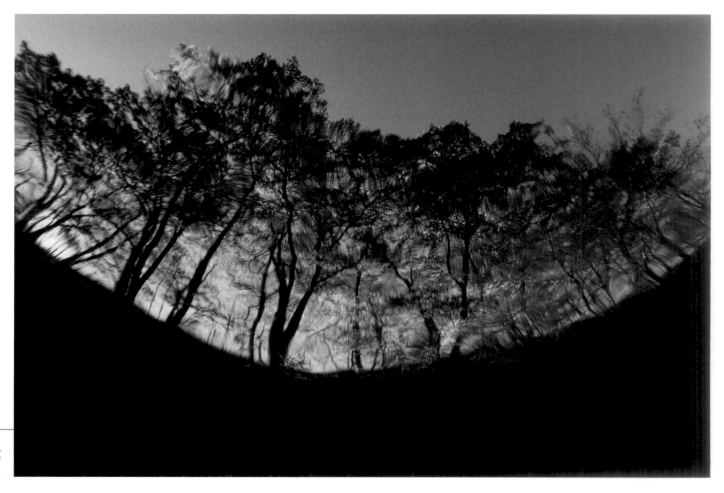

Little Wappinger Creek, Salt Point, New York October 19, 2001 /
Depth 1ft. / Temp. 56°F / Vis. 2ft.

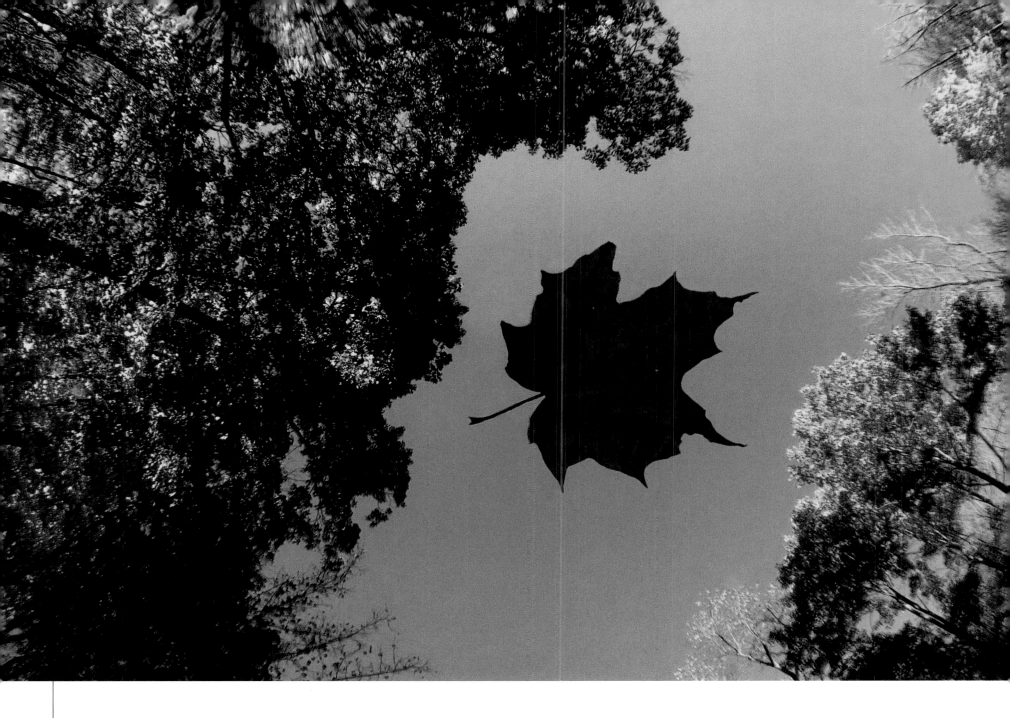

Maple leaf, Little Wappinger Creek, Salt Point, New York October 18, 2001 / Depth 2ft. / Temp. 56°F / Vis. 2ft.

During a summer visit to my friends John and Sarah in Salt Point, a group of us went for an afternoon walk. We began by crossing a creek across the road from their house, which I'd never noticed because it was so well camouflaged by a canopy of trees. That summer day I felt there was a potentia image awaiting the peak of fall foliage. Sarah called me in October with "leaf reports": "No, not yet; wait one more week." Finally the call came. Yes, the trees were in their full fall splendor. The day before I arrived, a blustery storm had blown through and by the time I leaned back in the shallow water scores of leaves were drifting down the creek.

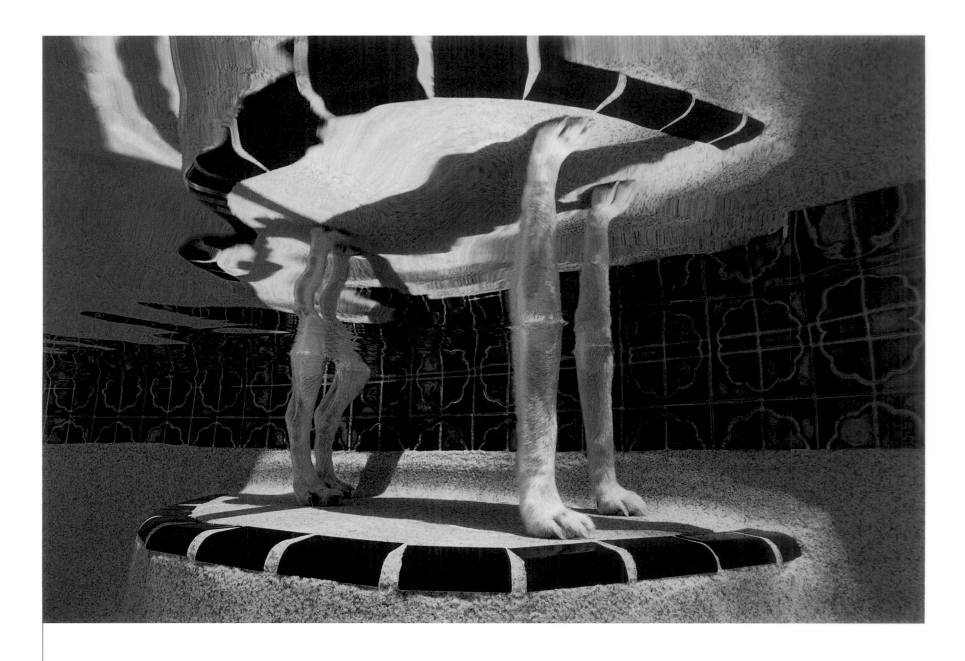

Bubba, Greg and Julie's pool, Crystal River, Florida May 4, 2002 / Depth 2ft. / Temp. 72°F / Vis. 20ft.

This photograph takes me back to the very beginning of the project, when Hazel and I were first introduced to our Airstream trailer. This was a momentous occasion for us: We finally had our home for the the trip. The trailer was being stored by our friends Greg and Julie on the west coast of Florida, where we stayed while we attempted to come to grips with a 35-foot mobile home. One day early in the visit I was relaxing in the pool when Bubba, Greg and Julie's smooth-haired fox terrier, came roaring out of the house barking like crazy. Julie explained that he loved to jump in the water and fetch his ball. It didn't take long before our game of fetch turned into a photo shoot. Time after time I photographed Bubba from underwater as he leapt in. The dog had endless energy, and would never have stopped. Just when I was ready to call it quits, I saw a wonderfully surreal image of disembodied terrier legs on the top step.

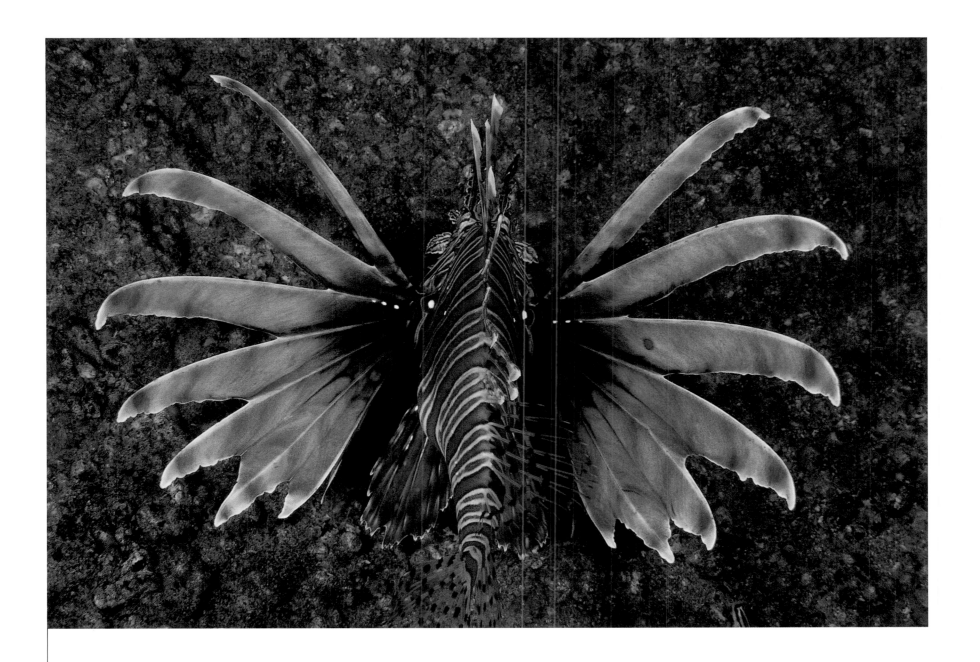

Lionfish, the *Papoose* wreck, Atlantic Ocean, North Carolina August 11, 2004 / Depth 117ft. / Temp. 75°F / Vis. 60ft.

It was a curious mystery when the lionfish, a flamboyant bottom-dweller indigenous to the Indo-Pacific, began to appear on deep-water wrecks off the North Carolina coast in 2000. Eventually, the perpetrator was discovered to be that master of mayhem, Hurricane Andrew. The monster storm of 1992, which demolished much of the Miami zoo and countless homes, was also responsible for the escape from captivity of six lionfish, which adapted readily to the warm waters of the Gulf Stream. Once I heard of this bizarre occurrence, I placed the fish on my "shoot list," but first I had to find them. I tracked a pair of them down on the wreck of the *Papoose*, the victim of a German torpedo in 1942, where the fish seemed perfectly at ease, wandering up and down their 412-foot-long residence.

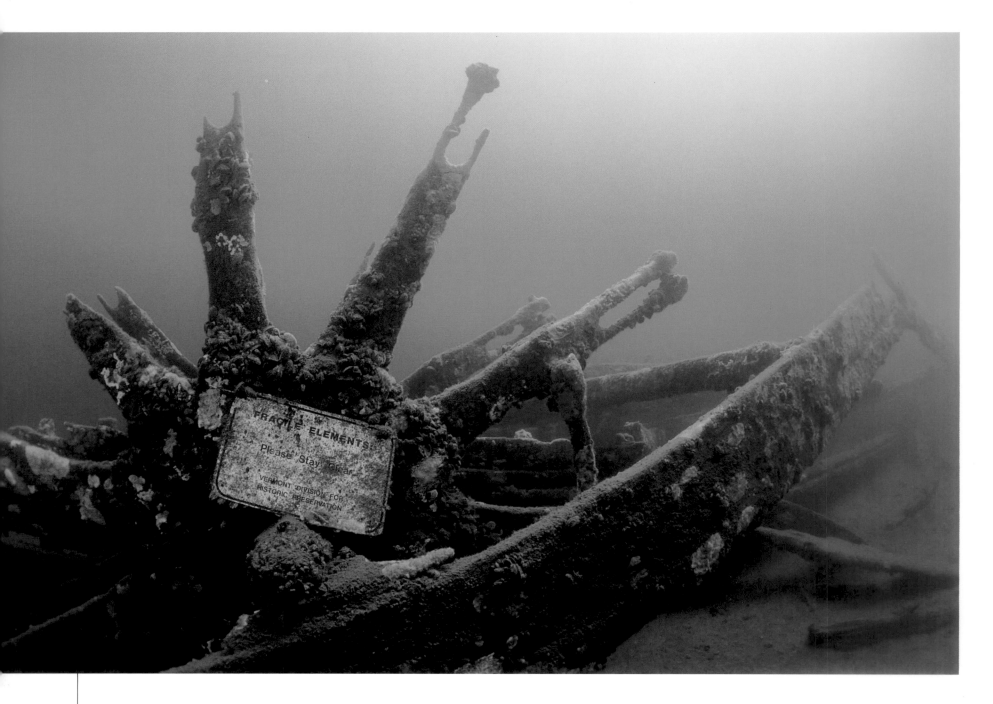

The paddle wheel of the Burlington Bay horse-powered ferry wreck, Lake Champlain, Vermont September 5, 2002 / Depth 51ft. / Temp. 60°F / Vis. 35ft.

Lake Champlain is 110 miles long and 12 miles across at its widest point. In the early nineteenth century, when bridging great distances was still an engineering impossibility, these dimensions proved a major obstacle for the ever-increasing population of the American northeast. In 1814 animal-powered vessels were introduced in the United Sates. "Teamboats" used horses as their engines by placing them on a turntable and were the most popular form of transportation, until steam power arrived in the mid-nineteenth century. This wreck is the only known surviving artifact of that era.

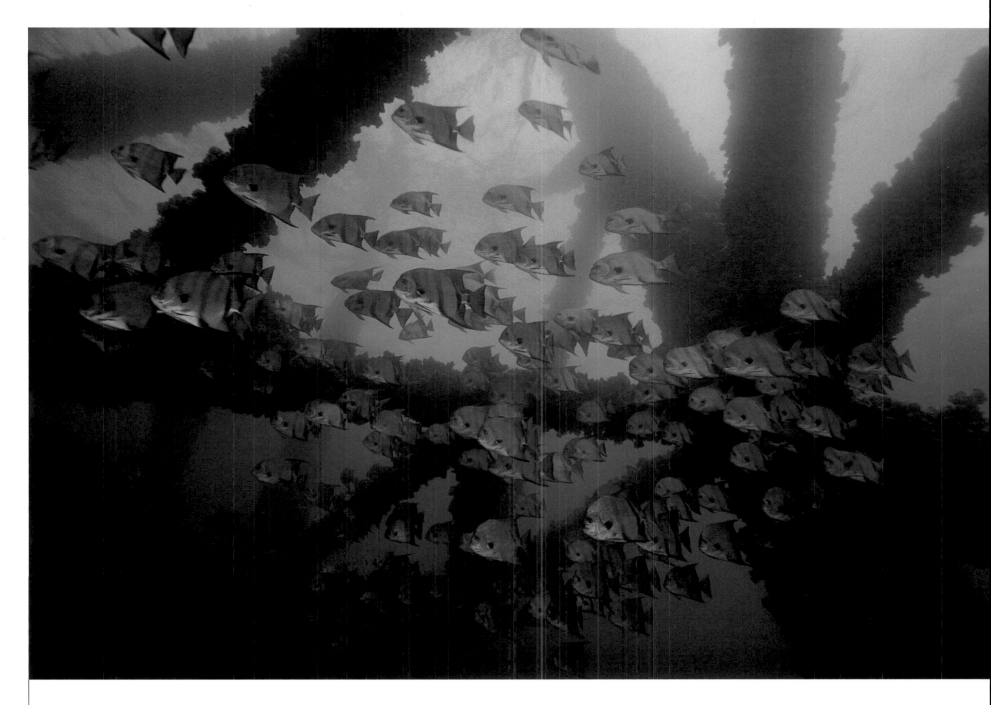

Atlantic spadefish, Oil Rig #175-A, the Gulf of Mexico, Mississippi May 20, 2003 / Depth 50ft. / Temp. 75°F / Vis. 60ft.

The motorboat sped out into the Gulf at dawn. There was no alternative but to travel at full throttle if we were going to reach Oil Rig #175-A, 67 miles out of Biloxi, and return by dark. There are some 4,000 oil and natural-gas rigs in the Gulf and over time many of their substructures have become artificial reefs, providing hard surfaces for such prolific encrusting organisms as spiny oysters, barnacles, sponges, and corals. The massive "legs" of 175-A were covered with such life, which draws in huge amberjacks, red snapper, and this school of Atlantic spadefish.

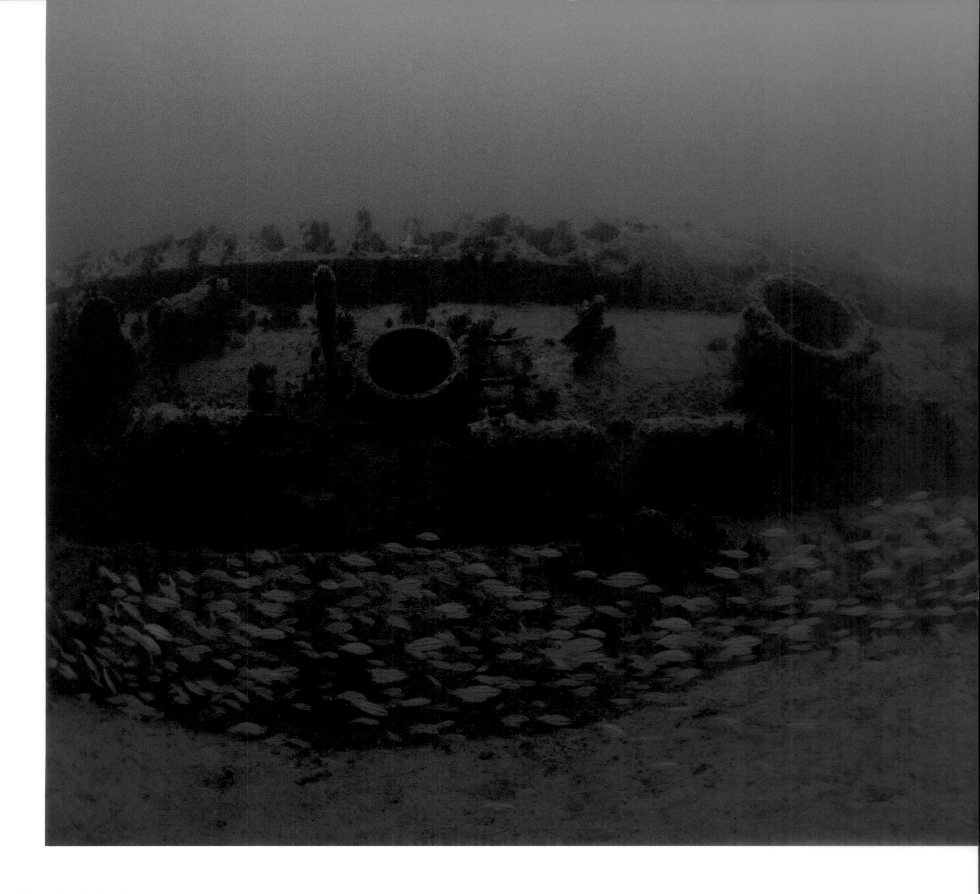

The U-352, Atlantic Ocean, North Carolina May 24, 2005 / Depth 110ft. / Temp. 70°F / Vis. 50ft.

I grew up in England captivated by World War II, which is hardly surprising because I was living amid so many reminders of it. There was an extensive bomb shelter at school and a smaller one in the back garden of our home in London. My favorite teacher at prep school, Mr. Yates, had served in the Royal Air Force. He still had the classic RAF "wing" mustache, and we pupils loved to listen when he told his stories at lunchtime.

During one session, he spoke of the German U-boat menace, and the grave danger it had posed to the survival of Britain. If enemy submarines had succeeded in controlling the Atlantic—which they very nearly did—the Allies would have been deprived of Great Britain as a base to launch operations against the Third Reich, and for the invasion of German-occupied Europe. Listening to Mr. Yates, our imaginations ran wild, picturing periscopes cutting the cold green waves and then the ominous wakes of the deadly torpedoes.

With those boyhood memories still fresh in mind, it was an absolute thrill for me to dive the wreck of a U-boat. This particular "wolf of the sea," the U-352, met its demise on May 9, 1942, when it attacked the U.S. Coast Guard cutter *Icarus*, mistaking it for an unarmed merchant ship. Once Kapitänleutnant Hellmut Rathke realized his error, he knew he was in serious trouble. The sub was in shallow, clear water and he wouldn't be able to move deep enough to avoid the inevitable onslaught of multiple depth charges. Forty-five minutes after the battle had begun it was all over. Thirty-three members of the U-boat crew survived; they became the first German POWs captured in the U.S. Today, the wreck site, 30 miles off the coast of Morehead City, is a German national war-grave monument commemorating the 13 men who met their end trapped inside.

I was surprised how intact the sub looked. Fortunately for historians and divers, the fatal depth charges hit the forward torpedo room, limiting structural damage. Once I finished the photography, I just stared at the wreck, thinking about the casualties of war. I bowed my head and paid my respects.

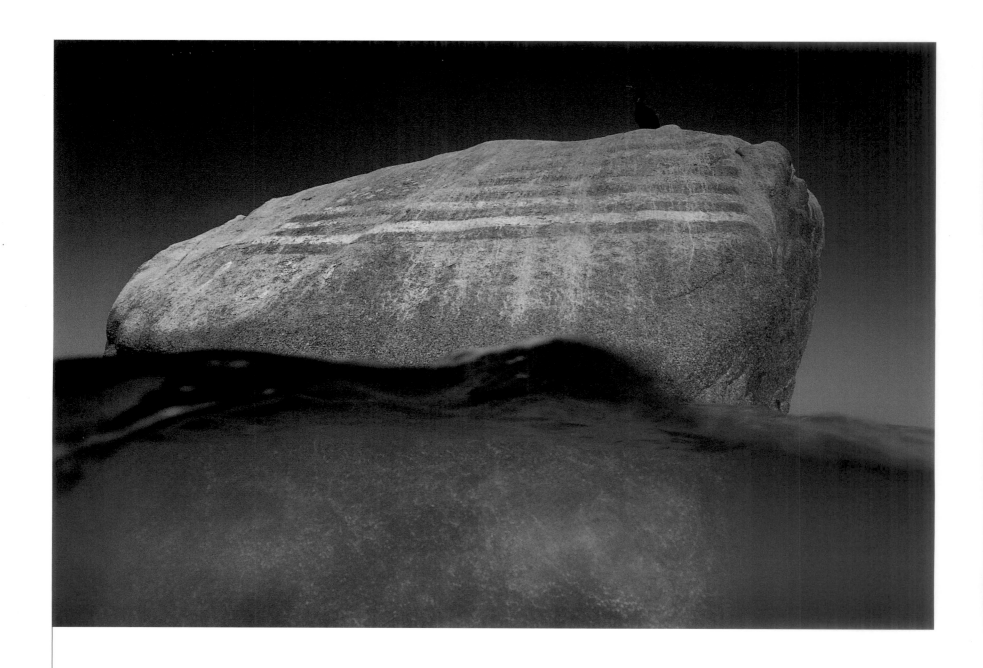

American flag and cormorant, White Horse Beach, Massachusetts October 7, 2002 / Depth 1ft. / Temp. 50°F / Vis. 20ft.

A local dive shop suggested White Horse Beach for shore diving, where skate, horseshoe crabs, and sand sharks congregate in the sandy bay. But even before we could wade into the water, Hazel and I were struck by the flag on the singular rock, which cormorants have claimed as their private island. We asked around and soon learned the story. During World War II, some prankster—or worse—painted a swastika on the rock. At the end of the war, patriotic locals painted over the Nazi emblem with a U.S. flag, and it is repainted most Fourth of Julys. I never had a chance to investigate underwater. I spent my limited time concentrating on the split-level image, but I was content to walk away with this picture of the Stars and Stripes, its time and tide-worn colors reminiscent of the Jasper Johns 1954 masterpiece, "Flag."

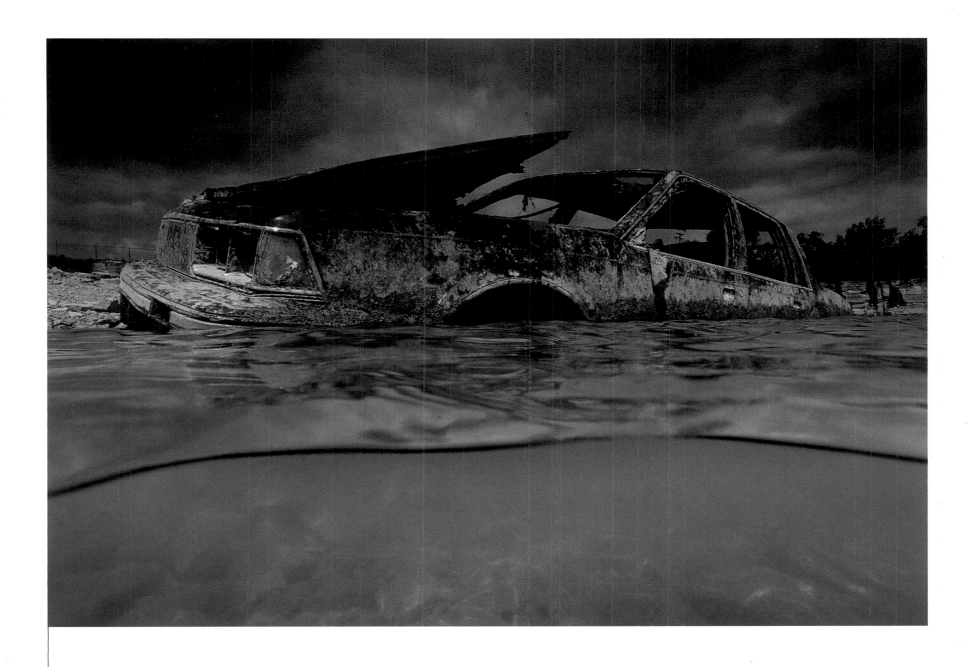

Stolen and abandoned United sedan, Brandon Road Quarry, Joliet, Illinois June 3, 2004 / Depth 1ft. / Temp. 58°F / Vis. 10ft.

After the fenceless quarry closed in 1962 and before it became a dive site in 1988, the flooded limestone pit was a dumping ground for discarded cars. At one point there were as many as 86 stolen cars underwater before insurance companies decided to retrieve them. But after collecting 70 of them they gave up, and the police department held a fishing tournament for tow-truck companies to see which team could recover the most cars. But apparently they, too, accepted defeat after only a few had been dragged out. The sedan, a now-obscure United, used to be submerged in 12 feet of water, but the lack of snow over the last three years caused the groundwater level to diminish considerably, which in turn dropped the water level of the quarry by a good 10 feet. If that trend continues, the United may yet succeed in recovering itself, when everyone else has failed.

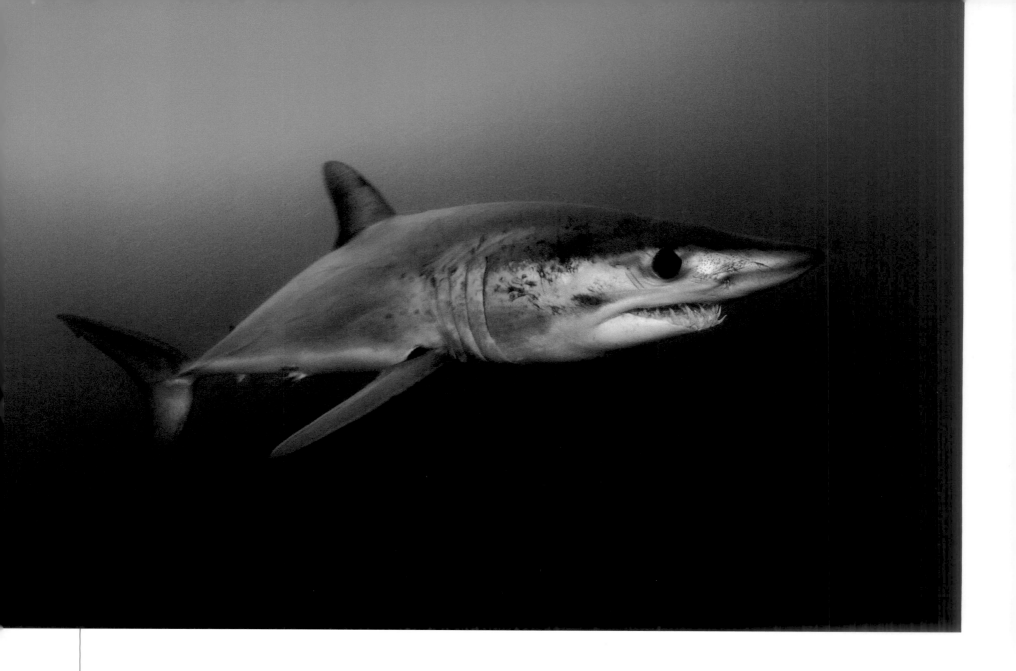

Mako shark, Pacific Ocean, Southern California July 30, 2005 / Depth 25ft. / Temp. 65°F / Vis. 25ft.

Short-fin makos are aggressive, incredibly fast, and renowned for their ability to leap 20 feet out of the water. They are also seriously mean-looking sharks! These sleeker cousins of the great white shark can reach speeds of around 22mph, which enables them to chase down even such fellow speedsters as tuna and swordfish, and shred them with their ever-visible, daggerlike teeth. Due to their beauty, speed, and agility, these high-flying fish are much prized by game fishermen. Ernest Hemingway immortalized the species in his famous book,

The Old Man and the Sea when he described the toothy mako: "It is the stuff of which nightmares are made." I met this six-footer a few miles off the coast of San Diego when I was floating in the current, outside the safety of a shark cage. I'd been hoping to get close to some less threatening blue sharks, so I didn't take my eye off the dangerous pelagic as it circled the cage—and me—many times before it took off in search of a tastier morsel.

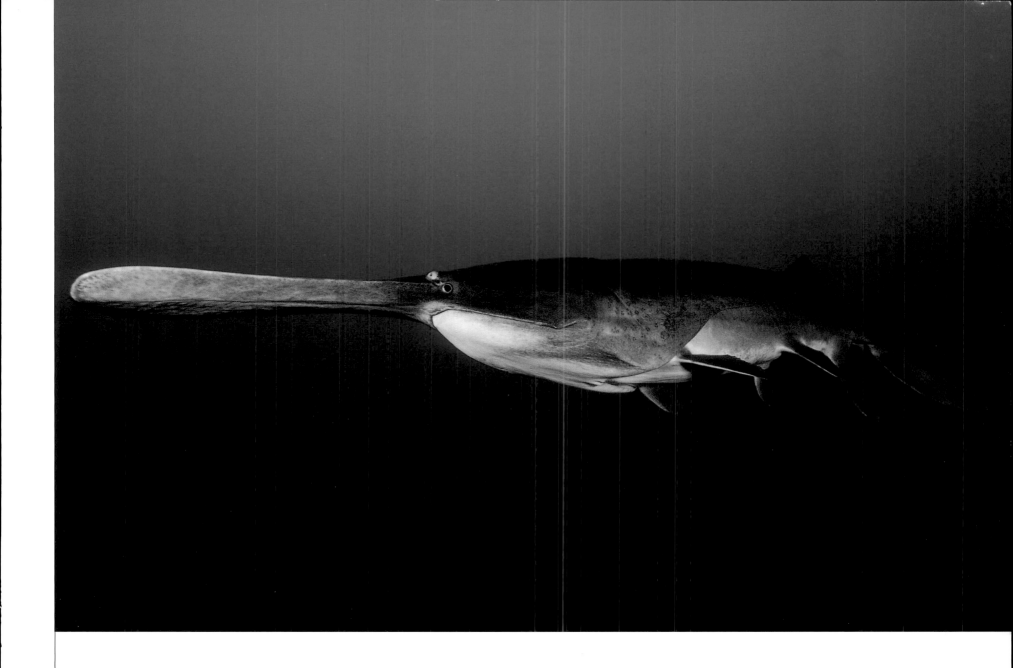

Spoonbill, Mermet Springs, Illinois April 8, 2003 / Depth 82ft. / Temp. 39°F / Vis. 40ft.

The spoonbill, or paddlefish is a 300-million-year-old species, a prehistoric survivor, today valued for its roe, which is prized as highly as sturgeon eggs. Because of its dwindling numbers due to overfishing, and its extraordinary pedigree, it was one of the freshwater fish that absolutely had to be included in this collection. There was a major problem though: the fish inhabits such muddy rivers as the Mississippi, so a photograph in the wild was out of the question. I'd read about

a flooded quarry in southern Illinois, now a nine-acre lake used by divers, where 200 spoonbill had been transported from the Ohio River. During my visit in April 2003, the spoonbill were all congregated below 80 feet in dark green, 39°F water, a tricky place for photography. I had to wear a cumbersome dry suit, but it was still numbingly cold. My time was limited and the light was so low I could barely see to focus. Over the course of four days I spent seven hours in the water attempting to

get within 18 inches of the skittish fish. In order to be that close many factors had to be in place: I had to spot the fish in time to react; I had to be at the same depth or a little below and approach it from behind; and the sun had to be out for the available light. Somehow it all came together, one time and one time only, and this generous creature allowed me to cruise alongside for five seconds.

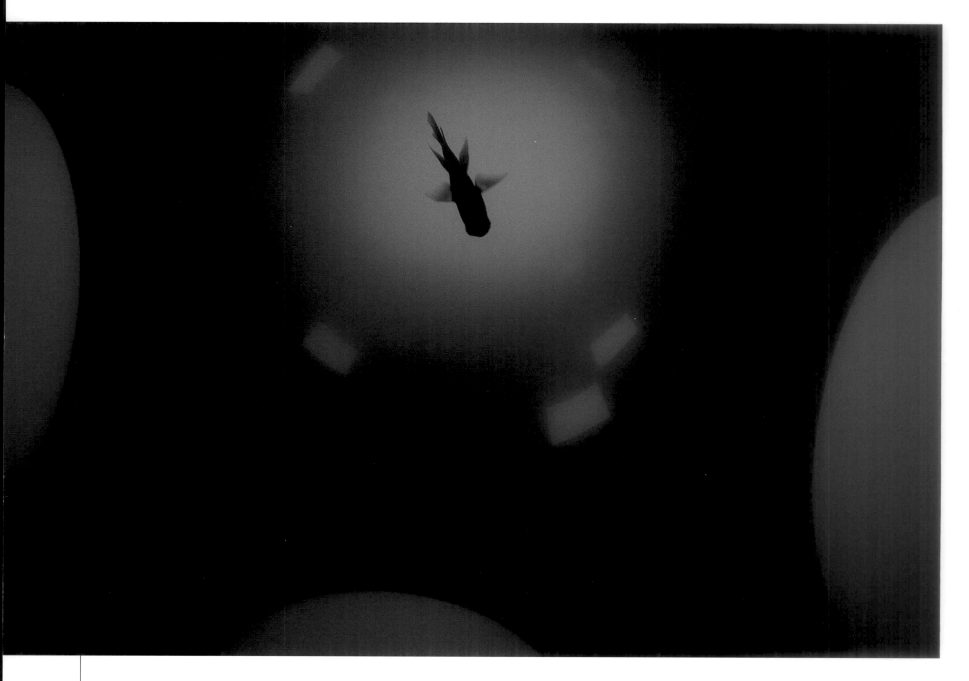

NASA Space Station, Madison Aquatic Park, Alabama November 2, 2002 / Depth 41ft. / Temp. 68°F / Vis. 15ft.

If you sink it, they will dive it—that's the maxim at flooded quarries all across the underwater U.S. Like latter-day P.T. Barnums, rock-pit impresarios have always sought out sizable junk—from the twin-engine Cessna to the perennial favorite schoolbus—for the wonder of their wetsuited clientele. Occasionally, though, these deep-six museums strike a poignant, even poetic note. At the Madison Aquatic Park in Alabama, an arched steel bridge underwater is a striking reversal of its own lost original purpose. And the 30-feet-high NASA Space Station prototype turns divers into astronauts exploring inner space.

Giant Pacific octopus inking, Lena Bay, Alaska March 17, 2005 / Depth 71ft. / Temp. 40°F / Vis 45ft.

One of the most useful tips I was given when I began documenting wildlife was to always be ready with a preset camera. This image was a grab shot in the heat of an encounter—a collision, actually—with an octopus. John, my dive buddy, had suggested Lena Bay for the "Alaskan-sized" nudibranchs and king crabs. During our search for these creatures on the sloping muddy bottom, we came across a long, flat piece of metal. A king crab was nearby, initially looking like it was ready to play but it took one look at John and retreated under the metal. A second later the octopus flew out in a panic and headed straight for me. I couldn't get out of the way in time and the unfortunate creature—10 feet long and weirdly soft, yet solid at the same time—thumped my stomach. Mistakenly thinking it was in imminent danger, the octopus squirted its ink and rapidly forced water out of its body so it could propel itself quickly backward and escape from us dangerous beasts. Equally startled, and similarly acting on instinct, I took the shot during the brief melee

The angel at Sunset Lake, Linton, Indiana

June 14, 2004 / Depth 9ft. / Temp. 70°F / Vis. 15ft.

In the summer of 2001 Jesse Bedwell, an ex-marine who manages the Sunset Park campground, had an unusual visitor. A wild-looking man with the word "Gravedigger" written on the side of his truck asked him if he could put a statue in the lake, actually an old flooded mine. Scuba divers used the lake so Jesse said no problem, knowing that it would be a fine addition to the sunken old schoolbus.

The day the gravedigger came Jesse was out. On his return he found a note pinned to his door, which simply said, "She's in the lake." Jesse donned his scuba gear, thinking that some bizarre she-devil was there only to find a beautiful statue of an angel sparkling in the early morning light.

Considering the history of the lake, Jesse had an idea why the angel had arrived. Once the mine pit closed in 1920, it quickly filled with groundwater and soon became a place where the locals swam and were baptized. Everybody would say, "See you at Sunset" and the name caught on.

Tragedy struck sometime in the mid 1920s when two young siblings, Kyle and Mary, drowned; their bodies were never found. There are no records of their deaths but the story has been passed down from generation to generation. Jesse believes that the angel appeared to take care of their spirits. It does seem to have some sort of power; in the late summer of 2001 when the lake was very low, a boat prop hit one of the angel's wings, breaking it off. A few days later Linton was hit with some of the worst storms in 20 years.

Recently divers have remarked that the angel appeared to be breathing as air bubbles rose from beneath her. I saw the bubbles myself, and thought they were coming from the algae. However, when I looked at other algae in the area, I realized this could not have been the case.

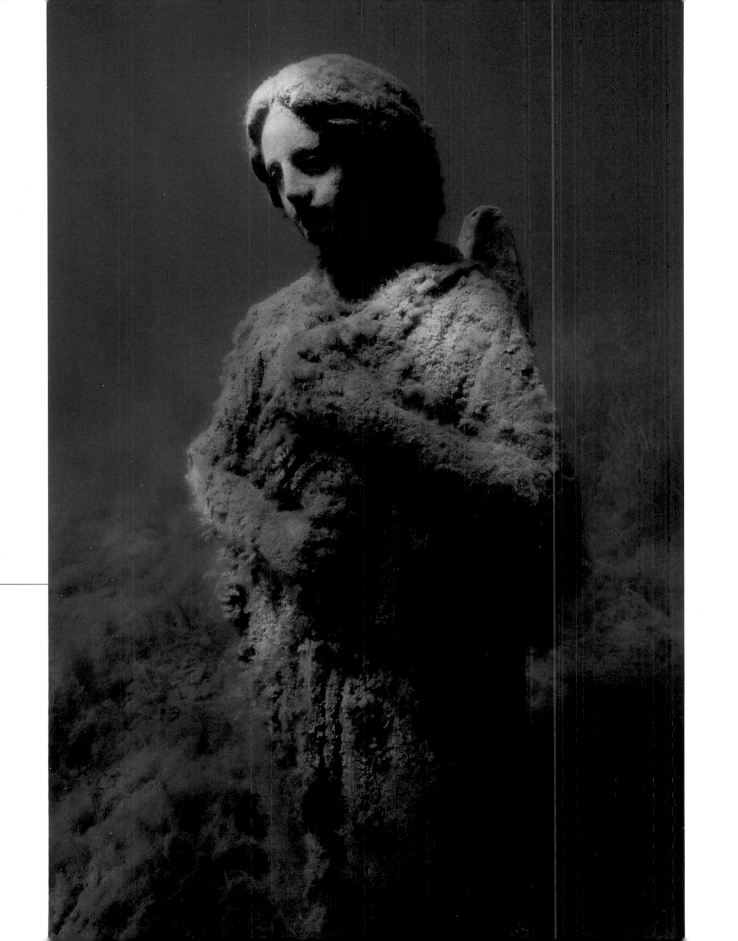

Route 2, on the way to Cuny Table Pond, South Dakota

on the road

ADAPTING TO LIVING in the Airstream motor home, with its fully equipped kitchen, shower, air-conditioning and propane heating system, was relatively easy once the art of hooking and unhooking the trailer from the SUV had been mastered. Learning to drive the monster rig took a little longer.

It was pretty scary at the beginning. After all, it was the largest vehicle most nontruckers will ever get to drive, and the combined weight of both vehicles, with equipment and supplies, was more than 17,000 pounds. The first long drive was naturally the toughest and the most nerve-racking, especially when we encountered an intense tropical storm in Florida, and couldn't see more than 20 feet in front of us on an Interstate highway. But it was trucks that initially proved the most harrowing. As they overtake you, they suck your rig into their lane and then push it back as they pass. It's very disconcerting because it feels like you're losing control. However, I soon learned that by keeping enough space between the trucks and the rig this unpleasant sensation could be minimized, and, with experience, ignored.

Initially, the most demanding part of manipulating the 55-feet-long machine (the combined length of the SUV and trailer) was backing up into a campground site. Even with a walkie talkie in hand and Hazel directing me into the site from the back of the trailer, it was still tricky. You are dealing with two vehicles joined together, but each with a separate chassis, like

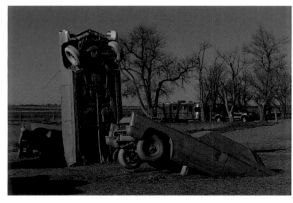

Car Henge, near Alliance, Nebraska

one person with two brains. It's counterintuitive: You have to turn the car in the opposite direction to that which the back of the trailer needs to go. At first we were all over the place, especially after a six-hour journey. Without a doubt, the worst arguments between couples on the road stem from trying to park their homes successfully. We realized it was a classic marital flashpoint when a campground manager in Maine helped us back in to a very tight spot with the words, "I've saved a lot of marriages helping couples back in!"

When you drive as many miles as we did, you expect to have some flat tires. Changing a tire on a rig is complicated and strenuous because you have to unhook the trailer before you can begin. Remarkably, we only had four flats throughout the entire journey, the first of which was in Mississippi. As I began the lengthy process on a small road, a very kind gentleman stopped and helped. Then he escorted us to a local tire outlet and made sure we were OK before he continued on his own journey. A fine example of the Southern hospitality we had heard so much about.

Sometimes the drive was just too long to make in a day, and it was necessary to spend the night in a rest area beside a highway, or in a Wal-Mart parking lot. It was less time-consuming than registering at a campground, and often there were no campgrounds nearby anyway. These impromptu stops led to some discoveries, like our favorite lay-over place: Car

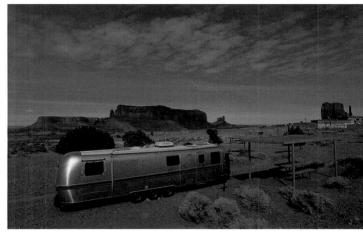
Camping at Monument Valley, Arizona

Henge in Nebraska, a replica of Stonehenge, in England, except with upright old cars instead of the ancient stones.

Living on the road was a wonderful experience, and it was a privilege to drive around the entire country. Best of all, we only had to open the trailer door to enter the great outdoors.

Because I gave myself a time frame of 36 months, from September 2002 to September 2005, to cover all 50 states and complete the project, I had to be very precise with the planning of when and where to go. Even though I would have liked to have gone to every state twice at different times of the year, I was only going to be able to visit most of the states once, and for no more than two and a half weeks. This was really pushing the laws of Nature, because many of the days were consumed by traveling, but my gut feeling was that it could be done—just. However, every time I examined a large map of America, I felt completely overwhelmed.

It was a planner's dream, or nightmare, depending on how you feel about planning a thousand details. We would have to be in each state when a variety of underwater sites were at their clearest, and when the weather was right, and when certain indigenous creatures were active. Not only that: dive boats in certain parts of the country were only operational at certain times of the year. Also, this tight schedule meant I couldn't afford to get caught and stranded in an early snowstorm, or be delayed for too long by bad weather or any mechanical failures.

A few days before we left, I spoke to my mother about the trip. She has always been incredibly supportive of my work, and very calmly said, "If anyone can do it, you can." I know she's biased, but still those carefully chosen words immediately calmed me and released me from my fears. I soon found that by breaking down the trip and concentrating on a few states at a time, and not even thinking about states I would be visiting in the next year, I was able to keep anxiety at bay—at least enough to get started, the hardest part of any formidable task.

In 2001, while I began preproduction and tried to figure out how to make the project happen, I made a jump-start on the photography. Previous magazine shoots had yielded a few images, and by grabbing a few more in the northeast before the main part of the journey, I was able to make inroads on the task that lay ahead of me. I hired a researcher, Madeline, for two months; her tasks included picking as many as six dive shops from different areas of each state, and finding an experienced diver who had been exploring their local water areas for years and was willing to chat. Divers around the country were incredibly helpful, and Madeline's detailed notes, along with my initial ideas, provided a first-draft roadmap.

Once I knew where we needed to be at certain times of the year—and which images simply had to be in this collection, such as the humpback whale—I plotted these destinations on the map and filled in the gaps. And by leaving a few days' leeway

at each location for weather and other opportunities that unexpectedly arose, I was able to fit most of my image ideas into the schedule.

Research, of course, remained an ongoing, evolving process. As we traveled and talked to other campers, divers, and fishermen—and looked through local tourist brochures–we discovered many potential images along the way. Other ideas simply presented themselves. For example, I met Barbara one night at dinner in New York City. We began to talk about my upcoming project, and she mentioned that she could find ancient shark's teeth in the Potomac River near her house in Virginia. We stopped by to investigate the teeth, which we found with the help of Barbara and Charles, but the water was too murky for photography. However, just down the road from our new friend's house lived a man who fished for blue crabs, which, serendipitously, led to the blue-crab molting image I was eager to find.

Even with all the research, there were still times when we felt stumped in certain states. When this happened, we literally drove around a potentially promising water area to see what we could find. But this was what this project was all about: stretching myself creatively to see if I could make something happen.

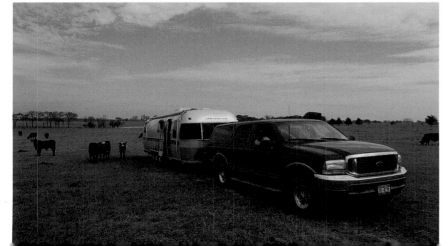

Driving through a field at Adios Ranch, Texas

Cottonwood tree, the Blue Hole, Santa Rosa, New Mexico July 1997 / Depth 5ft. / Temp. 61°F / Vis. 60ft.

During my 1997 magazine assignment across the country, we briefly stopped in New Mexico. Now this was a 4,000-mile, 9-day shoot so the actual photography time was very limited. At the Blue Hole I had just 90 minutes to dive the hole and investigate the adjacent creek before the day's 900-mile drive to Las Vegas, Nevada.

It was a speed dive and I was relieved the hole was only 60 feet across, with 61°F, artesian-spring water. It produces 3,000 gallons of freshwater every minute so the visibility was excellent. For thousands of years, Native American People have come to these waters, which were, and still are, the purest in the desert for miles. The Anasazi, who later became the Pueblo and Navajo tribes, dominated the area around the Blue Hole and Billy the Kid most likely took a dip here on his way to town in the late 1800s.

With no time to waste, I rapidly dropped to the bottom at 81 feet but I couldn't find anything of interest. So I ascended to concentrate on the cottonwood tree, which overlooked the water. The shot was working but it lacked emotion. At the end of my last roll, a brief, light breeze brushed the surface of the water, creating this impressionistic effect and before I knew it the wind had disappeared. It was as if a Native American spirit had shown me the way.

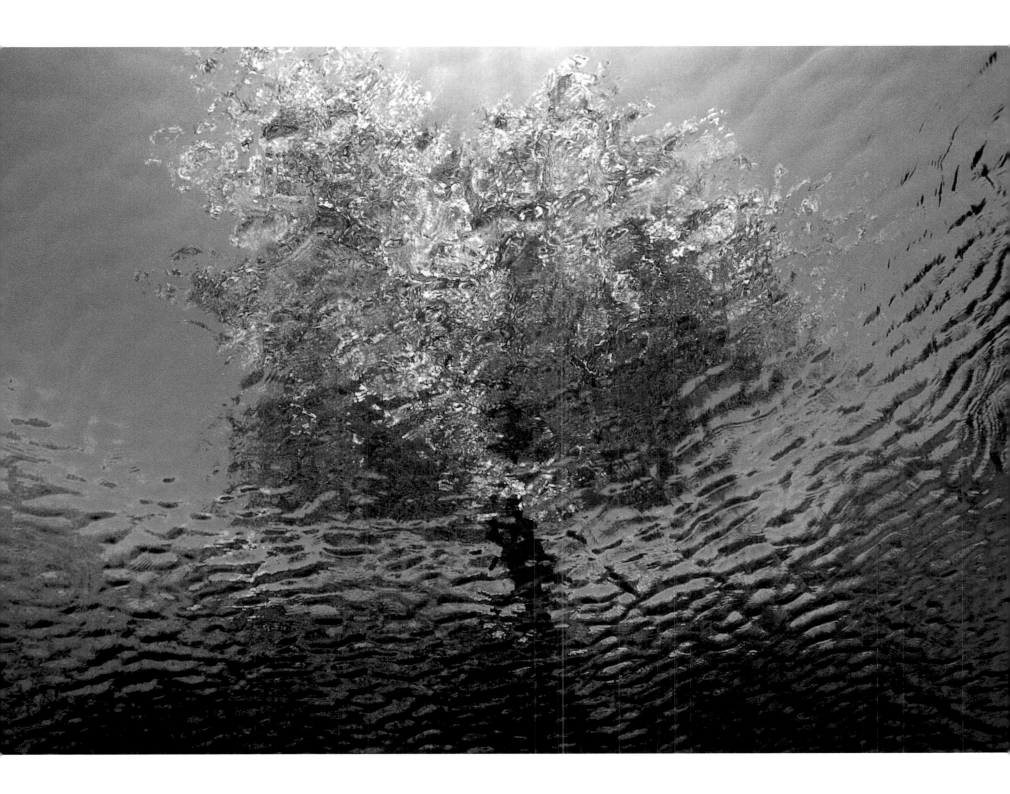

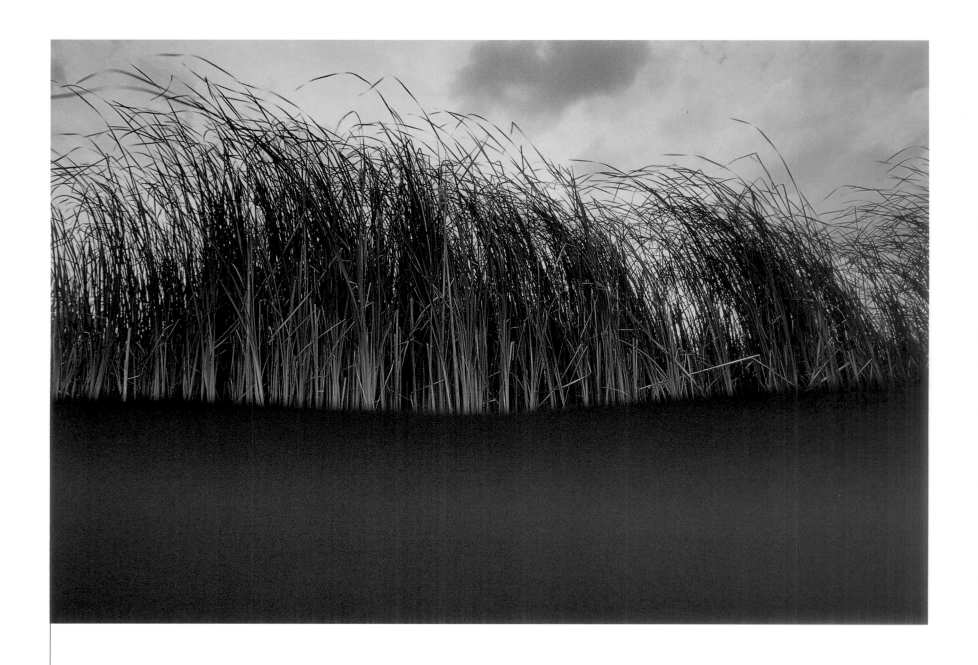

Cattails, Pratt Fish Hatchery, Kansas July 1997 / Depth 1ft. / Temp. 78°F / Vis. 3ft.

On a Sunday morning during the 1997 magazine assignment, my assistant Sebastian and I had to drive the entire breadth of southern Kansas in order to reach New Mexico the following day. For hours we'd been humming "Home on the Range," the Kansas state song, and muttering about how we needed to wash off the dust of the trail—classic cowboy stuff. We were aquanauts at heart, keen to get our feet wet somewhere in the prairie, and all we'd seen from the road was one miniscule creek after another. After studying the map over brunch in an old-fashioned diner, we decided to stop at this fish hatchery, whose manager very kindly gave us permission to paddle in his pond.

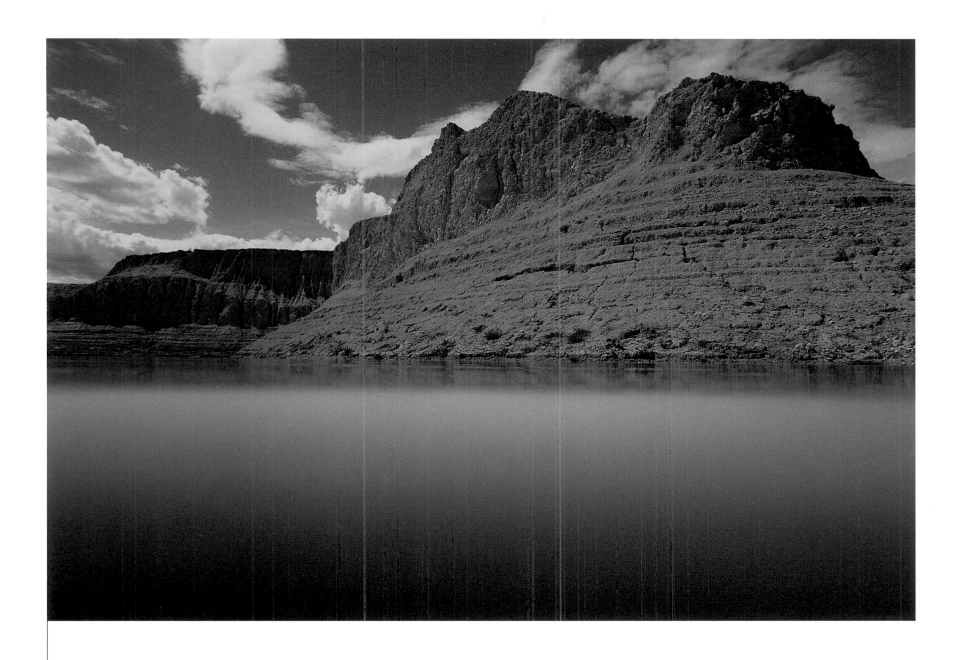

Cuny Table Pond, Pine Ridge Indian Reservation, the Badlands, South Dakota April 21, 2004 / Depth 1ft. / Temp. 54°F / Vis. 1ft.

Visually the Badlands are exquisite—a "magnificent city of the dead" in the words of Dr. John Evans, an early explorer. Naturally, I was enthusiastic about photographing the land the Sioux called "mako sika" (land bad), but I couldn't find an interesting composition along the White River, the only permanent water source around. That is, until I came across a picture of a pond in an old brochure. Scott, the chief park ranger, helped me locate the exact spot, but he warned me that unless there was enough spring rain, the seasonal pond would not materialize. Thankfully, it rained heavily in early April 2004. I've rarely been so grateful for a downpour.

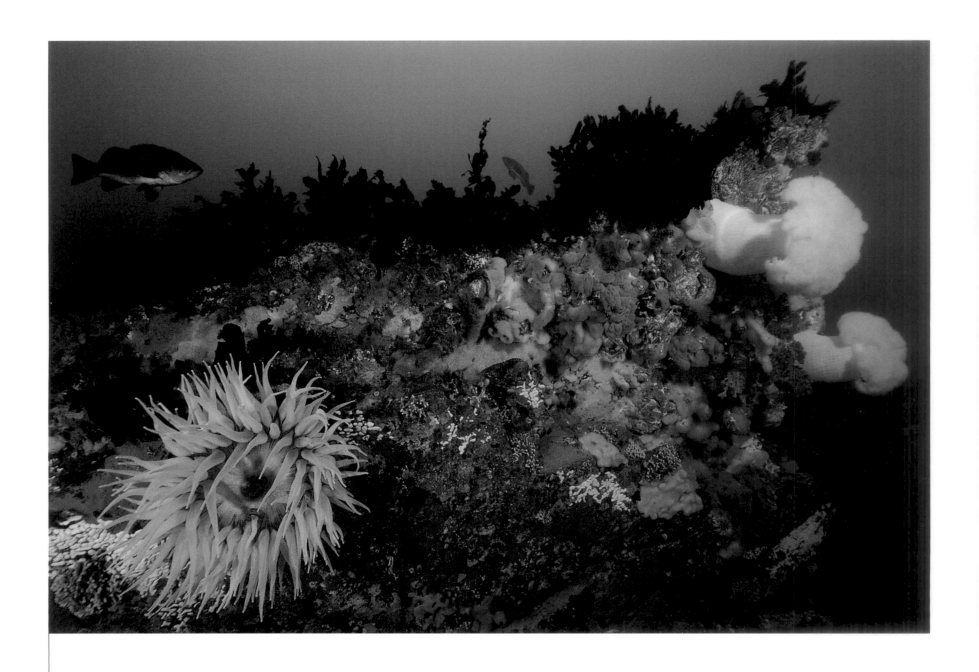

The Fingers, Waadah Island, Neah Bay, Strait of Juan de Fuca, Washington October 4, 2003 / Depth 46ft. / Temp. 45°F / Vis. 35ft.

In some water-starved states the decision about where to go was relatively simple. Others, such as Washington, were awash with possibilities, so to speak. It took months of research to choose where to spend the scant allocated time of 13 days in the water, and even then I was concerned about what I might be missing. At Waadah Island, a stone's throw from the town of Neah Bay, those anxieties were swept away. I explored an area called The Fingers, where the unyielding currents have created a series of parallel canyons, standing 20–30 feet tall. Once I had quickly dropped through the fierce current and into the nearest rocky ravine, I found myself sheltered in a phenomenally rich environment. From the broken white-shell bottom to the tops of the walls, every inch of the rugged terrain was decorated with sponges, and hard and soft corals. Enormous, colorful sea anemones and sea stars proudly made the ledges and outcroppings their home, while blue rockfish swam serenely over the seaweed and bull kelp. They seemed not to have a care in the world. Nor did I.

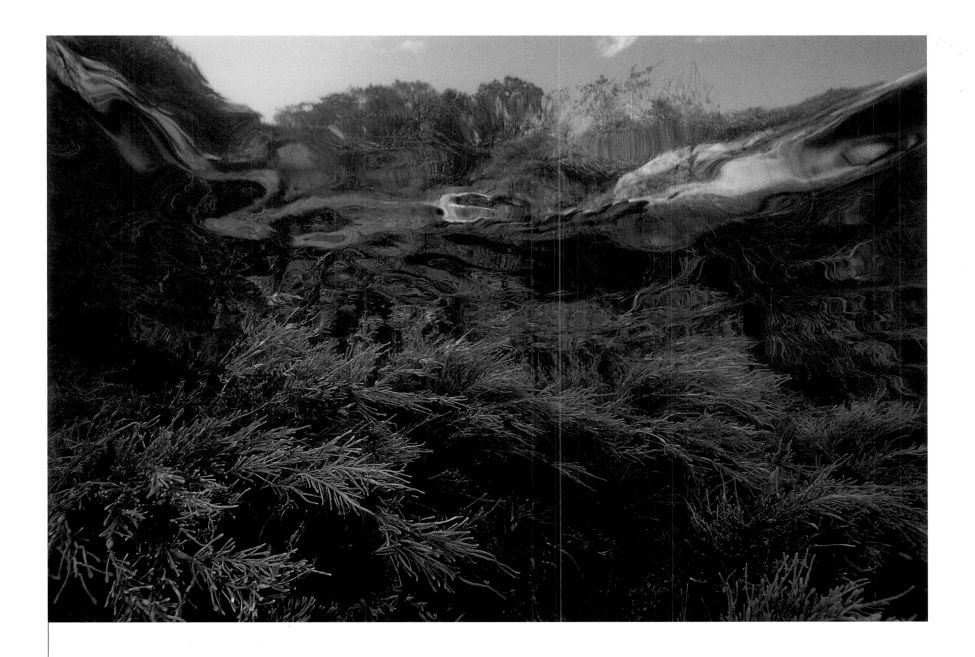

Knotted wrack, Folly's Cove, Cape Ann, Massachusetts October 1, 2002 / Depth 5ft. / Temp. 58°F / Vis 30ft.

One of the many pleasures of the journey was the anticipation of finding an interesting dive site and, once I was in the water, the excitement of knowing that I had a chance for a good shot. Folly's Cove exceeded my expectations. From the very first moment of submersion, I could tell that Folly's was a fortuitous spot. The east side is a gentle slope scattered with boulders—an ideal place for sea stars, lobsters, and bottom-dwelling fish such as skate and torpedo rays; the west side is a sheer wall, decorated with anenomes, sea peaches, and knotted wrack near the surface. So, no problems, right? Except that at this point of the trip the schedule was extremely hectic. We were due to dash south to witness a cranberry harvest the next day, and with just a single span of daylight to produce a worthy image I was going to have to be exceedingly lucky, with Mother Nature firmly on my side. And indeed she was. Everything was perfect: a clear blue sky, very calm water, 70°F air temperature, and decent visibility. I spent three hours in the water and found this picture in the afternoon when the sun and the tide were exactly where I needed them to be.

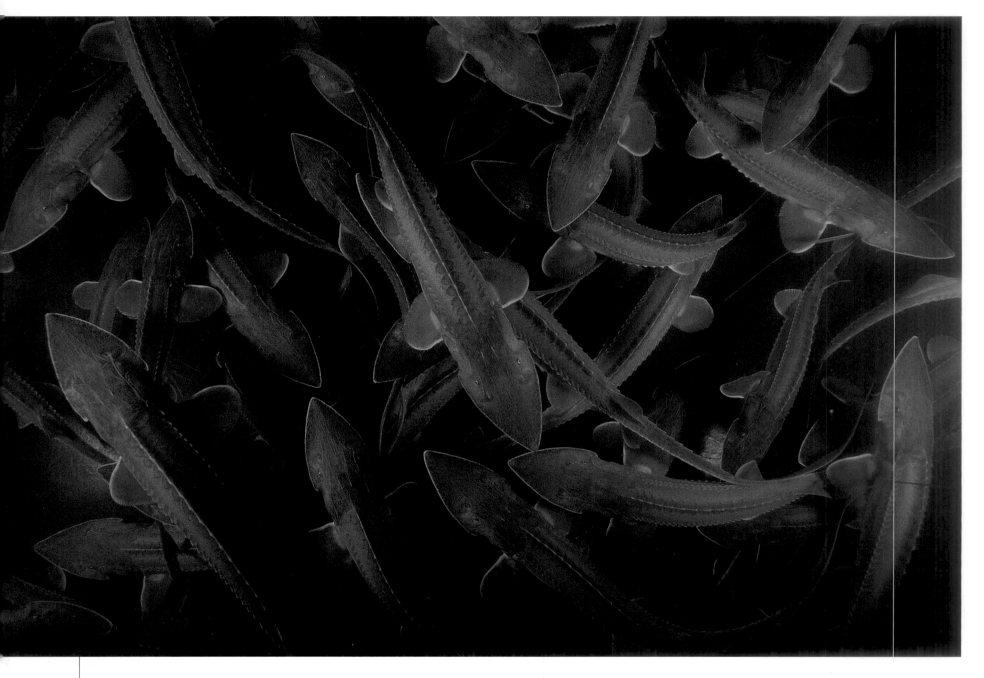

Juvenile pallid sturgeon, Garrison Dam Fish Hatchery, North Dakota July 16, 2003 / Depth 1ft. / Temp. 64°F / Vis. 5ft.

The pallid sturgeon, which can grow to more than six foot long and live for up to 50 years, is an ancient and very rare fish that has existed since the age of dinosaurs. Historically they ranged the entire length of the Missouri River and most of the Mississippi. Unfortunately habitat alteration resulting from dam construction has caused a serious decline. However, over the past decade hatcheries have begun programs to help restore the population. At the Garrison Hatchery, pallids are captured in the wild in April and held in tanks until June when they spawn. A month later the adult pallid sturgeons are tagged and released allowing biologists to track their movements in the wild. The young are held at the hatchery for a year, then tagged and released into various parts of the Missouri. I took this picture of the juveniles the day before they began their journey into the wild. According to the hatchery, four years later they remarkably appear to be surviving well.

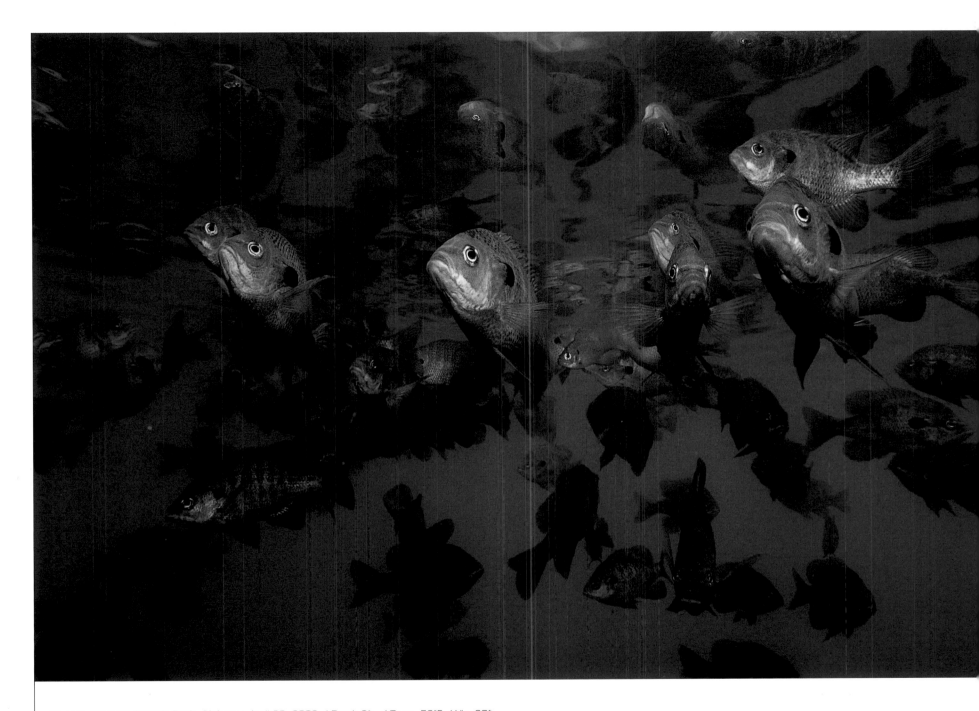

Bluegill, Madison Aquatic Park, Alabama April 28, 2003 / Depth 2ft. / Temp. 56°F / Vis. 30ft.

I was the first diver in the lake and within seconds of hitting the water found myself surrounded by bluegill expecting a hand-out. Illinois' state fish, easily identified by the dark blue "ear," an extension of the gill cover, will eat pretty much anything that will fit into their mouths. This is one reason they're so popular with fishermen. The other is that they are one of the tastiest of panfish. The "scarry piranha," as they are endearingly called at the park, pestered me until another diver came along with some food and the fickle school of panhandlers never bothered me again.

Mount Carmel cemetery, Lake Jocassee, Blue Ridge Mountains, South Carolina
August 18, 2004 / Depth 131ft. / Temp. 64°F / Vis. 50ft.

While researching possible dive sites in the Blue Ridge Mountains I found mention of a flooded cemetery at the bottom of Lake Jocassee. According to my source, several headstones remained in place. I was intrigued by the eerie photographic possibilities and so phoned Bill Routh, a local dive-shop owner. He told me the Duke Power Company, in charge of the new lake project in 1970, had given the relatives of the deceased a choice: they could have the bodies exhumed and moved to a new cemetery or the deceased could be left to rest in peace. The majority chose to move their loved ones, but some thought it best to leave them be. It sounded fascinating. We arranged to dive together in August, when the water at depth was clear.

Nine months after the phone call I was following Bill down the anchor line to the cemetery. At 75 feet everything went dark, which was momentarily quite spooky under those circumstances. But after a few minutes my night vision kicked in, and as we left the safety of the line, I began to make out four perfectly shaped rectangular coffin holes—another startling surprise. We cruised over these memento mori to a large white gravestone, upon which was chiseled "Silas Hinkle, Sept 12 1918 – Age 80, his wife Winnie Nicholson, June 8 1917 – Age 58."

At 131 feet your bottom time is extremely limited, even when you plan a decompression dive on Nitrox. So Bill and I had to be quick while we experimented with lighting and be very careful not to disturb the silt. It certainly was a diving and photographic challenge.

After the dives, we invited Bill over for a meal. He told us that the conclusion of the 1972 movie *Deliverance*, was shot around Lake Jocassee as it began to fill with water. The coming flood, which may or may not bury forever all evidence of the weekend canoe trip from hell, is dramatized by a background view of gravediggers loading coffins into the back of a pickup truck. I remembered the scene; what I didn't know was that it was truly an instance of *cinema verité*, a mini-documentary on the fate of the deceased of Lake Jocassee.

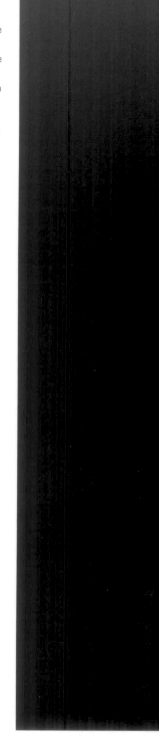

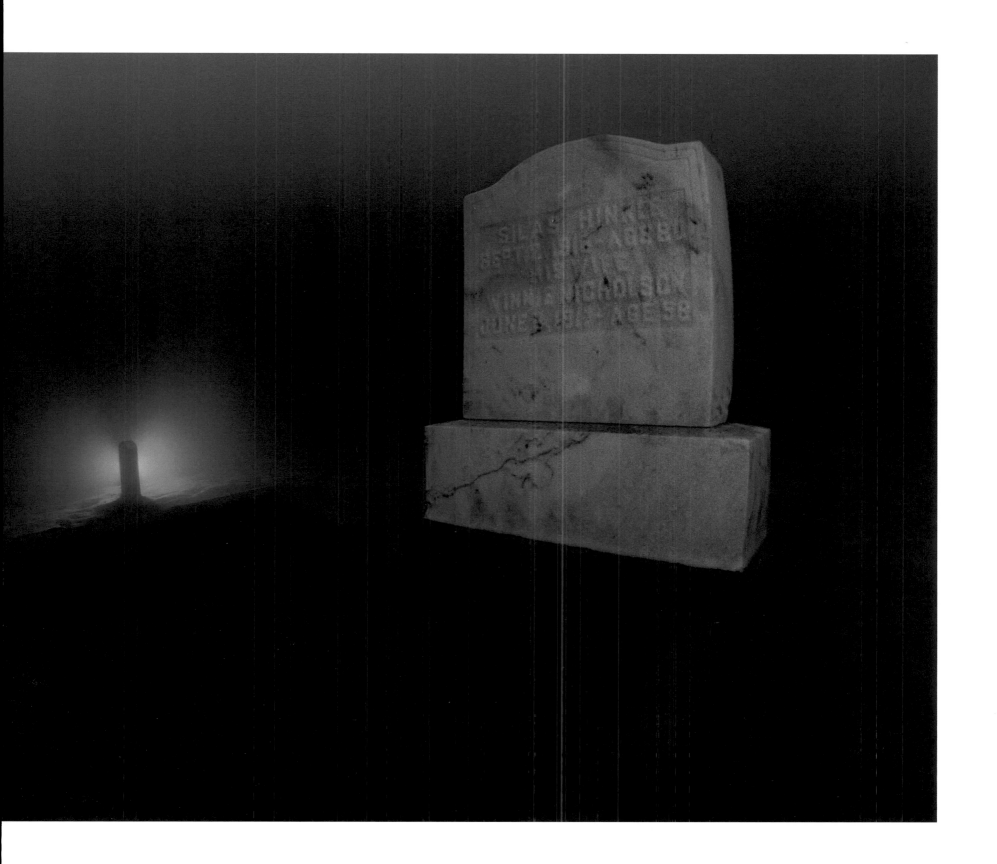

Kawarimono koi, Madison Aquatic Park, Alabama April 28, 2003 / Depth 1ft. / Temp. 56°F / Vis. 30ft.

Koi, a variety of the common carp originally from Eastern Asia, and now a worldwide favorite as an ornamental fish for decorative ponds, are believed to have been introduced to Japan by the invading Chinese in about 200 B.C.E. In the seventeenth century, when they began to be raised for protein value alone, esthetically attentive aqua-farmers noted that some koi were more brightly colored than others. These individuals were captured and selectively bred, becoming living palettes of vividly contrasting or subtly blended tones. As koi became treasured for their beauty, the tradition arose that they were lucky as well. Whether or not these few colorful individuals living in a flooded quarry in northern Alabama bring good fortune to anyone, they do brighten up the place famously.

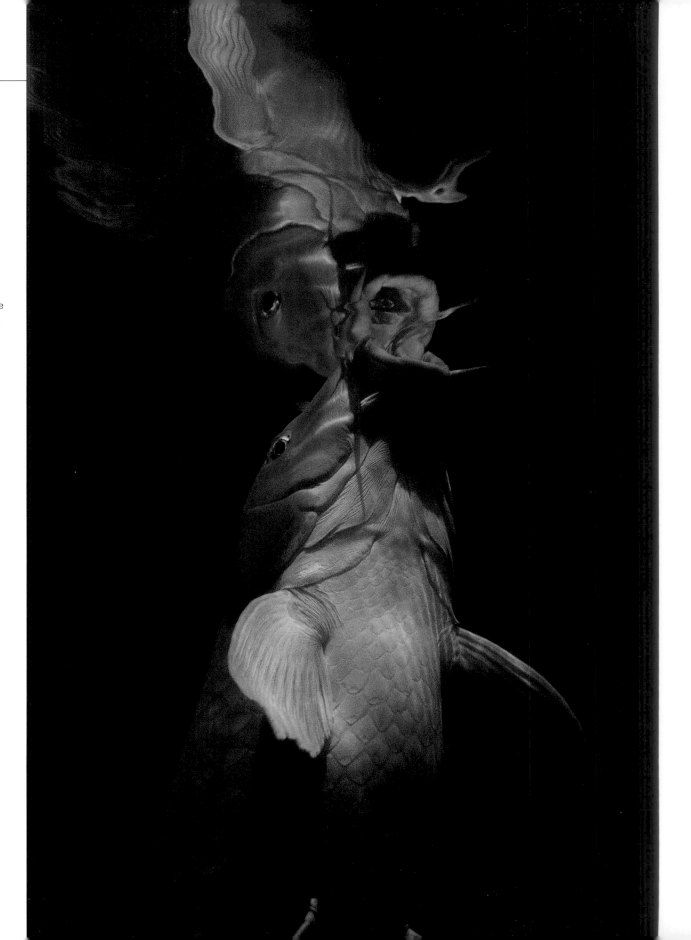

Texas spiny soft-shell turtle, San Solomon Springs, Balmorhea State Park, Toyahvale, Texas February 16, 2003 / Depth 10ft. / Temp. 78°F / Vis. 100ft.

This subspecies of the spiny soft-shell turtle primarily occupies the Rio Grande, the Pecos River, and their drainage areas in western Texas. Their shells are mostly thickened skin, so they are more vulnerable than their hard-shelled cousins. When I was in the San Solomon Springs pool, a large female swam toward me, sat on the bottom, stretched out her impressive neck, and posed.

Native American myth: All creatures existed on the back of a gigantic turtle and when crabs came along and heaped sand on her back the world as we know it was created.

Periwinkles, The Rachel Carson Salt Pond Preserve, Permaquid Point, Maine September 22, 2002 / Depth 3ft. / Temp. 50°F / Vis. 8ft.

Standing on the rugged, rocky shore, you cannot help marveling at the size of the tidal salt pond. Instead of a few isolated rock pools, Ms. Carson's tidal preserve, which is only exposed at low tide, was 100 feet wide and long. But even more impressive was the complex community of sealife within its shallows. Wherever you dipped in you were bound to eavesdrop on some drama of survival. As I carefully snorkeled the three-feet-deep mini-ecosystem, I caught sight of a shrimp darting away from the claws of a green crab. Directly below me a juvenile flounder glided past a tiny blood star the size of my thumbnail. At the other end, dozens of periwinkles scraped the orange encrusting algae off the rocks with their filelike tongues. After spending two hours in the water, I could see why the noted ecologist Rachel Carson, credited with launching the contemporary environmental movement, conducted most of the research for her classic book, *The Edge of the Sea*, at this extraordinary salt pond.

"The more clearly we focus our attention on the wonders and realities of the universe about us the less taste we shall have for destruction."
Rachel Carson 1954

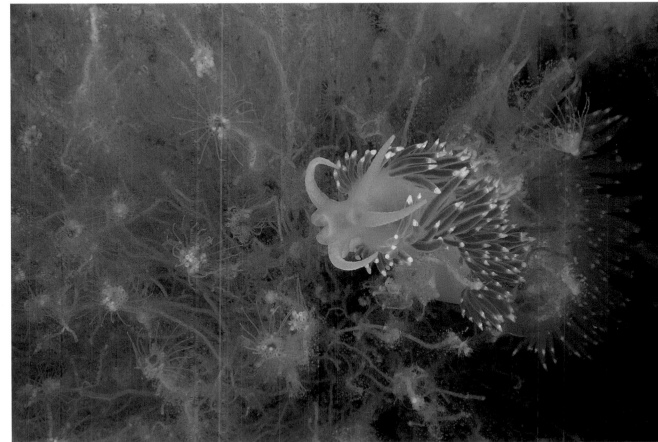

Red-gilled nudibranchs, wreck of the *Manhattan*, Atlantic Ocean, Delaware
July 17, 2004 / Depth 86ft. / Temp. 49°F / Vis. 12ft.

The visibility was poor the day I went diving on the *Manhattan*, an 1879-vintage passenger-freighter, which sank when it collided with the schooner *Agnes Manning* on the night of November 20, 1889. I drifted past the two big anchors, past the boilers, engines, and flattened debris until my eye caught the nudibranchs. Through the course of evolution, these soft-bodied snails have lost their shells and developed another form of defense—camouflage. Frankly I didn't expect the shot to work. These champions of adaptive color clung tightly to a Tubularian hydroid, which the powerful surge swung back and forth, making it a real challenge to focus.

The *Ocean Wave* wreck, Lake Michigan, Nr. Whitefish Point, Wisconsin June 4, 2005 / Depth 104ft. / Temp. 41°F / Vis. 80ft.

Early that morning at Bailey's Harbor pier, my rendezvous point for the dive boat, a man was spearing carp with a bow and arrow. The hunter dumped each huge, dying fish in a large garbage can, which bumped and thudded and inched across the pier as the fish inside fought for their lives. It was a surreal sight, which strongly affected me. Strangely, I felt a powerful surge of compassion for these struggling fish, which seemed to extend to all things trapped and embattled—especially to the mariners of the Great Lakes who have found themselves in a fight for their lives.

The men aboard the *Ocean Wave*, a scow schooner sailing from Moonlight Bay to White Lake, Michigan with a load of limestone, were among the more fortunate victims of these perilous waters. At 3 a.m. on the night of September 23, 1869, she foundered in a violent storm and rapidly sank. The crew barely had time to launch their yawl boat and escape, paddling through the night to the nearest landfall, Whitefish Point. It was a terrible ordeal, with death a constant threat.

Whenever you dive to a wreck you can't help thinking of mortality. The experience was peculiarly vivid that day, starting with the dying carp and continuing with the visibility on the wreck—an unusually good 80 feet. From the tip of the bowsprit I could see the entire wreck—well, what was left of it, the sheer weight of the limestone having demolished the majority of the hull. There was a scientific explanation for the extreme clarity—zebra mussels. Having arrived via a transoceanic vessel in about 1986, zebra mussels were discharged into Lake St. Clair, near Detroit. Since then the invasive mussels have flourished, quickly spreading throughout most of the Great Lakes and their tributaries, causing ecological havoc to some of the native fish species by devouring phytoplankton. This process effectively "cleaned" the water. Consequently this image would not have been possible a few years ago. But science aside, the clarity seemed part of an eerie spell. Some days you see too little; some days too much.

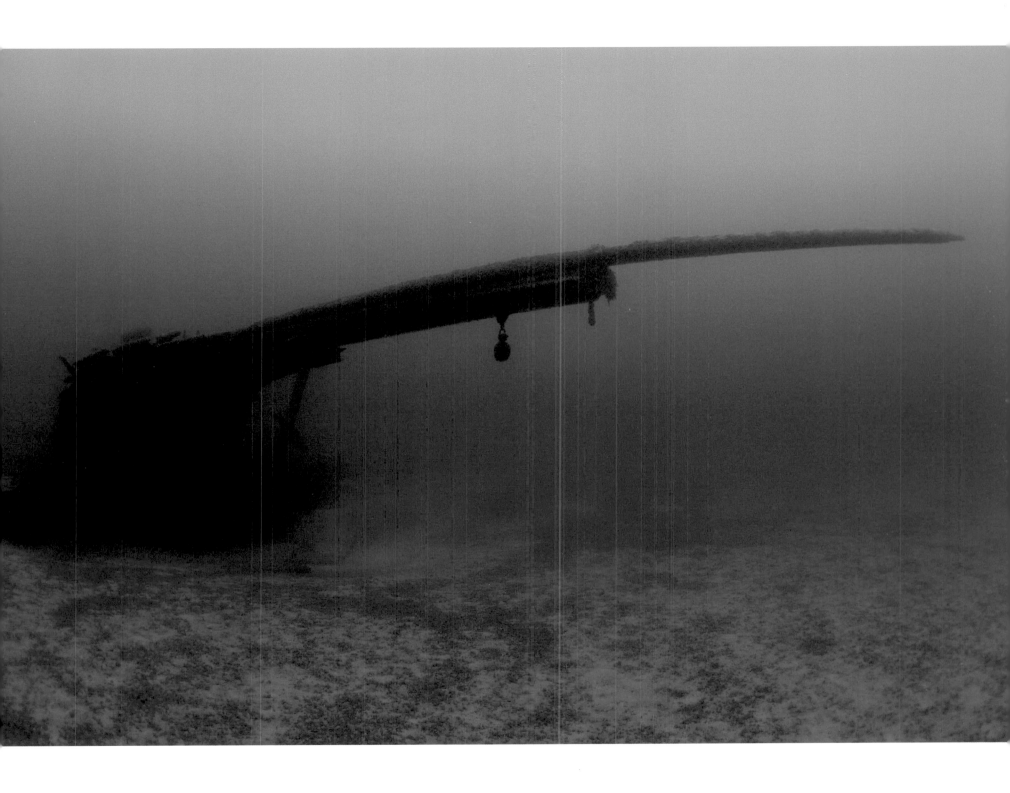

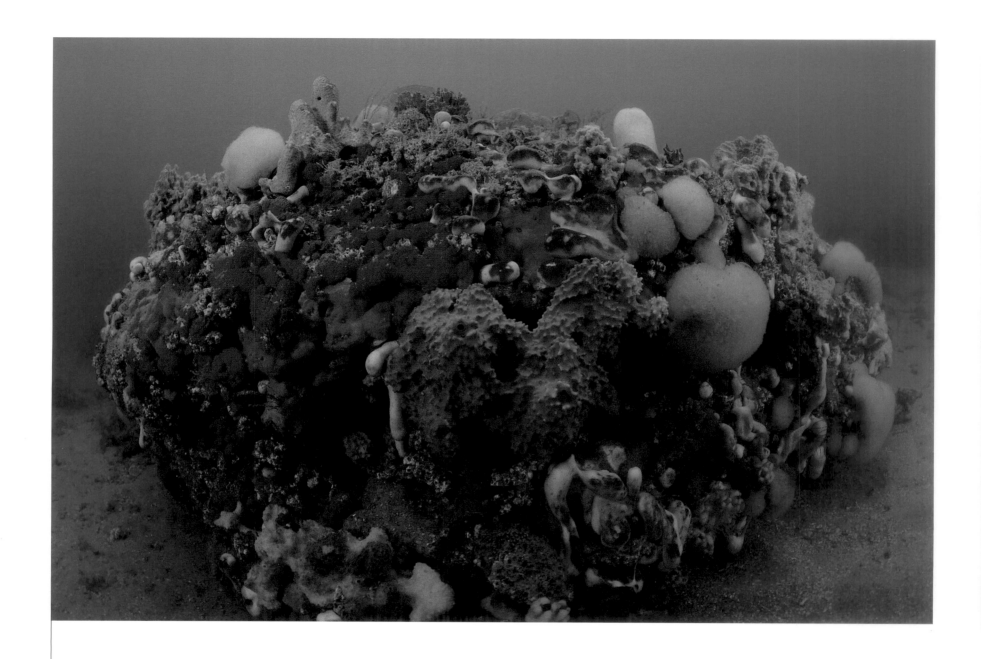

Coral outcropping, Gray's Reef National Marine Sanctuary, Atlantic Ocean, Georgia June 22, 2005 / Depth 57ft. / Temp. 77°F / Vis. 15ft.

On our way through the flat coastal marshland on the Altahama River, we passed seventeenth-century vintage rice paddies and then came to an island called the "Lesser Andes," the former home of three short men, each called Andy. After 25 nautical miles we arrived at Gray's Reef, designated a marine sanctuary in 1981. There's a very good reason: the 17-square-mile area of limestone ledges and outcroppings is the only known winter calving ground for the endangered North Atlantic right whale. The threatened loggerhead turtle lives on the reef year round. Gray's Reef biologists believe that the animal and plant diversity found here is comparable to a tropical rain forest. After waiting for an inquisitive six-feet tiger shark to leave the vicinity of the boat, I descended through the bottle-green water and watched a school of Atlantic spadefish swim by before I found a coral outcropping covered with a truly diverse array of sponges.

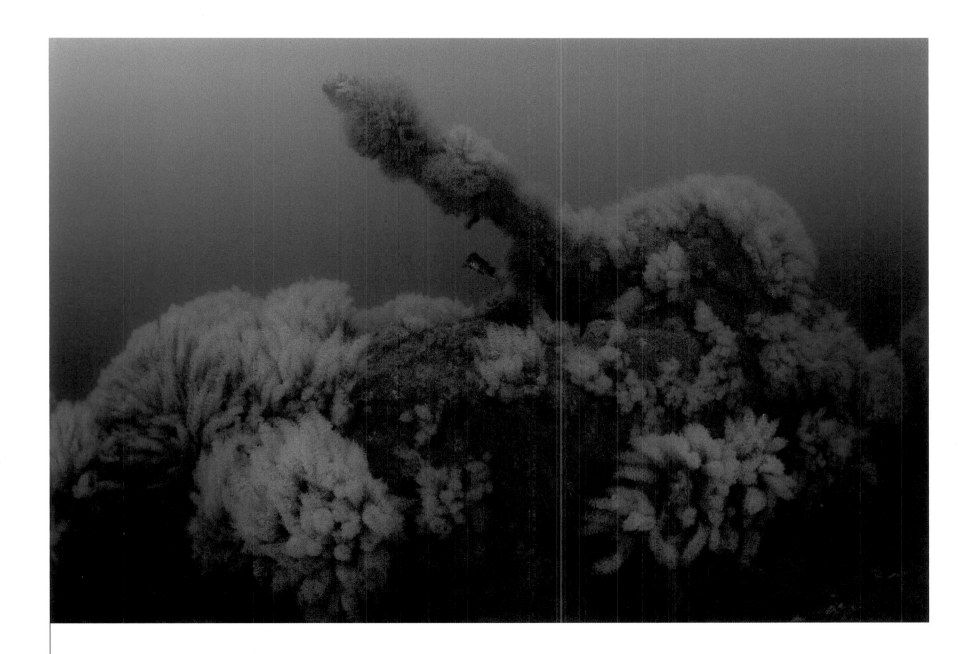

World War II Valentine tank, *John Morgan* wreck, Atlantic Ocean, Virginia July 25, 2004 / Depth 34ft. / Temp. 52°F / Vis. 20ft.

The *John Morgan* was one of the 2,700 Liberty ships built during World War II to supply the U.S. troops with food and war materials around the globe. On the night of June 1, 1943, while on her maiden voyage from Chesapeake Bay en route to the Pacific, she collided almost head on with the SS *Montana*. Both ships were in blackout mode to avoid being spotted by German U-boats. The *John Morgan* carried tons of fuel and ammunition, and the explosions were heard in North Carolina, with flames visible from Virginia Beach 30 miles away. Eighty-four crew members lost their lives.

The wheelhouse of the *Duane*, Florida Keys National Marine Sanctuary, Key Largo, Florida October 11, 2004 / Depth 86ft. /Temp. 80°F / Vis. 100ft.

At the time of her decommission in 1985, the U.S. Coast Guard Cutter *Duane* was the oldest active U.S. military vessel. In her fifty-year service, the 327-foot-long vessel patrolled the Bering Sea before being reassigned in 1939 to protect shipping in the North Atlantic. During World War II, the *Duane*, along with her sister ship, the *Spencer*, sank the German U-boat *U-77*, took part in the amphibious-force invasion of southern France, and participated in four rescues at sea, picking up 346 survivors. Near the end of her illustrious service, she was an escort vessel for Cuban refugees making their way to the United States in the 1980s. On November 27, 1987, the *Duane* was sunk upright on a sandy bottom in 120 feet of water where, swept by powerful Gulf Stream currents, she provides a habitat for fish, and a colorful window to the past for divers.

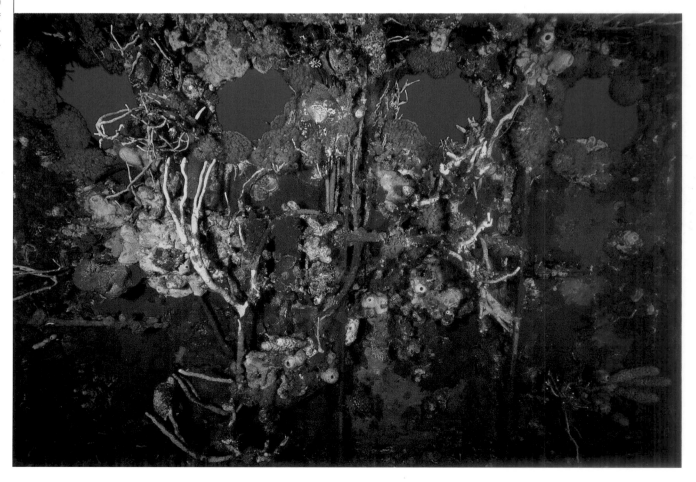

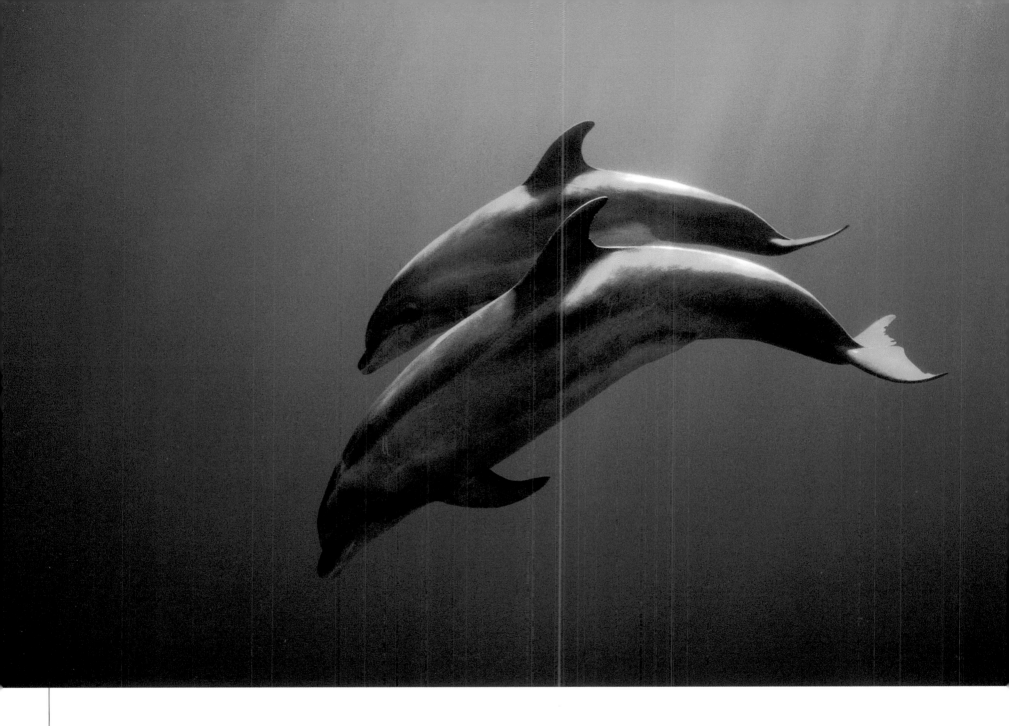

Pacific bottlenose dolphins, Auau Channel, Maui, Hawaii February 18, 2005 / Depth 12ft. / Temp. 74°F / Vis. 100ft.

Dolphins are one of the most intelligent and empathetic inhabitants of the ocean. They appeared in many legends of the ancient Romans and Greeks, who believed they brought good luck to mariners. In addition to being a lucky charm, these playful, speedy creatures have been known to help distressed humans at sea. I have seen them form a protective circle around a panicked diver, making sure he reached the safety of the boat. Once I was acoustically scanned by a bottlenose, that is, subjected to a barrage of clicks and pings. This echo-location, known as dolphin sonar, is used for a variety of reasons, from communication and hunting, to locating friends or foes. I'm glad to say I was identified as a friend and a pleasurable shiver went down my spine—I felt I had been blessed by Poseidon, the Greek god of the sea.

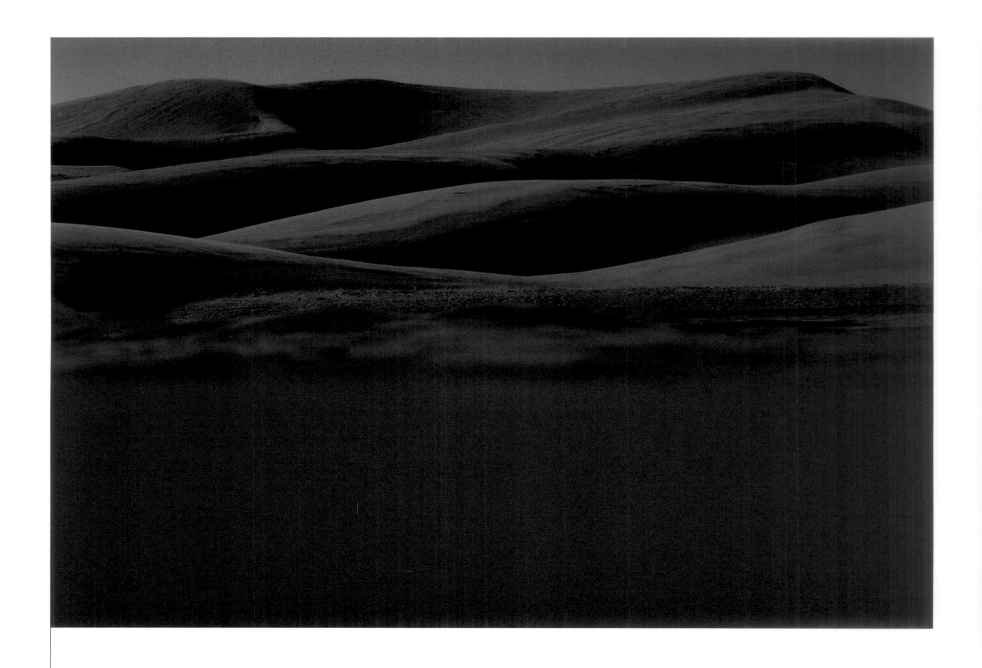

Medano Creek, The Great Sand Dunes National Monument, San Luis Valley, Colorado April 12, 2004 / Depth 1ft. / Temp. 65°F / Vis. 1ft.

The Great Sand Dunes are the tallest dunes in North America, rising to a height of nearly 750 feet. When the Rio Grande changed course millions of years ago, the prevailing winds blew the remaining sand into a giant heap at the bottom of the snowcapped Sangre de Cristo Mountains, creating the dramatic effect of a desert and alpine landscape. During the spring thaw, meltwater from the snow fields of Mount Herald flows rapidly down the steep mountainside and into the valley directly in front of the dunes, forming Medano Creek. The shallow creek appears in April and vanishes in August, when the 14,000-feet mountains begin to freeze again.

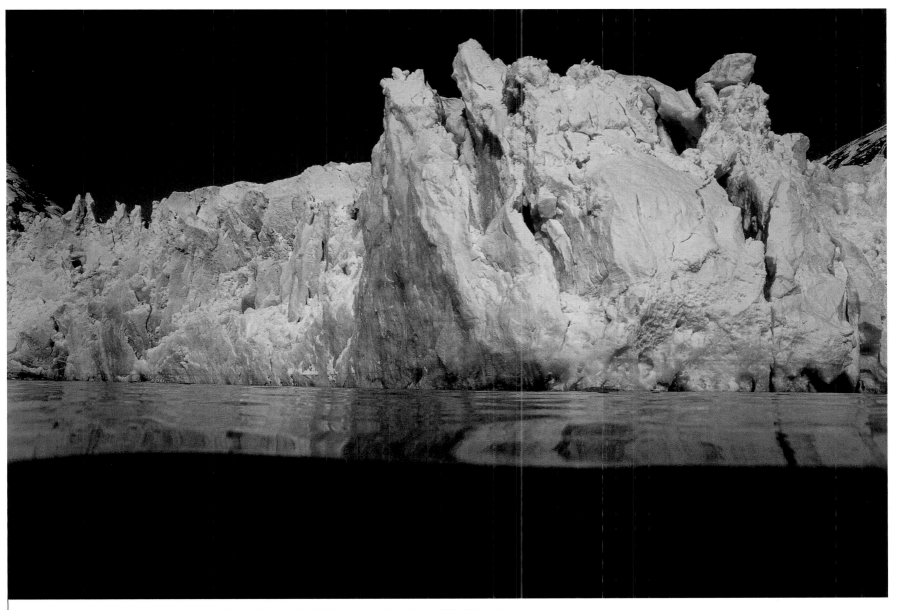

North Sawyer Glacier, Tracy Arm Fjord, Alaska March 16, 2005 / Depth 1ft. / Temp. 35°F / Vis. 5ft.

As the boat turned into Tracy Arm from Holkham Bay, the spectacle of the 26-mile-long fjord began to unfold. Framed by snow-capped mountains, the twisting narrow passage was bordered by sheer granite cliffs reaching up to 2,000 feet. Icebergs floated past us on their way to the sea. At the end of this dramatic waterway were very active reminders of the Ice Age—the twin Sawyer Glaciers, just two of approximately 100,000 glaciers in Alaska.

Surprisingly, there were no icebergs directly in front of North Sawyer, which allowed the boat to creep close to the towering, five-mile-long frozen river. In order to fill the frame with my wide-angle lens, I snorkeled as close to the glacier as I felt was relatively safe. John Lachelt, my dive buddy, was a distance behind me, acting as a safety diver. For a moment I just stared in awe at the wall, a half mile wide, and two hundred feet high. Its fresh cracks revealed deep blue crystalline ice. Except for a fleeting visit from a seal, the wilderness was calm and quiet until halfway through my second roll, when a deafening roar emerged from the glacier as it calved. A huge block of ice had sloughed off and slid into the water, and a small flotilla of icebergs began bobbing toward us. John nervously yelled at me to get a move on. I finished shooting without any other interruptions, but just as we climbed aboard the boat, we heard the most almighty thunderous noise. I looked up and watched a five-story-high jagged piece of ice crash into the water below. Immediately after the ice dust had settled, a tsunami-like wave began rolling toward us. The young captain anxiously grabbed the wheel and spun us around so that we could ride out the wave. We were safe but certainly humbled by the glacier's force.

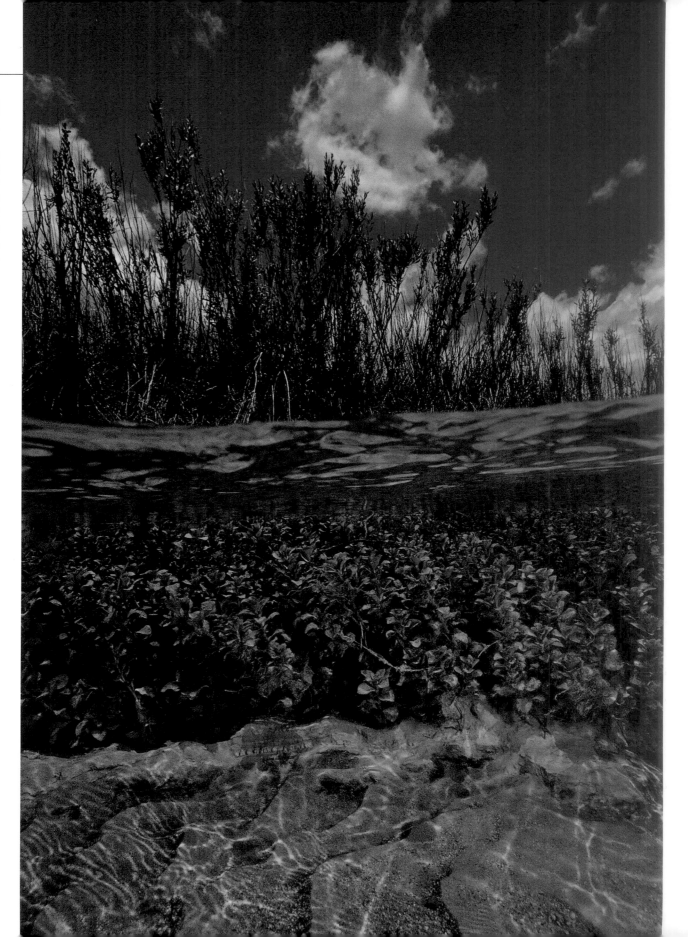

Blue Hole Creek, Blue Hole Cienega, Santa Rosa, New Mexico July 1997 / Depth 3ft. / Temp. 61°F / Vis. 20ft.

The constant flow of water from the Blue Hole sustains one of New Mexico's last intact natural desert spring wetlands, or cienegas. The Blue Hole Cienega is a rare habitat, an oasis on the northern edge of the Chihuahua Desert, which provides a precarious niche for many unique plants, such as the endangered Pecos sunflower.

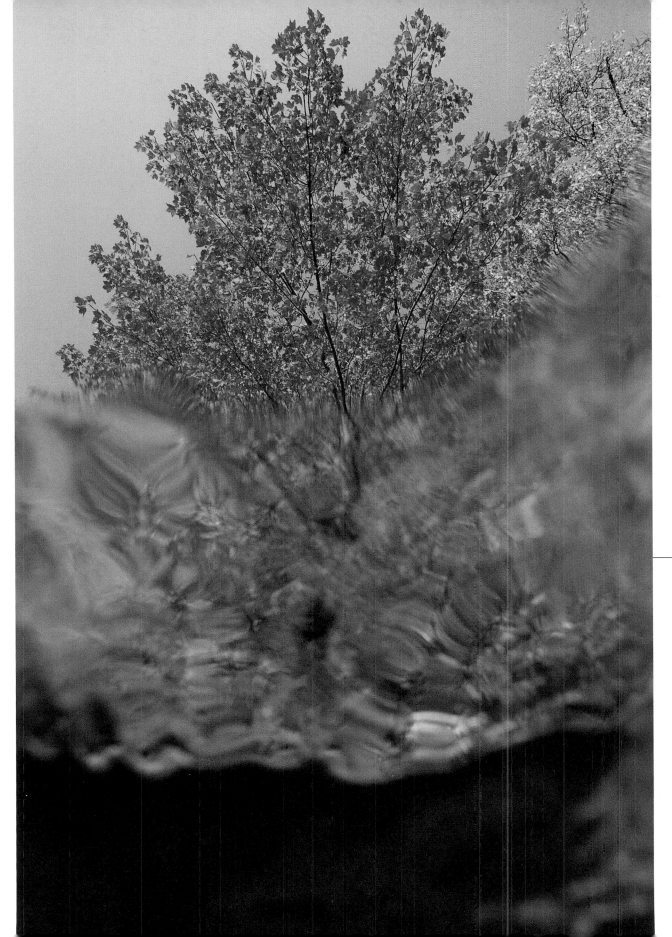

Maple tree, Russell Pond, the White Mountains, New Hampshire
October 5, 2001 / Depth 1ft. /
Temp. 51F / Vis. 20ft

A tip from my friends Stuart and Susanne led me to this remote pond deep in the heart of the White Mountains. The unspoiled forest, its shadowed glades still congenial to moose, reminded me of Walden Pond, where Henry Thoreau lived for two years, two months and two days and wrote his famous book, *Walden*, widely regarded as one of the major sources of modern day environmentalism.

"In wilderness is the preservation of the world." Thoreau

**Sudley Springs Ford, Manassas
Battlefield, Virginia** / July 20, 2004 /
Depth 1ft. / Temp. 66F / Vis. 1ft.

The first battle of the Civil War was
imminent. The Confederate army under
General Pierre G.T. Beauregard was
encamped near Manassas Junction, 25
miles south of the capital of the United
States. The Union General Irvin McDowell,
appointed by President Abraham Lincoln,
was being harassed by Washington
politicians to march his numerically superior
army south for a quick victory. McDowell
succumbed to the pressure and at
5.30 a.m. on July 21, 1861 the battle
began. Union troops passed this tree twice
that terrible day. Once in advance, when the
enthusiastic soldiers felt confident of victory
and once in defeat, when the inexperienced
young volunteers "fleed like frightened foxes."

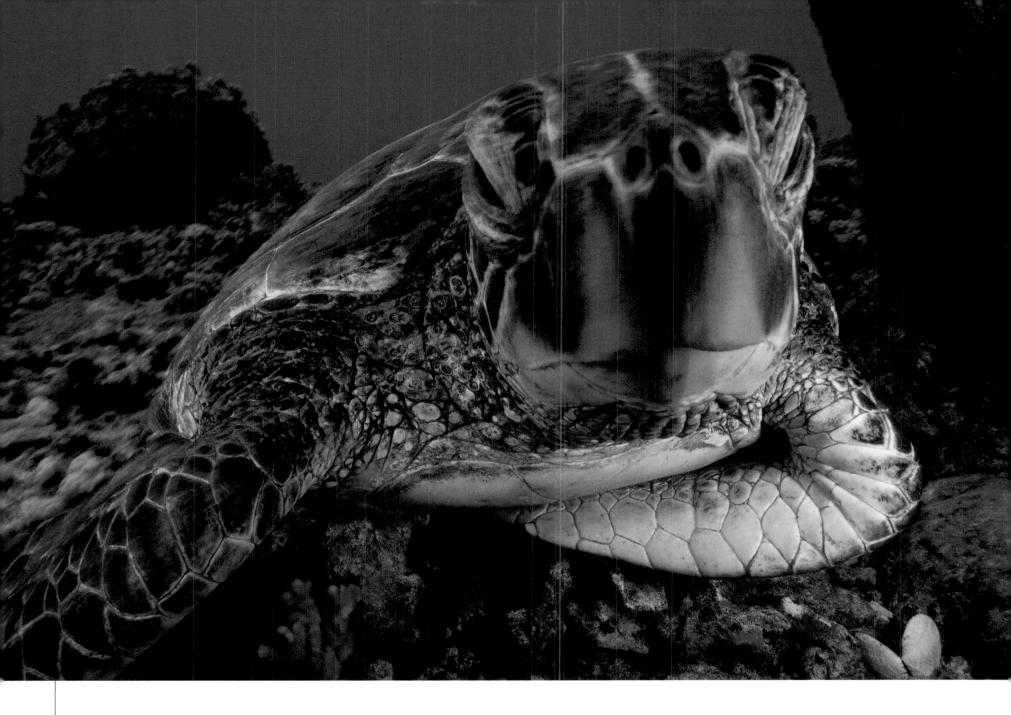

Hawaiian green sea turtle, Turtle Pinnacles, near Kona, Hawaii February 4, 2005 / Depth 53ft. / Temp 78°F / Vis. 60ft

For about 150 million years sea turtles have been swimming the Earth's oceans, but today six out of the seven species are threatened or in danger of extinction. The Hawaiian green sea turtle, which is listed as threatened, can grow to more than three feet, weigh in at a ponderous 350 pounds, and may live 100 years, peacefully munching sea grasses and algae. In one Hawaiian legend, a green sea turtle called Kauila possessed special nurturing powers: During the day it would change into a girl and watch over the children playing at Punalu'u Beach on the Big Island. If you visit that beautiful black sand cove, you'll see the legend come to life, because Punalu'u remains popular with children and green turtles alike.

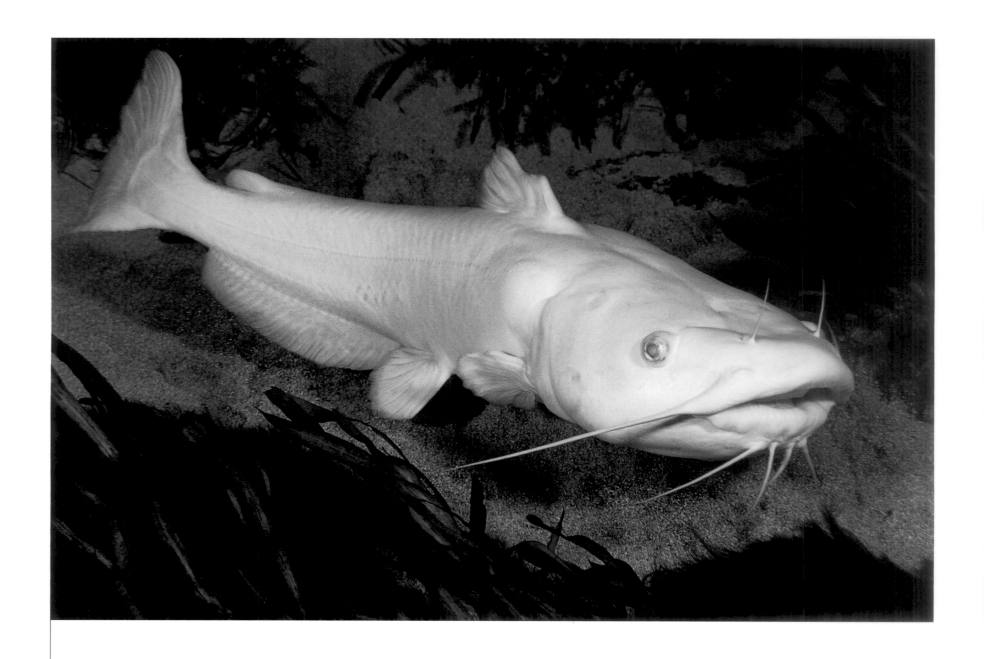

Channel catfish, Spring Lake, San Marcos, Texas February 24, 2003 / Depth 22ft. / Temp. 72°F / Vis. 80ft.

This 20-year-old blind catfish is one of the last survivors from the time when Spring Lake was an amusement park. Over the course of 50 years, tourists were motored around the lake in glass-bottom boats to view the specially bred, white catfish ghosting in the clear aquatic landscape, and to gawk at such entertainments as the scantily clad Aqua Maids performing their mermaid ballet, as well as Ralph, the swimming pig who stole the show with his tricks and dives. Despite the talents of Ralph and the Maids, some people objected that a site sacred to Native American People, and continuously inhabited for 12,000 years (the oldest such site in North America), should be thus abused, especially as it fell into sad disrepair. In 1994 the lake and adjoining land was purchased by Texas State University, which changed the former amusement park into an environmental learning facility called the Aquarena Center. Nowadays, tourists are still taken around the lake, but instead of the freaky catfish and Vaudeville shows, they enjoy the beautiful, ecologically fragile Spring Lake.

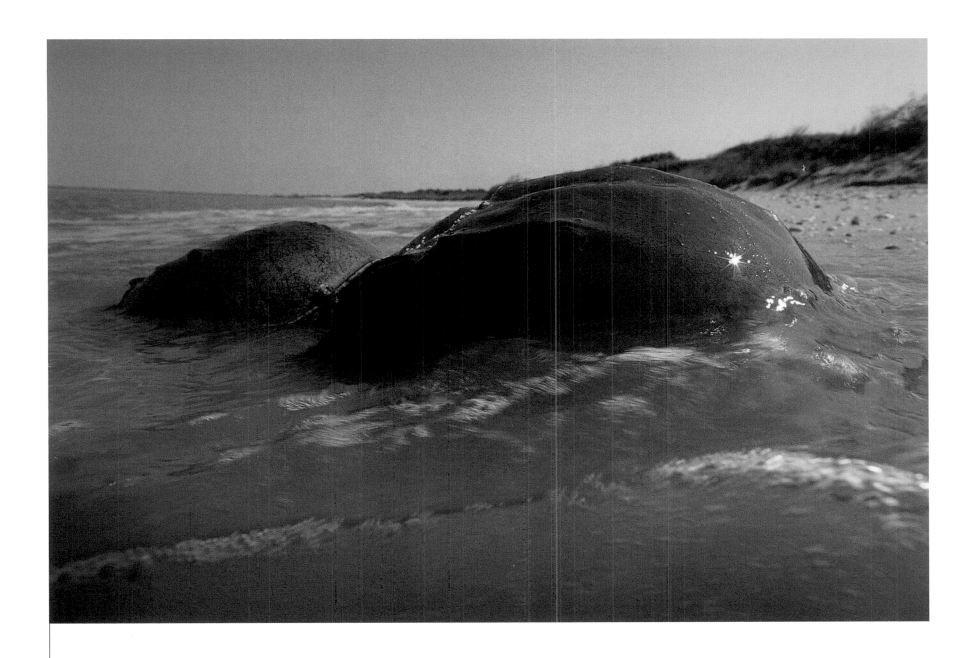

Mating horseshoe crabs, Higbee Beach, Delaware Bay, New Jersey June 5, 2001 / Depth 1ft. / Temp. 58°F / Vis. 1ft.

When it comes to sinister looks, Darth Vader has nothing on the common horseshoe crab, which has been shuffling along the ocean floor for the last 400 million years, an unchanging masterpiece of defensive design. When they are hunkered down in the sand, beady eyes peering through a hard curved shell, they are nearly impossible to overturn. Invulnerable to predators and unpalatable to humans, horseshoe crabs, which are not actually crabs but rather distant relatives of the spider, have little to fear when they creep ashore like little amphibious tanks to spawn. Here on the Delaware Bay they launch their amorous assault by the hundreds of thousands during the spring high tides of full and new moons. Males arrive first, then wait patiently along the water's edge for the larger females to lumber ashore. When they do, the males grapple onto the females' shells and are hauled up the beach, where the ancient mating ritual takes place.

Mating crayfish, Spiritwood Lake, North Dakota April 30, 2004 / Depth 20ft. / Temp. 45°F / Vis. 10ft.

Without the local knowledge of divers and fishermen, many of these images would not have been possible. This is a classic example. When I called Pete Renschler, who owns one of the few dive shops in the state, and asked him when the crayfish mate, he categorically stated, "They'll begin two to three weeks after the 'ice off.'" He went on to inform me that before the ice-off, the typical lake water temperature is around 35°F; immediately afterward it drops another two to three degrees. "Cold, right? It needs to warm up to a balmy 40–45°F before the crayfish begin to get amorous. In that narrow range they'll go at it like rabbits, but let it heat up to 50°F or more and it's no dice. So there's really just a 10-day window of opportunity when hundreds of crayfish line the lake floor, either mating or trying to cut in for a tango." Wow. Impressive answer. I asked him how many dives it took to gather this extensive information. "Oh," he replied, "About 300 dives over 20 years."

Once I knew the actual day of the ice-off, I could plan an eight-day trip, hoping it would coincide with the crayfish cotillion. Pete and I met at Spiritwood on a day with winds of 25mph and white caps frothing the surface of the small, shallow lake. Not a propitious start; we both knew the water would be stirred up and sure enough it was. Most of the time I could barely see five feet until we moved to the water directly in front of an old fish-hatchery site. There the visibility improved and we began to find the mating couples out in the open. That was a good sign: usually crayfish remain under rock ledges except for the spawning period. These were the largest crayfish I had seen anywhere. Later Pete told me that big crayfish meant a healthy lake, and that Spiritwood, with no tributary creeks or nearby agriculture, was particularly pristine.

Over the course of five days of diving, despite persistent winds and continued poor visibility, I found many couples and the occasional threesome. A threesome, according to Pete, is not that uncommon, because the uninvited male is really just trying to pick a dominance fight with the other male and, well, things snowball from there. Usually the male in the saddle just ignores his attacker—what concentration! Whether by twos or threes, the mating ritual was intense, with much claw waving, the acquiescing female finally clinging tightly to the male, both completely oblivious to my advances—photographic, I mean, not romantic. Due to the sketchy weather, I never did see the full-blown 10-day mate-fest, but it was nevertheless wonderful to witness such a primal, undisturbed scene.

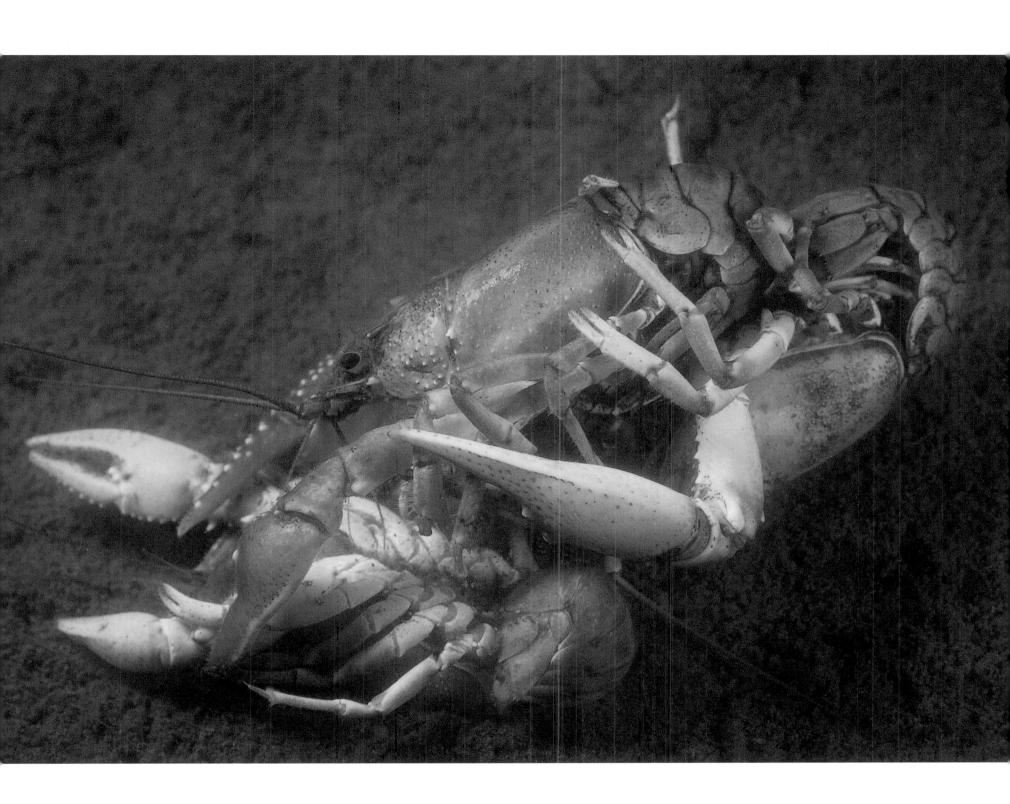

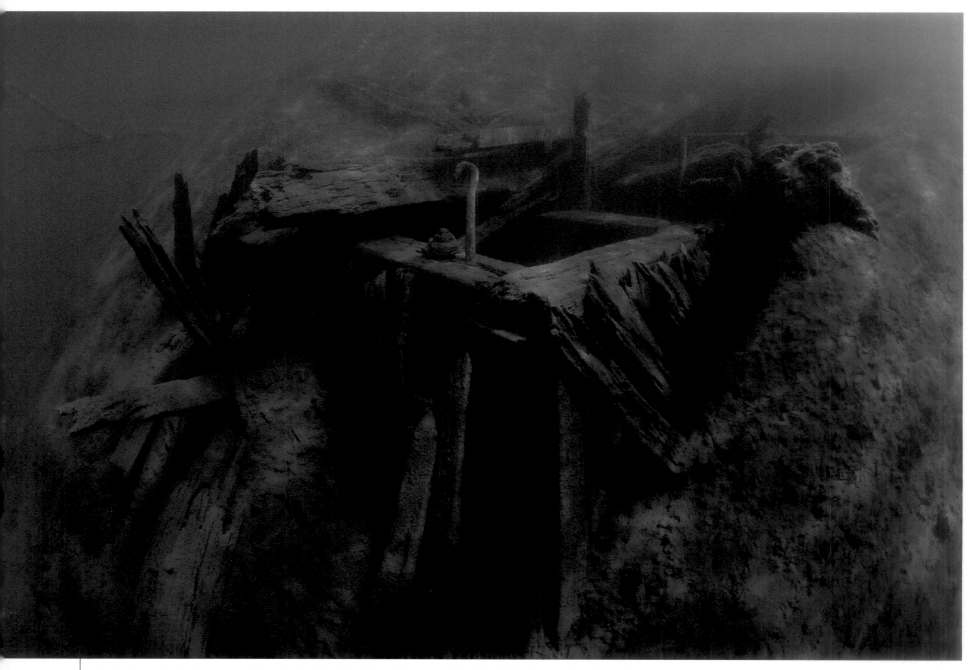

Vertical mine shaft, Huntington Lake, Crosby Mine Pit Lakes, Minnesota May 26, 2004 / Depth 18ft. / Temp. 50°F / Vis. 30ft.

We have Cuyler Adams to thank for the Crosby Mine Pit Lakes. He discovered a large iron deposit on his newly acquired land when his compass behaved erratically. Being an engineer by trade, Culyer knew that only a concentration of some form of metal could make this happen. Seven years later in 1911, the first of his 55 mines opened. Rich in manganese, the Cuyuna Iron Range, as it was called, made a substantial contribution to military production in both World War I and II. Eventually the last of the pits closed in the late 1970s as cheaper foreign ore made them unprofitable. Today, all of the old mines are filled with water. Mining relics can still be found in many of them, but the once-industrial area has become a natural habitat for loons, beaver, and such fresh-water fish as walleye, northern pike, crappie, bass, and trout. It seems strange to me now, considering Minnesota's famous 10,000 Lakes, that I spent most of my time there diving the flooded mines. Like Culyer following his compass, I felt the irresistible pull of something rich—this time it was history.

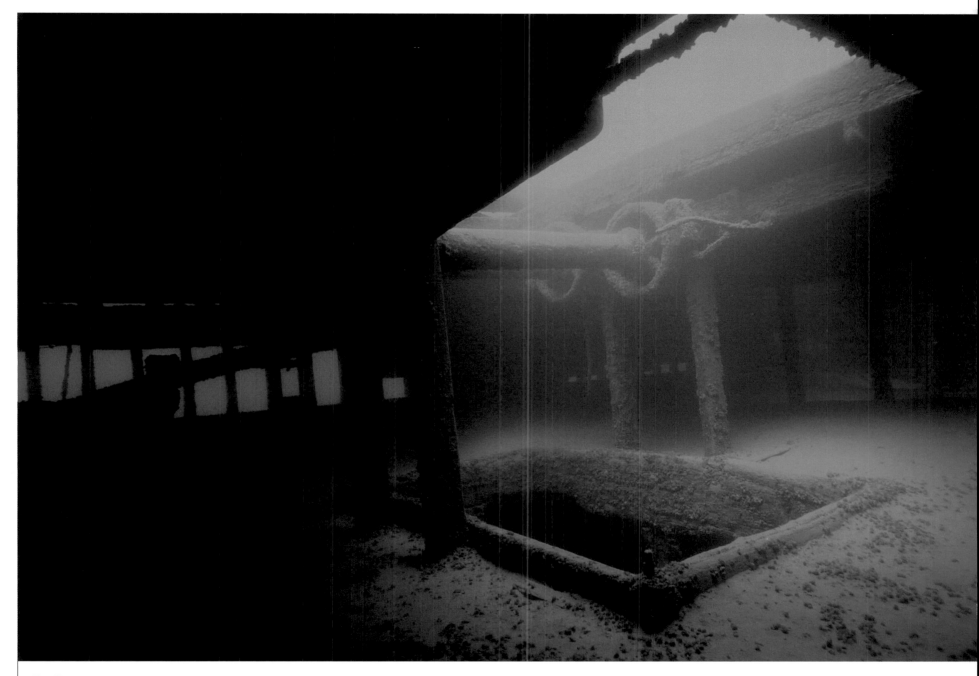

The *Eber Ward* wreck cargo hold, Straits of Mackinac, Lake Michigan, Michigan June 12, 2005 / Depth 122ft. / Temp. 45°F / Vis. 40ft.

In the Great Lakes where the chilly freshwater has preserved all the old wooden shipwrecks in a kind of perpetual cold storage, I found an incredible underwater museum that transported me back in imagination to the heyday of Midwestern maritime shipping. In the Straits of Mackinac, a hazardous conduit between Lakes Michigan and Superior, I explored the wreck of the *Eber Ward*, a 213-foot-long wooden steamer, which, after colliding violently with an ice floe, sunk just after dawn on April 10, 1909, with five fatalities. Designed to carry such package freight as bushels of corn, the *Eber Ward*'s interior was relatively open and accessible —ideal for an interior wreck image. I cautiously slipped through a hatch, wriggled through a doorway that was half caved in, and into the main hold. Even though you see a large opening at the top of this photograph, I had to approach another way, for fear of disturbing the two-feet-thick silt and ruining the shot. It was quite haunting, being inside a wreck that large and that deep by myself.

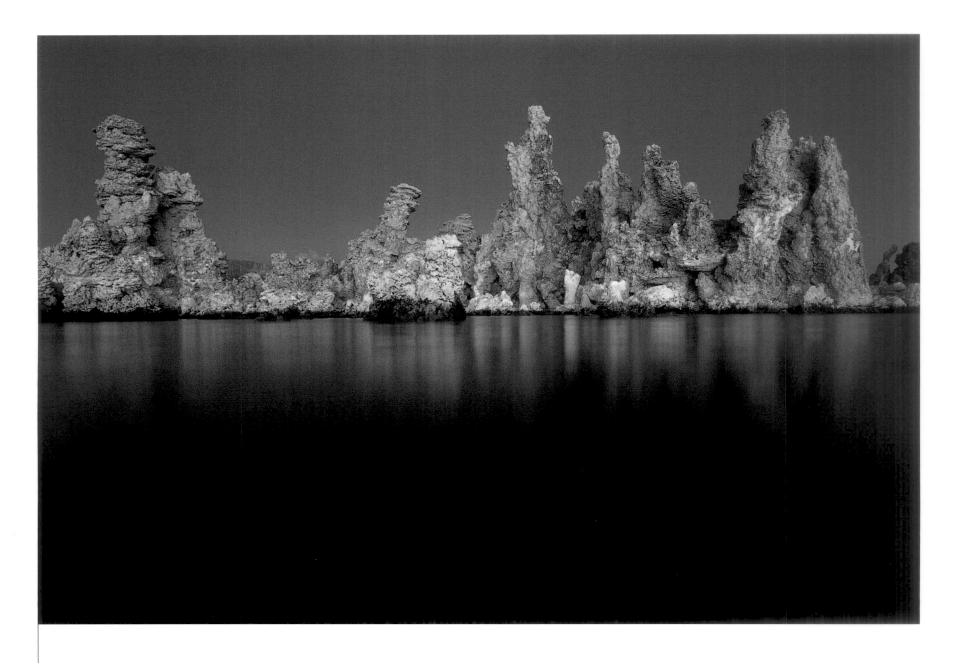

Tufa formations, Mono Lake, Sierra Nevada Mountains, California October 30, 2003 / Depth 1ft. / Temp. 58°F / Vis. 1ft.

As dawn was breaking, I was floating in Mono Lake, 6,375 feet above sea level, struggling to focus my camera on the tufa silhouettes. There was a fuzzy film on my mask I couldn't get rid of, caused by the soapy water. Salts and minerals wash into the water from Eastern Sierra Mountain streams, but because the lake, one of the oldest in North America, has no outlet, the freshwater can only evaporate, leaving the salts behind. Over time this natural process has created a body of water two-and-a-half times as salty and eight times as alkaline as seawater. In more recent times, diversion of Mono's source waters for a thirsty L.A. has lowered the lake revealing these towers of tufa—calcium carbonate deposits from the rich chemical brew. You might imagine this environment, surrounded by a dry desert covered in sage brush, to be inhospitable to wildlife, but an intense green-algae bloom every winter provides a feast for brine shrimp and the alkali fly, which flourish in the spring and summer. These lowly links in the food chain in turn attract eighty species of migratory birds, the most common being the vociferous California gull. Just before the sun eased above the mountains behind me, and I finally set my focus, a flock of eared grebes swooshed down in a celebratory dance of the new day. At that moment this so-called "dead sea" felt very much alive.

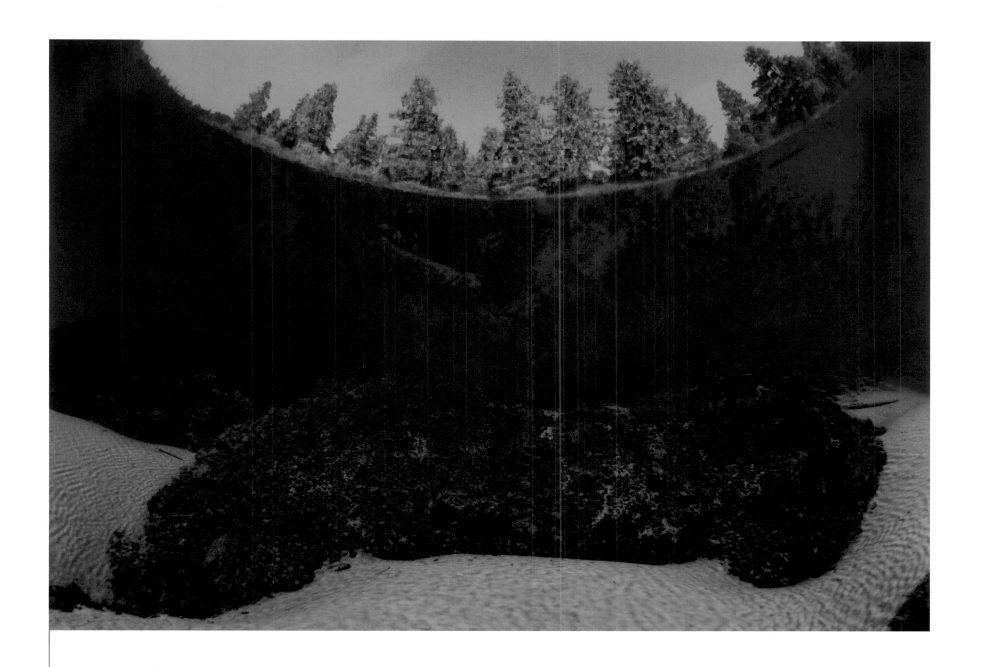

Ancient lava flow, Clear Lake, Cascade Mountains, Oregon October 11, 2003 / Depth 51ft. / Temp. 38°F / Vis. 200ft.

Of all the lakes I explored on my journey, this was the only one where from a depth of 51 feet I could look up and distinctly see the trees above. About 3,000 years ago the Sand Mountain volcano erupted. Hot, molten lava poured down the mountain side, burning the forest in its path. When the lava flow reached the headwaters of the McKenzie River and struck the cold water, it stopped dead in its tracks. The river quickly backed up behind the natural lava dam, and thus Clear Lake was formed. The remaining forest that had lined the river banks was submerged in places under more than 200 feet of water. A few remnants of the now petrified trees still stand today, preserved by the 34–38°F water. The ash-bottom lake is extraordinarily clear replenished by underwater springs percolating through the porous lava rock.

Humpback whale calf, Auau Channel, Maui, Hawaii February 22, 2005 / Depth 5ft. / Temp. 72°F / Vis. 100ft.

The Hawaiians enjoy an ancient connection with the whale, which they believe to be a majestic manifestation of the god Kanaloa. Every winter it is estimated that 2,000–5,000 North Pacific humpbacks migrate to the Hawaiian islands to breed. By the end of January, mothers and calves are frequently seen in the Auau Channel off Lahaina. A newborn calf begins life at a whopping 10–14 feet long, weighs in at about two tons, and may remain with the parent for a year or longer. At the beginning of my amazing encounter with mother and infant in Hawaii, I floated completely still while I waited to see if the 45-feet-long mother would be comfortable with my presence. She seemed unperturbed. The inquisitive calf swam toward me for what might have been its first meeting with a human. After surfacing for a breath, the calf rejoined its mother, who was still calmly watching in the wings.

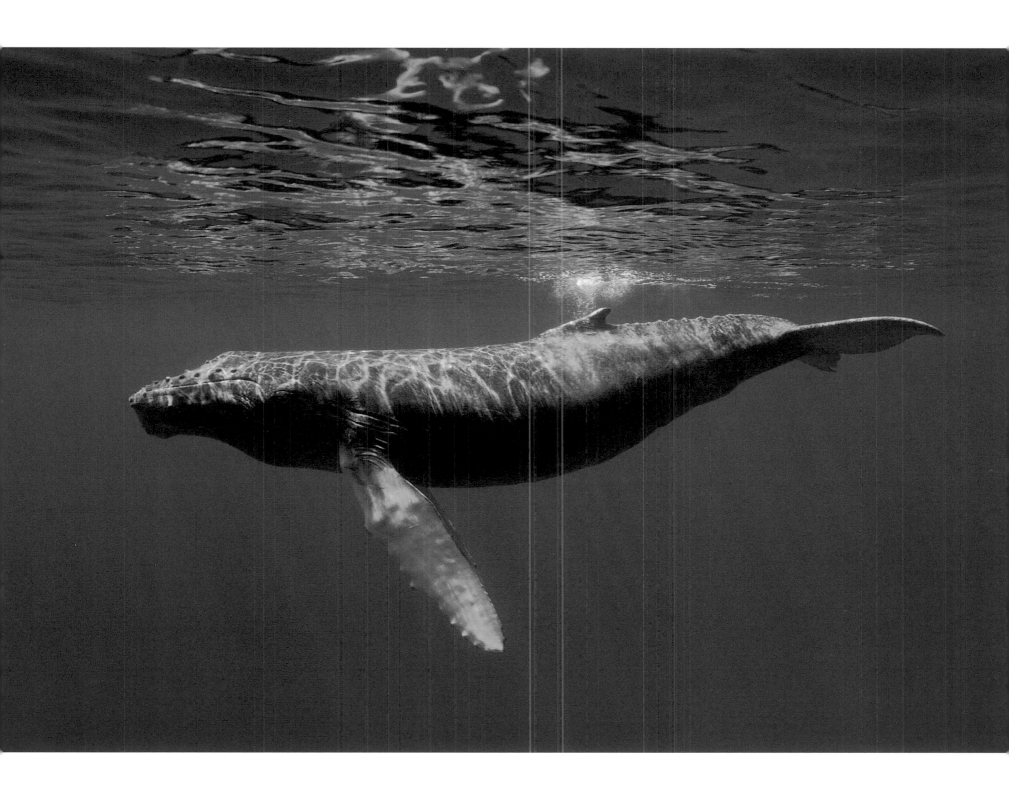

no limits

Any body of water was fair game for this project, so the quest for images led to diving and snorkeling in the most bizarre places, especially when it came to freshwater. Rivers, creeks, streams, lakes, springs, marshlands, caves, swamps, and wetlands were all explored. The expedition went to the source of the Mississippi River in Minnesota, and I even lay in a puddle in New York City. In Massachusetts at harvest time, I jumped into a flooded cranberry bog—cranberries being one of the few truly native fruits in the U.S.—to the great bewilderment of the farmers. For Kansas, when the time came to photograph cattle in some aquatic situation, I spoke to my friend Rob, the only person I knew from the Heartland State, the geographical center of the contiguous United States. Rob's father put me in contact with a rancher, whose foreman didn't think my notion too far-fetched—until I asked to jump into the cows' water tank.

In the vast swamplands of the south, I slipped into murky waters knowing there were alligators around and imagining them whenever my leg brushed up against a submerged tree trunk. But you force yourself to control those thoughts; you have to in order to concentrate on the task at hand.

Somewhere in the Atchafalaya National Wildlife Refuge in Louisiana, I broke this mental barrier, and sharing the water with lurking near-relatives of the dinosaurs became less of an anxious experience and more of an exhilarating one.

In a search to locate an image depicting Lewis and Clark's 1804–1806 expedition, which mainly followed water routes from St. Louis across the Great Plains and the Rocky Mountains to the Pacific coast, I found myself snorkeling the Missouri River on more than one occasion. Jim, a self-proclaimed water rat and a Huckleberry Finn-like character, kindly gave us a tour of the "Big Muddy," where its course forms the borderline between Nebraska and South Dakota. Huckleberry Jim pointed out snow geese and the Russian olive trees, which, as he noted off the cuff, were introduced in 1936 as windbreakers. At times, the river became very shallow with accumulated sand—"crushed Rockies," Jim called it. Eventually we came to Bow Creek where Lewis and Clark camped on August 26, 1804. The "crick" that day was a rich chocolate color due to the tornadoes that had bulled through a few days earlier, and the mud was the thickest I ever had to

Snorkeling a cranberry bog in Massachusetts

In the cow's water tank, Kansas

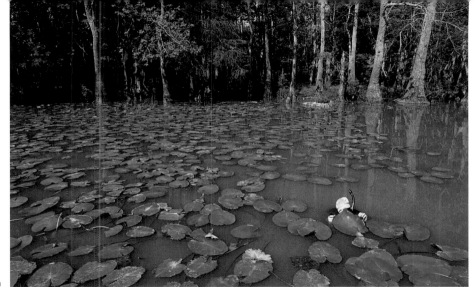

Amongst the Cow lilies in the Calcasieu River, Louisiana

trudge through. The slog was for nothing, as it turned out. I couldn't see a worthy shot. So we searched on. In Montana, a new guide, Gary, born and bred in the Big Sky State, drove us across his farmland before dawn to the White Cliffs mentioned in Lewis and Clark's journals. Today, that part of the 160-mile stretch of the Missouri is officially designated "Wild and Scenic." It certainly seemed unspoilt and peaceful—until I hopped in with a snorkel and was almost swept away by the stronger-than-expected current. I finally got the situation under control and shot the cliffs, but still wasn't satisfied. Eventually I found what I was looking for, further up the 2,341-mile-long river, at Sacagawea's Sulphur Spring. To reach this historic site, you hike a couple of miles beside the river over lovely rolling hills. Just watch out for the rattlesnakes.

From the beginning of the journey, one of the greatest challenges was what could be created in Nevada, the driest state in the union. Research had turned up Stillwater Marsh, where you can see the occasional sand dune from the water's edge. However, a five-year drought had all but dried out the shallow marshland. Instead, we found copious amounts of

buffalo carp bones lying where those fish had gasped their last breaths. We spent the entire morning driving around in search of an acceptable body of water and almost ran out of gas—a near-disaster that made us think again about those fish bones. By that point, Pyramid Lake in the Paiute Tribe Reservation seemed my best chance, and the most I expected was a split-level image of Pyramid Rock. Instead, a fortuitous meeting with a fisherman led us to some dramatic underwater tufa formations, and four days later we left the desert with Nevada in the bag, much to my surprise and delight.

In Florida, there are many cave systems, but they have been well documented. So I chose to look elsewhere, beginning in Arkansas, where we visited a couple of huge caverns. Spectacular, indeed, but not quite right for my purpose. As we left Arkansas's Hurricane River Cave, where Jesse James supposedly hid from the law, I came across a pamphlet for the National Cave Association showing the Lily Pad Room in the Onondaga Cave, Missouri. The Lily Pad Room turned out to be simply remarkable for photography.

After all that time underground, our thoughts turned to those

peculiar waters that fly into the sky—the geysers of Yellowstone, and the superheated pools that launch them. Perhaps some of the most unique water in America can be found in Yellowstone National Park, the world's first national park, founded in 1872. Yellowstone is home to some 10,000 hot springs and geysers, including, of course, Old Faithful, possibly the most famous fountain in the world. Now you can't just jump into these areas—you aren't allowed—and even if you were, you'd find yourself being boiled by the world's biggest Bunsen burner, the Yellowstone Caldera, the giant volcano that lurks beneath the parkland. There was another option, however, and one which was both very cold and very hot: Yellowstone Lake. Protected from the snow-melt chill by a drysuit, you can dive down to bubbling geothermal vents where there are also clusters of spires, and some very odd growths of green algae the size of 1960s beanbags. My dives in the high-altitude lake, where I felt the Earth shake with subterranean thunder, were unforgettable, and humbling. To dive in such unusual places, where few if any had been before, was one of the greatest joys of the journey.

Black Angus, Circle S Ranch, Kansas June 8, 2003 / Depth 1ft. / Temp. 66°F / Vis. 1ft.

The great American prairie in Kansas gives a feeling of tremendous freedom and space. But for underwater photography it is a real challenge. I was keen to try something with cows, and here I was in historic cattle country. All I had to do was find the right watering hole.

I spent a few hours with Steve, the foreman of the Circle S Ranch, scouting various locations. We looked at many ponds and stopped off at the Smoky Hill River near the Butterfield Trail, which had been the main wagon track across central Kansas in the middle of the nineteenth century. It was a wonderful few hours during which I learned a great deal about prairie flora—yellow yucca, crested wheat, K snake root—and about the Black Angus cattle, imported in 1865 to the state by Scotsman George Grant, that were everywhere munching it.

I finally chose a circular water tank and eased myself in while Steve assembled the cattle. There were a few teaser bulls among them that kept the cows away from me because they thought I was in competition for the females. To further lighten the mood, Steve tossed a couple of cow pats into the water. "Kansas humor," was all he said with a smile. And did I know that some people dry out cow pats and lacquer them to keep as ornaments? Indeed, I did not.

Once Steve removed the bulls, I kept still with only the top of my head out of the water. I could hear the cows approaching before I saw their heads pop over the edge of the tank, one by one. Soon these thirsty animals surrounded me. The cows kept looking at me nervously, but as I remained motionless they continued drinking. More cows came into the picture, pushing their way to the front. It was hilarious to watch and I chuckled to myself as I worked.

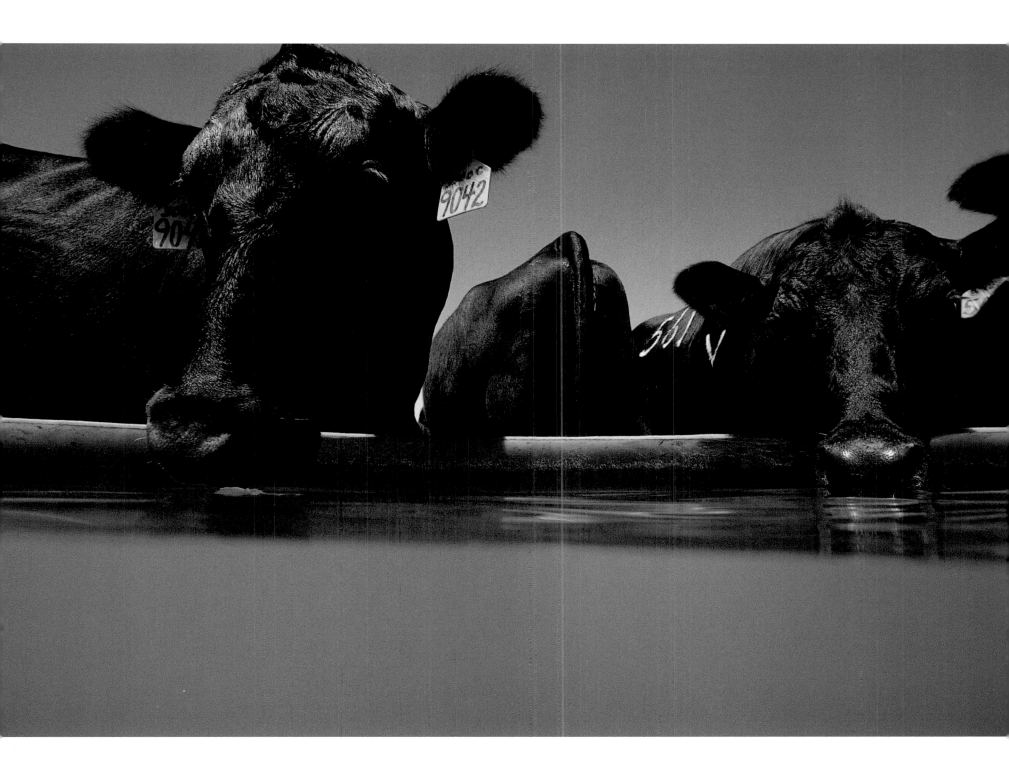

Fish Creek, Sierra Madre Park Range, Nr. Steamboat Springs, Colorado February 9, 2004 / Depth 1ft. / Temp. 33°F / Vis. 12ft.

One of the intentions of the project was to show all four seasons. So Hazel and I left our faithful Airstream in California and ventured into Utah and Colorado in the depths of winter to search for a frozen waterfall. We found a spectacular one at Fish Creek, but unfortunately all the water near the bottom of the falls was completely frozen. However, I did locate one isolated pool of liquid H_2O farther down the creek.

The following day we returned with the equipment and, donning snow crampons, walked down the mountainside. Ice climbers clasped onto the waterfall in the background as I gingerly scooted over a deep bank of snow and into the water. I had to be particularly careful; when you're shooting a split-level image in extreme cold conditions, any water touching the part of the camera-housing dome exposed to the air freezes

immediately. One tiny splash can result in an unpleasant smudge that ruins the photograph. This duly happened when the snow bank collapsed underneath me. We had no choice but to traipse up the long hill to the warmth of the car, clean the smudge when it melted, and start all over again.

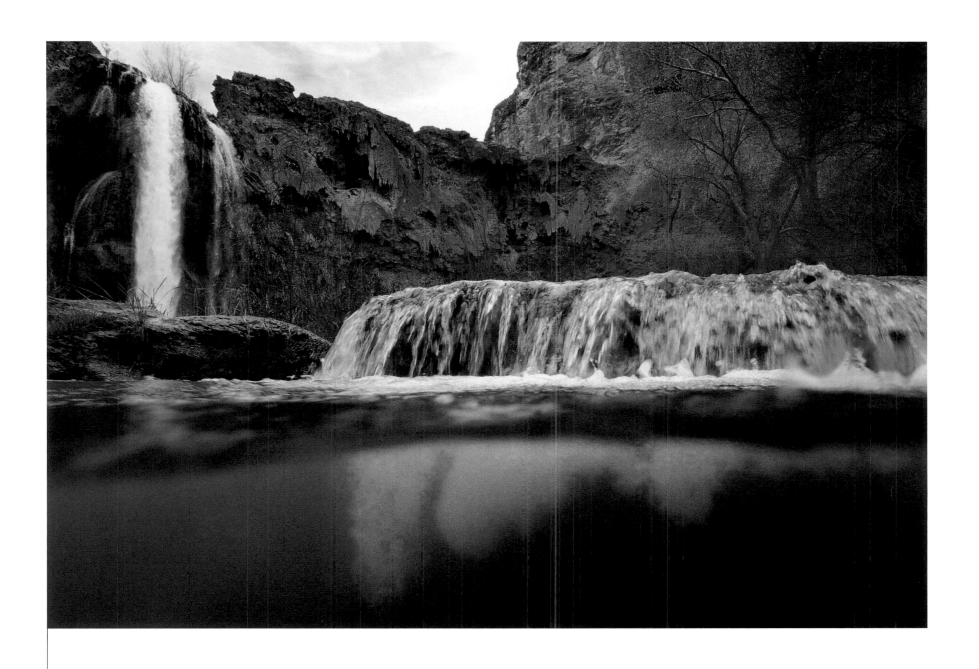

Havasu Falls, Havasupai Indian Reservation, Arizona February 17, 2004 / Depth 1ft. / Temp. 72°F / Vis. 20 ft.

It was quite a journey to reach Havasu Falls. First we drove the car to Hualapai Hilltop, at the top of Havasupai Canyon, a side branch of the Grand Canyon, where we met Leland, our guide. Then we then trekked eight miles by horseback down the side of the steep 3,000-foot canyon and through the red limestone canyon below to Supai. The village, inhabited since the year 1300, is home to the Havasupai, who believe that the Grand Canyon is the origin of the human race, and so deem the entire area sacred. Little has changed here over the centuries; there s no road because the tribe rejected an offer to have one built in their canyon. At one point we passed the postman carrying the town's mail in saddlebags. From the village it's a further two-mile walk to the top of the stunning 120-foot falls. There the red rock and the contrasting aquamarine pools, stacked in terraces, appear as a paradise on Earth. The precious water in this dry and arid land comes from Havasu Creek, formed by an underground river and spring. We had paradise to ourselves that winter day, and spent hours basking in the 72°F water, relishing the view. It felt a world away from modern civilization.

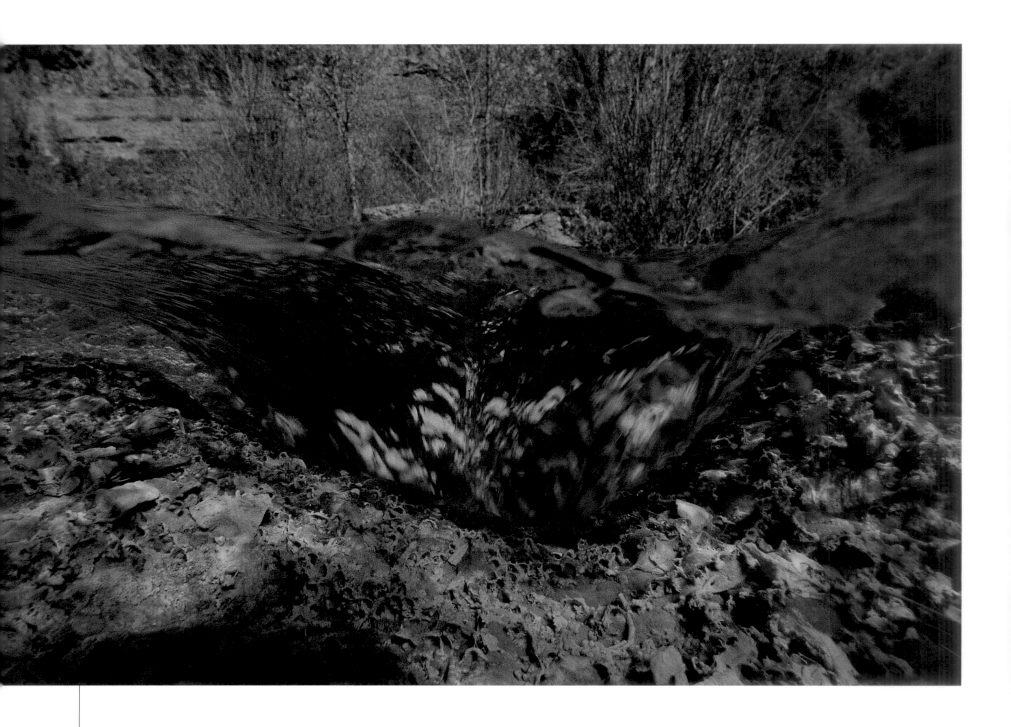

Water chute, Havasu Falls, Havasupai Indian Reservation, Arizona February 17, 2004 / Depth 1ft. / Temp. 72°F / Vis. 20ft.

A series of picturesque terraced pools with miniature
waterfalls join Havasu Falls to Havasu Creek. The photograph
shows the top of one these mini-falls, where the powerful,
fast-flowing water has eroded the rock to form a chute.

Rainstorm, the old man's pool, Watermill, New York July 2001 / Depth 4ft. / Temp. 78°F / Vis. 3□ft.

For years I've aspired to capture the visual magic of heavy rain pummeling the water's surface. Finally my chance came when I was visiting my father during preproduction for the project. A summer thunderstorm erupted above the house, and I hastily jumped in the pool with mask and snorkel. Underwater is a glorious place to be in this circumstance. The deafening noise creates a sense of danger, yet the water acts as a buffer and you feel safe and secure. It was a lingering storm and I was able to try multiple ideas. At one point I was lying on the bottom when the "old man" happened to look out of the upstairs bedroom window and noticed an immobile body in the deep end. Naturally he panicked, until a second later he realized it was only his photographer son.

White and green algae, Clear Lake, Cascade Mountains, Oregon October 18, 2003 / Depth 48ft. / Temp. 38°F / Vis. 200ft.+

I was diving in Clear Lake to investigate the old lava flow, so when the 12-feet-wide, floating white algae "pools" appeared at the bottom they completely surprised me. I carefully eased my arm into the dense smoke-like substance and to my further shock it seemed to disappear! To make a surreal situation even more bizarre, once I slowly lifted my arm out of the vaporous matter, it wafted up into the blue water like some Native American smoke signal. I left the lake bemused and fascinated, as if I'd visited another dimension. Biologists subsequently told me the white smoke was metaphyton algae, nicknamed cotton candy. It is a suspended, buoyant algae, which develops from nutrients brought into the lake via underwater springs. It is also filamentous—a loose matrix of tiny particles not attached to each other, which is why it seemed to disappear when I put my hand through it.

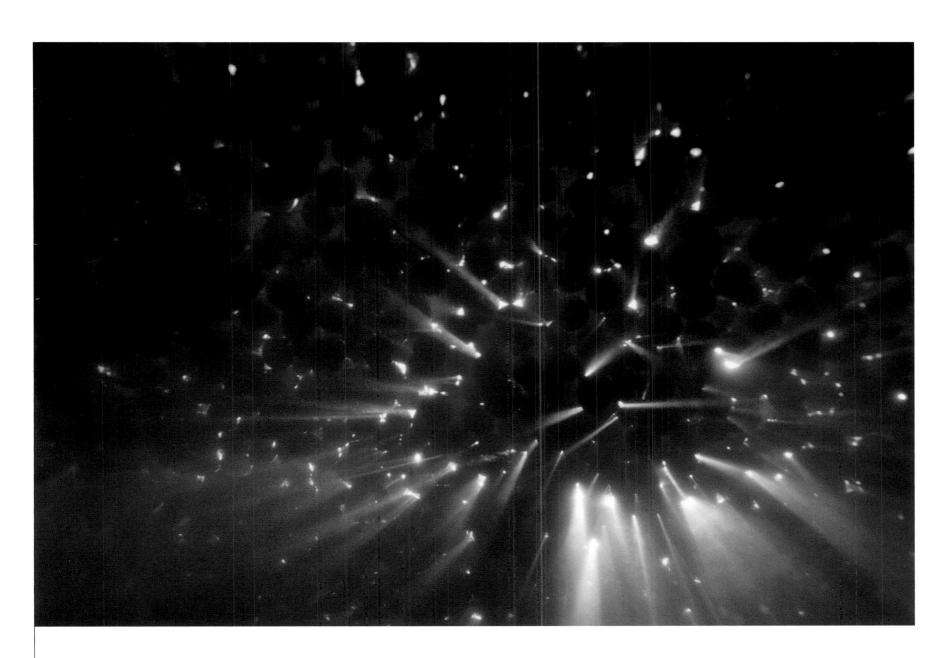

Cranberries, Edaville Bogs, Carver, Massachusetts October 6, 2002 / Depth 3ft. / Temp. 50°F / Vis. 3ft.

For Native Americans, the cranberry was an important fruit, for both cultural and culinary purposes. Mixed with wild game, it could be made into pemmican, a survival ration for the long winter months. The Delaware People, based in what is now known as New Jersey, revered the cranberry as a symbol of peace. The Pilgrims took an immediate liking to the essential berry. A 1663 cookbook describes cranberry sauce, which today we all associate with a scrumptious Thanksgiving meal. I was under the misconception that cranberries grew in water.

In fact, they grow on vines in ditched, dry bogs in wetland areas. At harvest time, the bogs are filled with water, and the buoyant berries float to the surface, where they can be easily corraled into a corner and vacuumed into a truck.

I appeared on the final day of the harvest. The crew thought I was nuts and found it highly amusing when I explained my intentions. Thus began one of the strangest shoots of the trip. The water was so shallow I initially tried a photograph from the deeper perimeter ditch but the water was completely black

because the thick carpet of cranberries completely blocked out the daylight—it was like doing a night dive, but in five feet of water at 9 a.m. Moving to the middle of the red soup, I pushed my head into the sodden bog floor to maximize the distance between the camera and the subject. The berries looked like red blood cells, and I felt like one of the characters from the sci-fi movie *Fantastic Voyage*, diving inside a giant human vein.

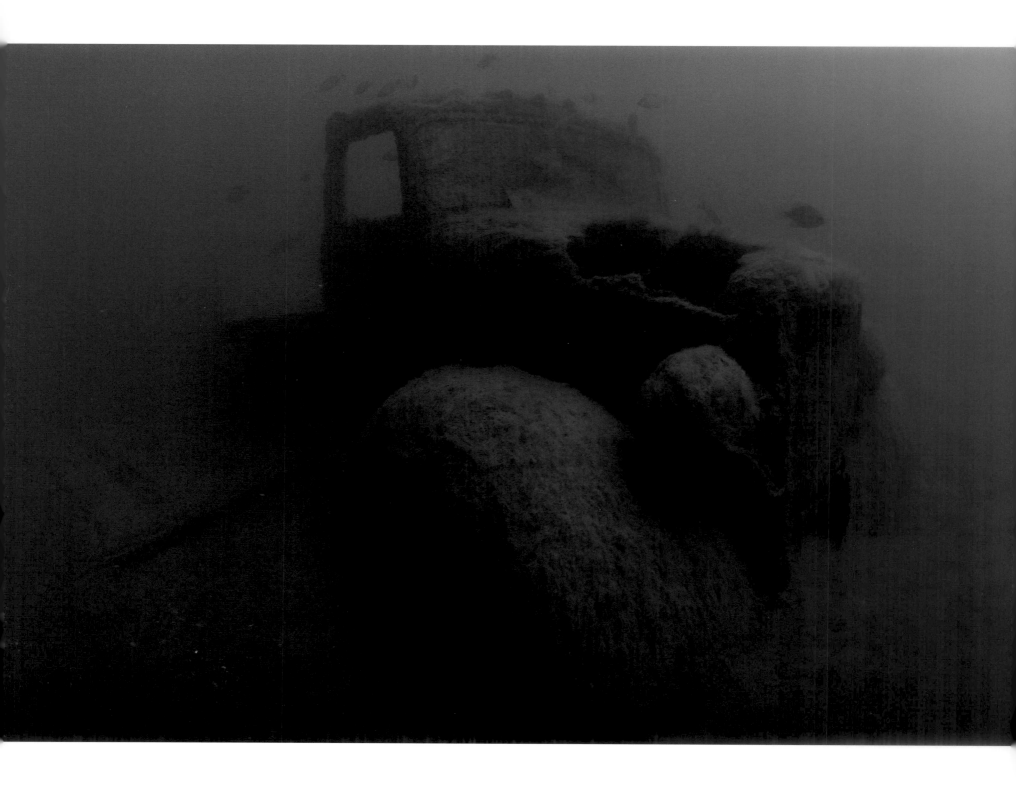

The Allen Ice Company truck, West Okoboji Lake, Arnold's Park, Iowa May 9, 2004 / Depth 26ft. / Temp. 52°F / Vis. 15ft.

This 1935 Ford belongs to the bygone, pre-refrigeration era when folks relied on Nature's ice from such northern states as Iowa. Ice was big business and the raw material was free—you just had to chop 700-pound blocks of ice off the frozen lakes and store it where it wouldn't melt. The ice from West Okoboji Lake was particularly prized because it was perfect and crystal clear. Among the hazards of harvesting ice, apparently, was loading on thin ice. Bill Stolley chronicled the Allen's truck sinking in the local paper at the time:

"On the sixth of January in forty eight
The ice cracked wide upon the lake.
Gregerson was driving with one foot on the ground...
The rest of the crew was standing around.
They were loading the chutes when she started thru
And it scared the devil out of the whole crew.
Sanders, Wright, and Zeherns ran for points afar
But Gregerson passed them like a shooting star.
Bill Allen was still in front of the truck
Trying to drain the radiator, before it hit the muck.
The wheels were spinning fast when it hit the ground,
But now, strange as it seems it's nowhere to be found."

In 1949 ice harvesting stopped in the area. By this time most people had fridges. When the ice truck sank in 1948 the company was struggling and did not have enough money to raise it. Divers finally located the truck 40 years later.

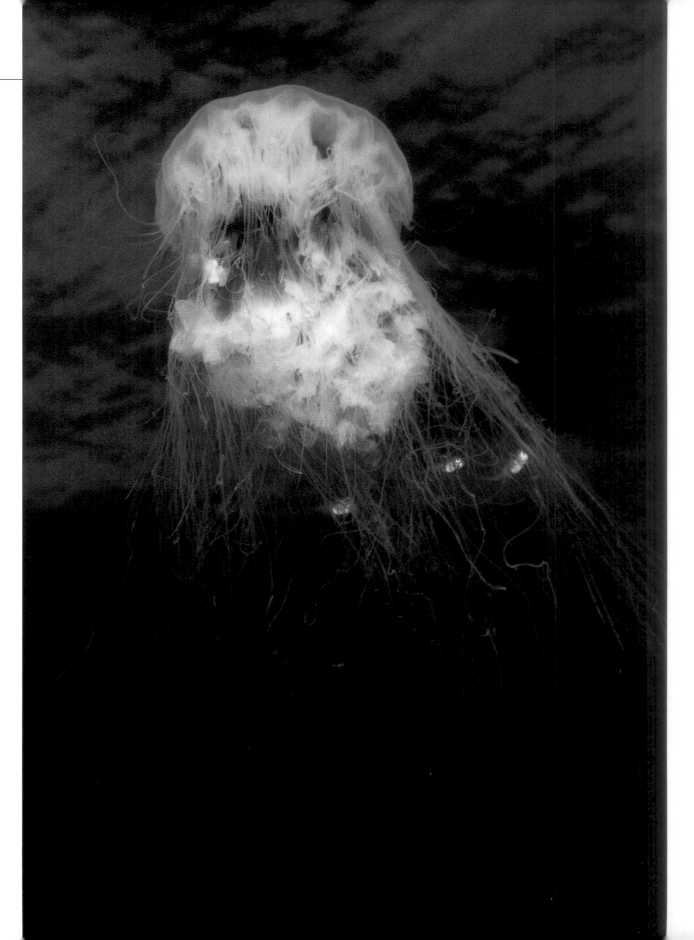

Lion's mane jellyfish, Atlantic Ocean, Maryland July 9, 2004 / Depth 23ft. / Temp. 56°F / Vis. 30ft.

Some 580 million years ago, long before dinosaurs walked the earth, jellyfish drifted in the ocean currents. Nearly 95 percent water themselves, they are an extremely early experiment from the aquatic crucible of life. The lion's mane jellyfish found off the East Coast are efficient predators. Their long tentacles are covered with miniscule stinging capsules, called nematocysts, which are used to paralyze their prey, or to provide a safe haven for certain small symbiotic companions, such as the butterfish. Sir Arthur Conan Doyle immortalized this jellyfish in his Sherlock Holmes tale, *The Adventure of the Lion's Mane*, when he chose one as the mystery's killer.

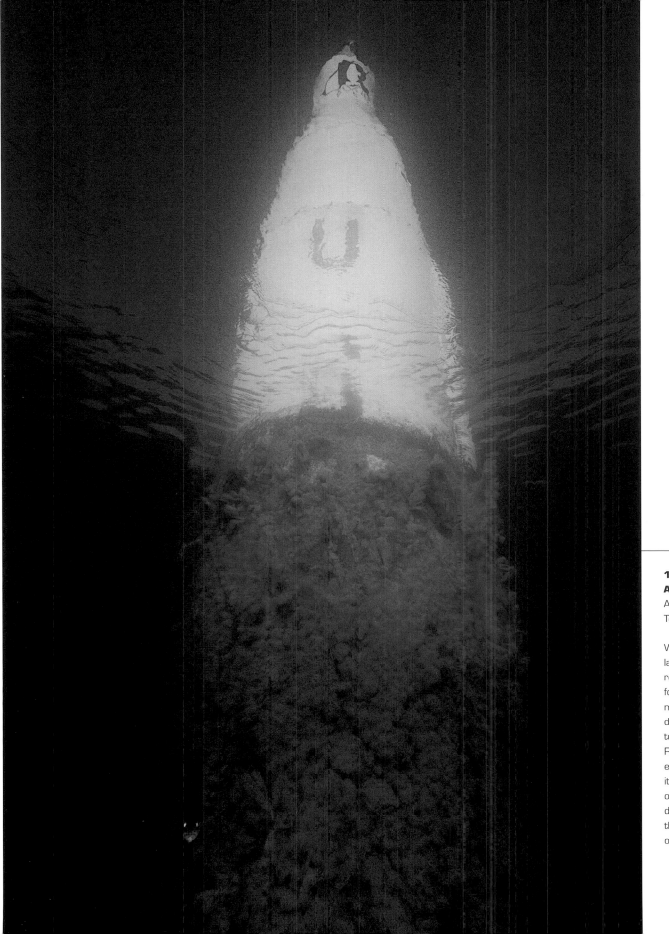

**1962 Minuteman missile, Madison
Aquatic Park, Alabama**
April 27, 2003 / Depth 12ft. /
Temp. 54°F / Vis. 30ft.

When I looked down at the eight-acre
lake from the cliff, the upright, protruding
rocket ominously looked like it was ready
for takeoff. The 53-foot-tall nuclear
missile, America's "Ace in the Hole"
during the Cuban Missile Crisis, used
to be on display at the U.S. Space and
Rocket Center's museum but since the
educational exhibits are updated regularly,
it was moved to a warehouse. When the
old limestone quarry was turned into a
diving park in 1995, the owners acquired
the gutted, Cold War relic, as well as an
old 30-foot-high space station.

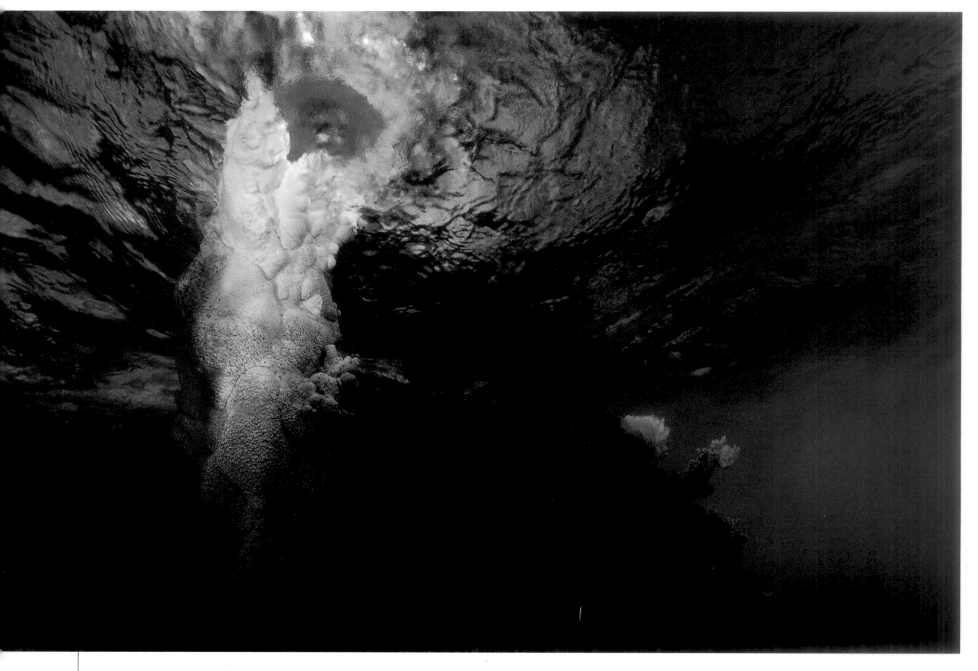

Tufa formations, Pyramid Lake, Paiute Tribe Reservation, Nevada October 26, 2003 / Depth 5ft. / Temp. 70°F / Vis. 25ft.

After driving through the silent and seemingly endless brush-stubbled desert, Pyramid Lake was a welcomed sight. The lake is the largest remnant of ancient Lake Lahontan, which covered most of northwestern Nevada at the end of the last Ice Age. We eased along the east side's dirt road to view the most spectacular of all the tufa-rock formations, the

400-foot-high Fremont Pyramid Island. The only other person there was Robert, an avid fisherman from Reno, who often kayaks around the island casting for cutthroat trout. He told me about a three-foot-high calcium carbonate (tufa) funnel just below the surface which was spewing out 205°F degree water from the Earth's core. As Robert observed, this new

tufa formation, which had only taken a few months to build up, offered a vivid example of how the entire pyramid was formed eons ago. After a long surface swim, I found the funnel, as well as many other smaller ones, dotted all over the mini-wall. At one point the surge from a passing boat pushed me into the boiling water but my hood saved me from a nasty burn.

Geothermal vents, Yellowstone Lake, Yellowstone National Park, Wyoming September 3, 2003 / Depth 15ft. / Temp. 56°F / Vis. 15ft.

The northern half of Yellowstone Lake is located within the caldera of the largest volcanic eruptions known to mankind, which occurred about 2 million, then 1.3 million, and again about 640,000 years ago. Today, heated gases move through the collapsed underground magma chamber, and up into the lake via geothermal vents. The continuous trail of bubbles at the surface was the first hint of what one diver calls "the champagne dive." I followed the bubbles down to a large sandy patch, which was percolating gases. Every few seconds I heard an ear-splitting loud thump and sand would spurt up like the geysers in the park above. Off in the distance I heard a faint but deep pounding noise. Upon reaching the large vent in the rocks, I could feel the powerful explosions right through my body, and see the rocks around the vent shudder from the sheer force. Unnerved, I began to feel I shouldn't be there. After all, some scientists say that the next caldera eruption is thousands of years overdue—and could happen at any moment. It certainly sounded like the Big One was about to blow.

Sacagawea's Sulphur Spring, near Morony Dam, the Missouri River, Montana

August 9, 2003 / Depth 1ft. / Temp. 70F / Vis. 12ft.

In 1803, when the U.S. map was virtually blank west of St. Louis, President Thomas Jefferson gave Meriwether Lewis and William Clark a specific task on their fact-finding expedition of the newly acquired Louisiana Purchase: "The object of your mission is to explore the Missouri river to the Pacific ocean…" Though the country was unknown to the United States government, it was far from uninhabited, and Lewis and Clark had to act as diplomats as well as explorers. Sacagawea, a teenage Native American, was hired as an interpreter and guide together with her husband, Jean Baptise, and proved to be indispensable to the success of one of the greatest explorations in all of American history. Apart from her uncanny ability to find food daily, her main contribution was as an interpreter with the Shoshoni. With Sacagawea's help, the expedition was able to parlay for horses and a guide to make the critical crossing of the Rocky Mountains before winter shut them off. But just before the crossing, in June 1805, Sacagawea fell ill and was near death. There was a sulphur spring near the camp, and Lewis, recalling that such a hot spring was used for medicine in Virginia, compelled the ailing guide to drink large quantities of the foul-smelling water. She made a speedy recovery, and within days was able to travel again.

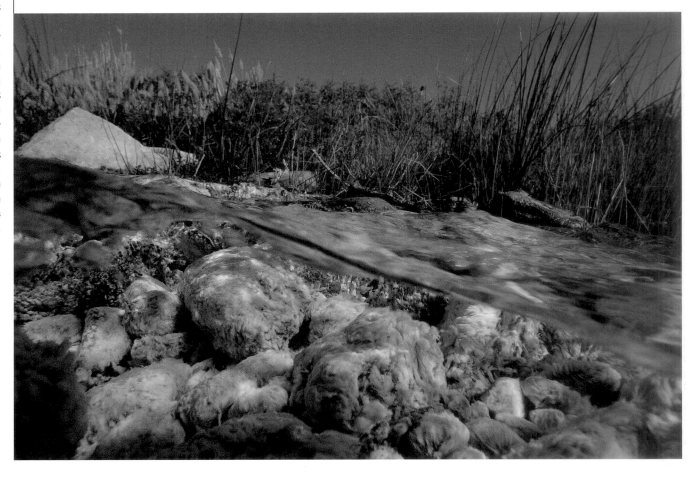

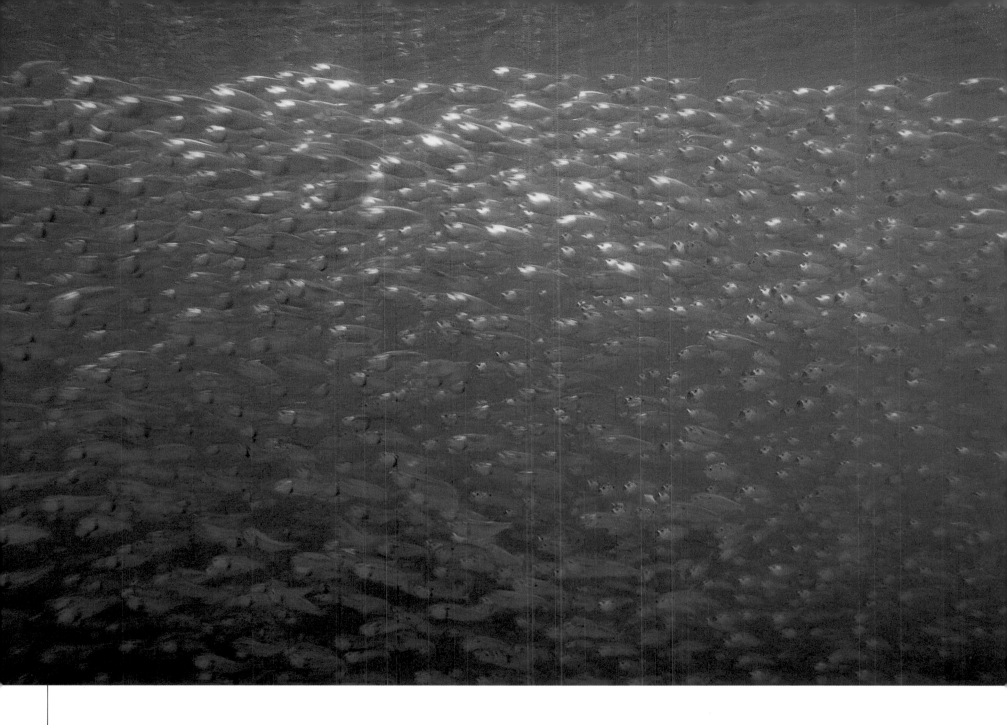

Peanut bunkers, Weekapaug Breachway, Rhode Island October 9, 2002 / Depth 6ft. / Temp. 60°F / Vis. 10ft.

In Rhode Island they call them peanut bunkers, in Maine, popcorn bunkers. One thing is for certain, though. Fishermen along the Northeast Coast love them. They are an excellent live-bait fish for striped bass, bluefish, and tuna; apparently these fish go as bonkers about bunkers as the fishermen. I learned this from Skip, whom I met on the bridge at the breachway, a canal connecting Brightman's Pond to the ocean. As we chatted the bunkers below us went berserk, frantically darting this way and that in a desperate attempt to save themselves from attack by a bluefish. The raid was over in seconds and the little fish settled down—until the next assault.

Autumn leaves, Mulberry Creek, Lynchburg, Tennessee October 30, 2002 / Depth 6ft. / Temp. 56°F / Vis. 8ft.

The flooded quarry we were hoping to find in Tennessee was unexpectedly closed, and we had a few days to fill before the next scheduled shoot. According to the map, there seemed to be many creeks and rivers in the southern central part of the state. They were as good a place as any to try.

We cruised south in the rain, which hadn't stopped in more than a week. As we checked into the campground, I noticed a brochure about Jack Daniel's Distillery. I knew it was in this state but I didn't realize we were only 45 minutes away. Now that could be a possibility. The next morning we visited the distillery to see old Jack's famous water supply. The tour was fascinating and there was one small, accessible cave but the water level was too low. However a creek conveniently swept past the parking lot.

I donned my dry suit and walked through the grounds. As I cleaned my mask I heard someone behind me say, "Can I help you?" It was the head of security for the distillery, whose men had spotted me on their cameras and must have thought they had seen some kind of alien. Not many people walk around with red dry suits with dodgy-looking hoods and camera housings. I explained what I was up to and we had a good laugh about the situation. The creek was deep and clear enough to work in. I snorkeled up and down until I found a congregation of leaves. I picked up a handful and watched them drift along in the mild current.

American crocodile, Florida Keys National Marine Sanctuary, Marathon Key, Florida October 13, 2004 / Depth 3ft. / Temp. 83°F / Vis. 15ft.

There are more than a million alligators in Florida but only a mere 500–1,200 crocodiles. The very rare and shy American croc inhabits areas where freshwater and saltwater mix, such as coastal wetlands and canals in the southern tip of Florida. Because of poaching for its hide, pollution, and loss of mangrove habitat, the primitive looking reptile, which can reach a massive 15 feet in length, and weigh up to a ton, is endangered in the U.S. The crocodile feeds at night on fish and any other animals it can ambush from the water, such as turtles, raccoons, and birds, swallowing its food whole. It is rarely seen by humans. I photographed this six-footer while it was in temporary captivity at the Keys Sanctuary within the Florida Keys Land and Sea Trust facility. If the croc hadn't been under the control of a handler, it would have come straight for me. Even so, it tried to do just that.

The loon, Alstead Lake, Crosby Mine Pit Lakes, Minnesota May 28, 2004 / Depth 6ft. / Temp. 43°F / Vis. 20ft.

Although I really desired a diving bird image, I hadn't had much luck in capturing one. Experience had taught me that when birds are hunting in the water they are extremely alert and cautious. However, at the end of a dive in Alstead Lake, one of the many Crosby Mine Pit lakes, I felt a presence and turned around and saw a pair of loons checking me out. They hung around and even ducked down for a closer look, which rekindled my enthusiasm for a bird picture. For a day and a half I played cat and mouse with the birds. I would wait until they were coming my way and try and move into their path, hoping to pique their curiosity. They were more interested in catching fish. A couple of times they came within 10 feet of me—still not close enough. All I could do was watch them as they effortlessly glided through the water; on one occasion four of them swam around in a circle playing. Late in the afternoon on the last day I was in the middle of the lake playing dead when the loons at last approached. In a flash one ducked down and bravely darted within shooting distance.

Atlantic sand tiger shark, the *Papoose* wreck, Atlantic Ocean, North Carolina
May 24, 2005 / Depth 102ft. / Temp. 73°F / Vis. 80ft.

The *Papoose* was one of more than one hundred merchant
ships torpedoed by German U-boats in the first six months of
1942. America had recently joined the war and the opposition
took full advantage of the initial lack of naval defense—so much
so that the East Coast was known by the German commanders
as "the happy hunting ground." Yesterday's wars have left us
with some incredible historical shipwrecks, which are teeming
with marine life. For reasons unknown, sand tigers began to
appear on a few shipwreck sites off Morehead City and the
Outer Banks in the middle of the 1980s, much to the joy of
the diving community. Indeed, recreational divers couldn't
have asked for a more visually exciting species. Despite their
ferocious demeanor and maximum length of 10 feet, they are
relatively docile—and so are ideal diving companions.

Texas wild-rice, San Marcos River, San Marcos, Texas
February 23, 2003 / Depth 6ft. / Temp. 72°F / Vis. 20ft.

Texas wild-rice requires such a specific freshwater environment—swift flowing, spring fed, with consistent temperatures—that it has only ever thrived in one river, the San Marcos. Today the endangered species is in decline and found only in the first two miles of the headwaters. The threat of extinction is mostly due to the ramifications of modern man's arrival in the area but in the last 10 years hatcheries have played a crucial role in the rare plant's conservation, by maintaining specimens. Remarkably the green leaves can grow to six feet long, which gracefully ripple and swing back and forth with the continuing flow of the current.

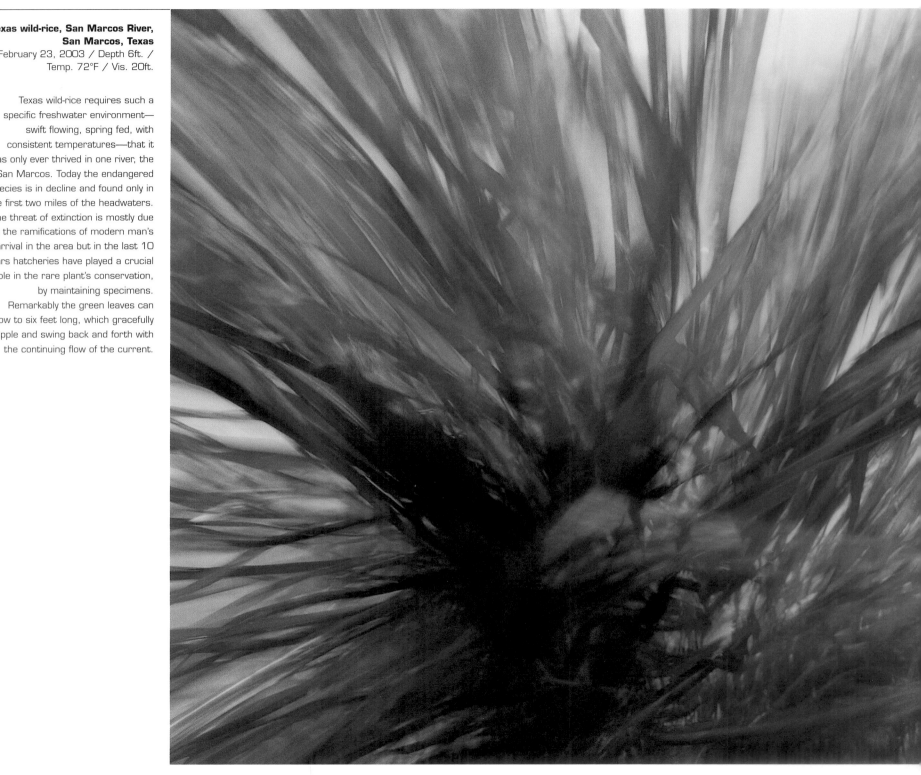

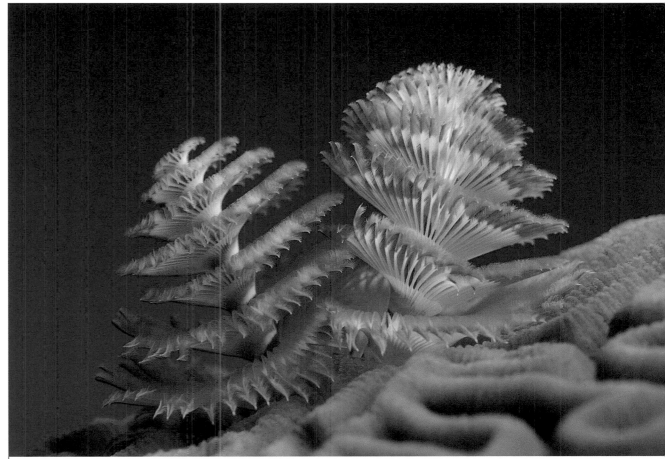

Christmas tree worm, West Flower Garden Bank, the Gulf of Mexico, Texas
August 25, 2005 / Depth 80ft. / Temp. 86F / Vis. 80ft.

The Christmas tree worm is an ingenious little invertebrate; it builds a calciferous tube on the surface of the coral and as the coral grows the tube is buried, leaving only its head showing. At the top of its head are antennae, called radioles, which catch microscopic plankton for food and also act as gills, allowing the worm to breathe. If the worm feels threatened by a fish or by the noise of a diver's bubbles, it instantly pulls its head back into the tube. This can be amusing to watch but frustrating to photograph, especially if you're dealing with a "Nervous Nelly" that refuses to pop back out for minutes on end. Its cautious ways pay off; this shy little creature, first identified by scientists in 1766, can live up to four decades. Fortunately, this one crept back out of its tube to have its portrait taken after only a minutes' wait.

Red Irish Lord detail, Waadah Island, Neah Bay, Washington
October 3, 2003 / Depth 50ft.
/ Temp. 44°F / Vis. 35ft.

Like the flounder, the Red Irish Lord can change color to match its environment, an adaptation that makes it a formidable ambush predator of crabs, shrimp, and small fish. Unlike the skittish flounder, this bottom dweller is unperturbed by divers, hence this rare occasion when I was able to get unusually close to a fish.

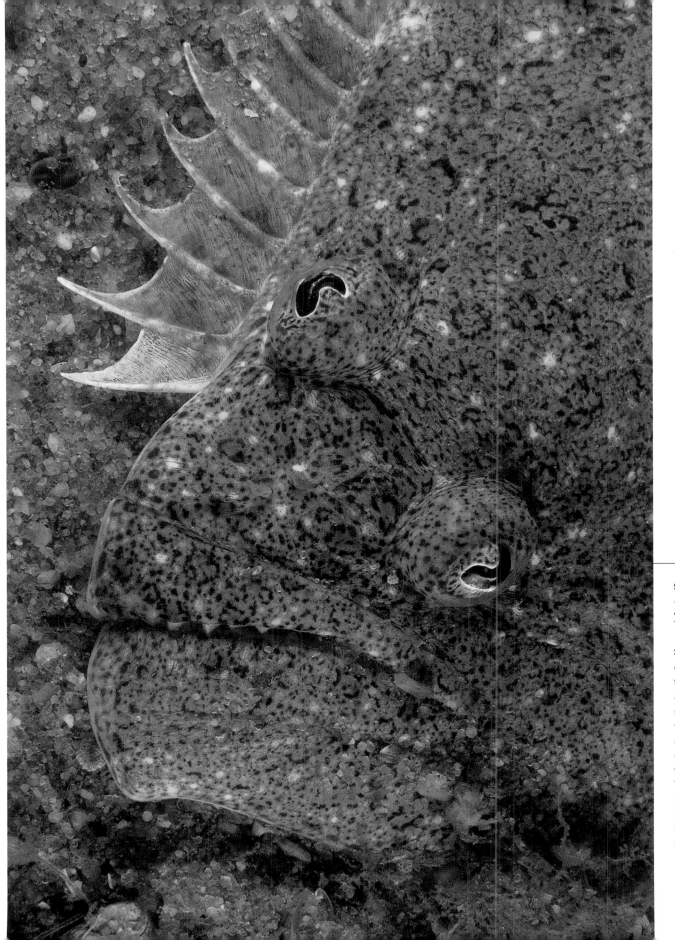

Summer flounder, wreck of the _Pharoby_, Atlantic Ocean, Maryland
July 9, 2004 / Depth 54ft. /
Temp. 56°F / Vis. 30ft.

Summer flounder are called the
chameleons of the sea thanks to
their uncanny ability to change color
and pattern to blend in with their
surroundings. These bottom-dwelling
flatfish partially burrow into the sediment
and wait to ambush their prey. They
can also use this effective camouflage
technique to hide from their predators.
The flukes, as they are also known, are
most abundant between Massachusetts
and North Carolina. They are not easy to
see, but their protruding, rolling, comical
eyes give them away.

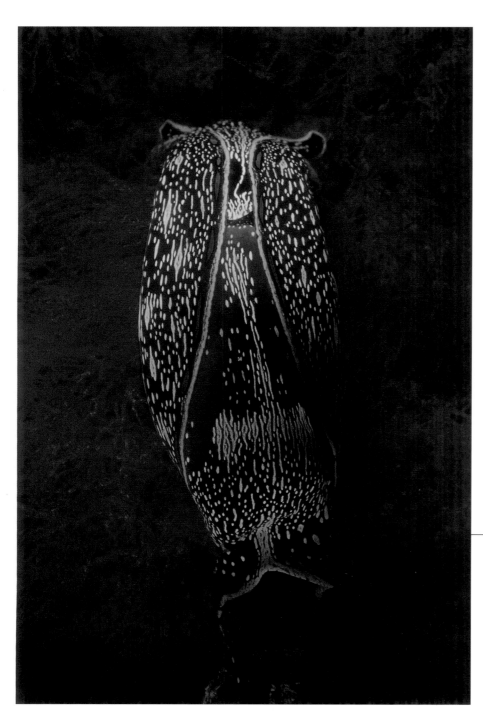

Bay sea hare, Coronado Cays, San Diego Bay, California
August 5, 2005 / Depth 6ft. / Temp. 78°F / Vis. 8ft.

Diving underneath a marina is not the most romantic of places. However the concrete pilings can yield some interesting critters, such as the sea hare. When threatened by predators, the slow-moving, seemingly defenseless sea slug releases a purple fluid made by digesting a diet of red algae, which acts as a smoke screen and chemical deterrent. Oddly enough the *Aplysia californica* is a hermaphrodite—both male and female. To accommodate this wondrous state of affairs during mating, dozens pile together to form orgy lines and whoever is in front plays the woman.

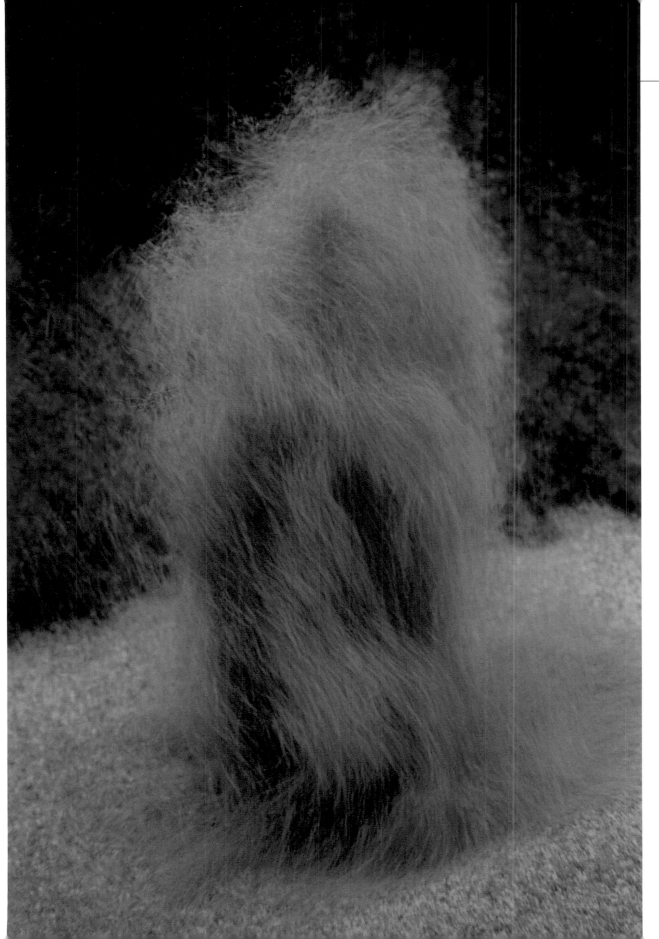

Sand fountain, Spring Lake, San Marcos, Texas March 18, 2004 / Depth 22ft. / Temp. 72°F / Vis. 70ft.

Before a dam was created in 1854 at the headwaters of the San Marcos River, thus creating Spring Lake, fountains of powerful spring water gushed skyward. Nowadays more than 200 springs still flow from three large fissures and other openings in the rock at the lake. This small opening continuously pushes sand up into the pristine water, creating a fountain of bubbling sand eight inches high— a reminder of the spring water fountains of yesteryear.

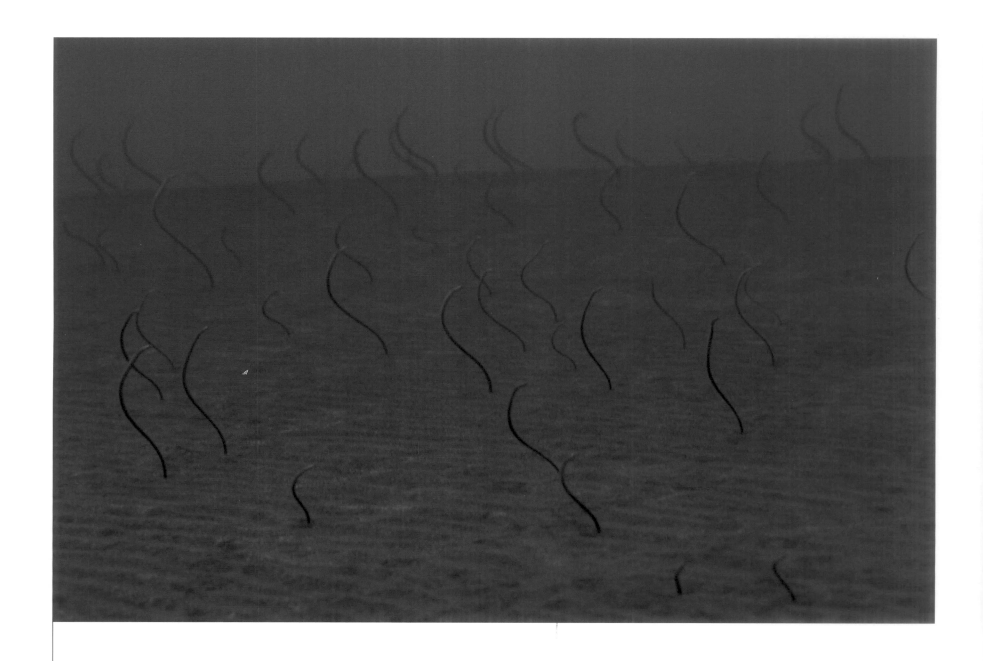

Garden eels, Garden Eel Cove, Nr. Kona, Hawaii February 6, 2005 / Depth 93ft. / Temp. 76°F / Vis. 60ft.

I love to wander the sandy expanses of undersea deserts around coral reefs. At first glance there doesn't seem to be any life, but a patient diver in unknown territory can be rewarded with a sighting of some kind of camouflaged bottom-dweller or cruising school of fish making moving shadows on the sand. On this occasion though, as the name of the cove suggests, I knew there was a colony of garden eels. I found them stretched 18 inches out of their holes, swaying hypnotically back and forth with the surge as they ate the drifting zooplankton. Knowing that these shy creatures rarely allow a diver closer than eight to ten feet, I inched my way toward them until they began to disappear into their burrows.

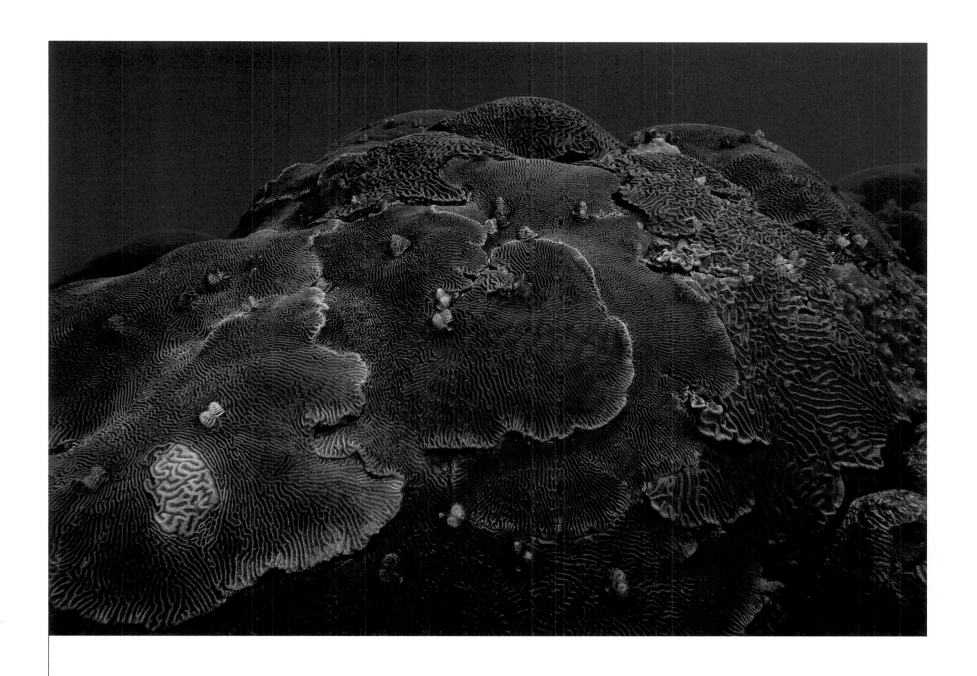

Brain corals and Christmas tree worms, East Flower Garden Bank, the Gulf of Mexico, Texas / August 26, 2005 / Depth 66ft. / Temp. 84°F / Vis. 100ft.

The Flower Garden Banks National Marine Sanctuary is unique. Situated 105 miles off the Texas/Louisiana border, it's the northernmost coral reef system in the continental U.S., and one of the healthiest in the Western Hemisphere. But why and how did a fragile reef grow here in the first place? The answer, like the reef itself, arose from deep time—160–170 million years ago, when the Gulf was a shallow sea. Hot and salty, it was prone to rapid, repeated evaporation so that over the course of time, enormous layers of salt were deposited. Then powerful geological pressures forced isolated pockets of this salt upward, creating distinct domes. This hard, shallow surface in warm, clean, sunlit water was an ideal environment for a coral reef to form. The only ingredients missing were young corals, which scientists believe drifted over from the east coast of Mexico. About 15,000 years later I drifted by to admire Mother Nature's handiwork.

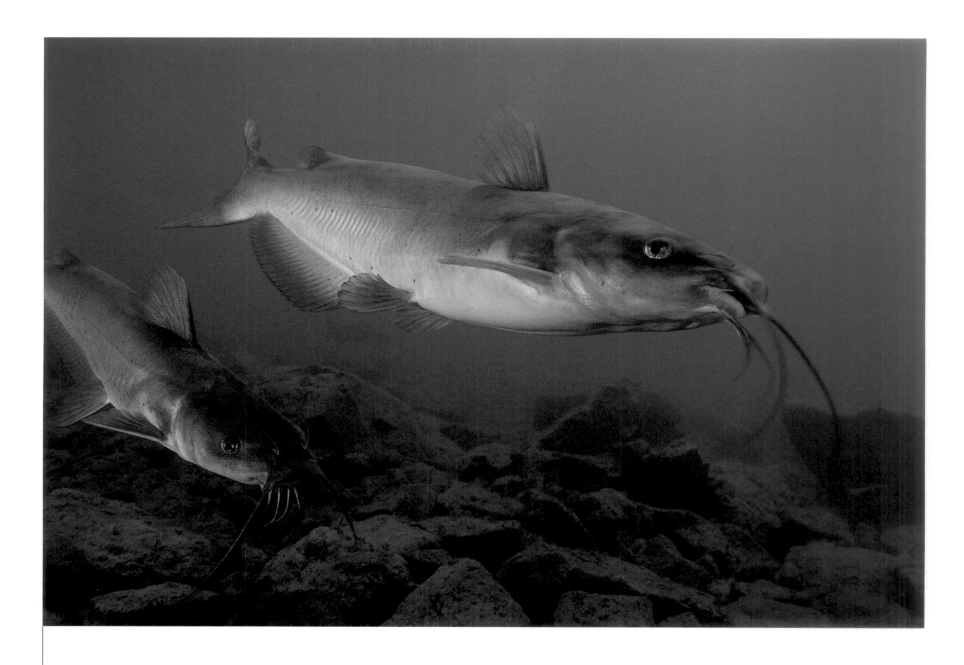

Channel catfish, Mt. Storm Lake, Allegheny Mountains, West Virginia October 21, 2002 / Depth 25ft. / Temp. 80°F / Vis. 20ft.

Channel catfish, which are abundant in Mt. Storm Lake, are a very popular food source in the southeastern states. These "whiskerfish" are also considered gamefish, at least in the strange sport of "noodling." We heard about noodling in Mississippi, where the tradition is passed down the generations. Reaching deep down inside a dark catfish hole, the noodler wiggles his arm like a giant worm to entice the fish. If all goes as planned, the unfortunate fish latches onto the arm of the fearless noodler and the struggle is on. Flatheads are primarily targeted because they tend to be sedentary and territorial. Some of the biggest fish caught can weigh more than 100 pounds. Imagine the impact when the fish clamps on! And imagine trying to wrestle a catfish that size without drowning. Some people are out of their noodle!

"Don't tell fish stories where the people know you; in particular don't tell them where they know the fish." Mark Twain

Orange-peel nudibranch eating a sea pen, Lena Bay, Alaska March 17, 2005 / Depth 44ft. / Temp. 40°F / Vis. 30ft.

The majority of nudibranchs are tiny—no more than four inches long. One of the exceptions to the rule is the orange-peel, the largest species in the world, which can reach lengths in excess of 18 inches. This Goliath is a fearsome predator of the plantlike animal, the sea pen. When threatened or disturbed, a sea pen will force water out of its "branches," retreat into its bulbous foot, and disappear into the sediment. But if a creeping nudibranch can ambush the sea pen, this tactical maneuver takes too long and the animal doesn't have a chance. Death is as slow as it is inevitable; the nudibranch will take many hours to consume a full length, two-feet-tall sea pen.

Yellow cab, Greenwich Village, New York City, New York May 1998 / Depth 1ft. / Temp. 70°F / Vis. 0ft.

In the early summer of 1998 New York had some heavy rainstorms. Back-to-back deluges meant a great deal of water had been dumped all over the city. I was walking in the West Village and noticed that a drain outside a movie theater was blocked and overflowing, almost to the top of the curb. I stuck my hand in the water and figured it was deep enough to use a small camera housing.

I returned the next day. It was raining so I put my wetsuit on in my apartment and walked out onto the street dressed for water work. You should have seen the looks! Even in this city people were very confused seeing a diver walking through the village. One man actually stopped me and asked where I was going diving. So I arrived at the puddle, delighted to see that the drain hadn't been unblocked. Now all I needed was a quintessential New York yellow cab to drive past, really close, practically on top of me.

There was a traffic light at the junction so whenever a cab stopped, I would ask the driver to splash me. Of course they all thought I was barmy and some couldn't understand what I was asking, but a few obliged. By this time a crowd had gathered behind me and people were hanging out of windows watching. "What on earth are you doing?", "Can I take your photo?", "Is this is a movie?", "You've lost your mind!" were some of the printable comments from the crowd. Every time I got splashed there was a roar of laughter and cheers from the audience. Eventually one cabbie drove close enough and as I was packing up a waiter from the corner diner came over and gave me a cloth, so I could wipe the dirty water off my face. It was a real New York moment.

On the way back from Fish Creek, Colorado

natural hazards

MOTHER NATURE PLAYED a critical role in the shoot. Sometimes she was in a good mood, and other times she was more like Hazel when the Airstream's plumbing backed up.

In February 2003 we worked in Central Texas, knowing that the Hill Country usually enjoyed 50–60°F weather. Instead, we got slammed by a rare ice storm and the entire side of the trailer was a solid sheet of ice for a week. All our pipes froze and we had no water. Then we ran out of propane for heating and cooking, and we couldn't drive anywhere due to dangerous black ice on the roads. So for a couple of days we ate dried food and slept fully clothed with our hats on. Eventually, the ice storm broke and we were able to find propane and thaw out in a nearby town.

From May until August of 2003, while we were in the south and midwest, we anxiously endured more than 70 severe weather warnings. The first time a warning came in over the Airstream's TV screen we didn't know what was going on. A horrendous beeping noise shrilled through the trailer before the words "severe weather warning" appeared at the bottom of the screen followed by a list of counties likely to be hit. Because we moved on average every four to five days, we rarely knew which county we were in. So you pull out the map, track the storm's path, and if possible, get the heck out of the way. And if the TV tells you to "take cover now, a tornado is going to hit your area," you run like the clappers to the campground shelter.

We were extremely fortunate during those months. In Nebraska we missed a United States record hailstorm by a mere 15 miles. Its hail stones, with a diameter averaging seven inches, would've annihilated the Airstream. Six times in Oklahoma and Iowa we missed tornadoes by fewer than 10 miles. Late one afternoon in Kansas, the winds picked up and roared across the prairie at 40mph, followed by the most dramatic thunderstorm we had ever witnessed. The lightning lit 180 degrees of the sky and exploded every few seconds. By the time we reached Montana we were very relieved to be out of "tornado alley." But it was out of the frying pan and into the fire—literally. We had to contend with multiple forest fires in that state for the next four weeks. Our trial by fire climaxed near Glacier National Park where we endured six days engulfed by very dense smoke—not exactly the photographer's best friend.

After we left Montana, Mother Nature gave us a break

and we successfully sauntered through Wyoming, Idaho, and Washington without any delays in 38 days. We were lucky in Washington, where the beginning of the rainy season was late. We enjoyed nine consecutive sunny days and the heavens only opened up on the day of our departure south. In Oregon high winds created a vicious sea for a week. Unfortunately I was unable to dive off the coast and forced to return in July 2005. We moved up into the Cascade Mountains where we had the odd glimmer of sunshine and managed to grab three out of the four images for that state.

We finished in Oregon on October 23 and had to make the choice of either investigating the northern California coast and the nearby rivers or of moving into western Nevada and the Sierra Nevada Mountains in eastern California, hoping to avoid the first winter snowstorm. We chose Nevada because I just couldn't see how we could fit the Sagebrush State in at any other time. Weather reports showed no sign of an imminent snowstorm for the next six days so we hauled down to Nevada from southern Oregon. Fortunately, it was the right call, and we enjoyed six sunny days in a row and managed to shoot in Pyramid Lake and Mono Lake. From Mono Lake, we had

hoped to dash to Yosemite National Park and explore for a few days. Instead, we had to bolt right through the beautiful park just ahead of rapidly approaching snow. To "get out of Dodge," we were forced to drive the rig up the Tioga Pass, a steep, windy road which brings you to an altitude of 9,945 feet. For more than an hour the SUV was in first gear, crawling up the seemingly never ending mountain at 20mph, while we worried the engine would overheat. Eight hours later Tioga Pass closed.

The only time we were seriously delayed was during the intense and destructive hurricane season of 2004 along the southeastern coast. For just more than five weeks, from August 2 until September 9, we survived six hurricanes and tropical storms. Fourteen diving days were lost in four states. However, this was a minor setback compared to the thousands of people who lost their homes. Our worst experience was being hit with 65 mile an hour winds on the South Carolina coast. The Airstream swayed menacingly back and forth, and when a gust blew through at more than 75 miles an hour, it felt like the trailer would topple over and begin cartwheeling to perdition. At times like that, all you can do is nervously sit, wait and hope that the trees directly around you don't fall and crush your home.

Three weeks later we were in central Florida at Ginnie Springs, tracking the movement of Hurricane Frances. Two million people were evacuated along the east Floridian coast. But we were reluctant to join the retreat en masse and potentially lose even more time, so we held on until the last possible moment, and then gambled by traveling south to Naples on the lower west side of the state to sit out the storm. Thankfully, it was the right call, and within two days we drove to Key Largo. There our luck ran out. Within 24 hours, we were packed up and on the run again from the next beast, Hurricane Ivan, which was heading directly toward the Keys. We couldn't afford any more delays and chose to move up north to Missouri and Illinois for three weeks, where a couple of less weather-plagued images beckoned. Once we returned to the Keys, we were uninterrupted for the remainder of the year.

Dealing with the weather was a constant guessing game. For part of the time, our campsites lacked internet access or cable TV reception, so we generally depended on local and regional TV stations for information and warnings. And I can't tell you how many times we were told, "You should have been here last week!"

An ominous cloud,
Council Bluffs, Iowa

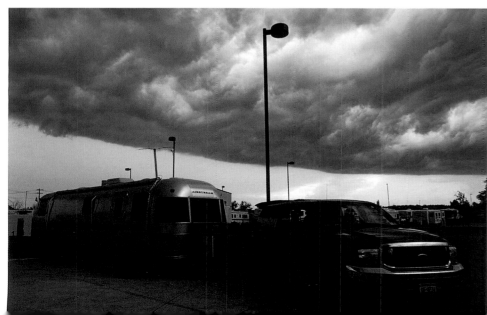

Frolicking smallmouth bass, Lake Tenkiller, Oklahoma June 1, 2003 / Depth 54ft. / Temp. 52F / Vis. 10ft.

To find this bit of sunken Oklahoma forest, all I had was a rough, hand-drawn map given to me by Gene Fruscher, the proprietor of a very funky floating dive shop. Gene was over 80 years old, but also very tall, strong and extremely calm, with a hypnotically relaxing mid-western drawl—a philosophical old salt far from the sea. He had been one of Tenkiller Lake's original rescue divers in the days before wetsuits, plunging into the freezing waters wearing the equivalent of Spandex. He told us that when the thin suits filled with water he had to slash the legs open with a knife in order to drain them so he could pull himself out of the lake. After 50 years of exploration he knew Tenkiller better than anyone.

With Gene's map in hand, Hazel and I cruised the windy lake in the old gent's rickety boat, headed for the lee of the island where I would begin the dive. Underwater in an unknown area with only 10-foot visibility, it took me some time to locate the trees. It's a peculiar exercise, swimming around, staring at your compass looking for some semblance of a land-based feature in a man-made lake, all the time thinking you're going the wrong way. However, once I found the drowned trees, I was uninspired by them and meandered through the murky mini-forest until I stumbled across a couple of playful smallmouth bass, who kindly danced for my lens.

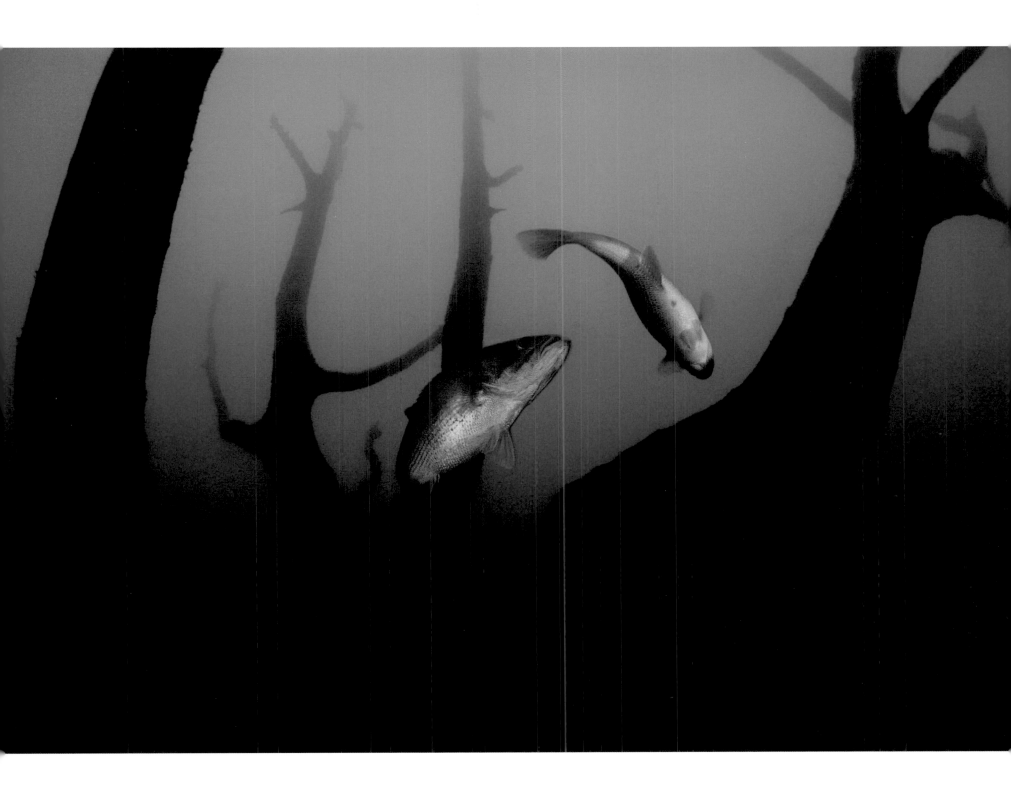

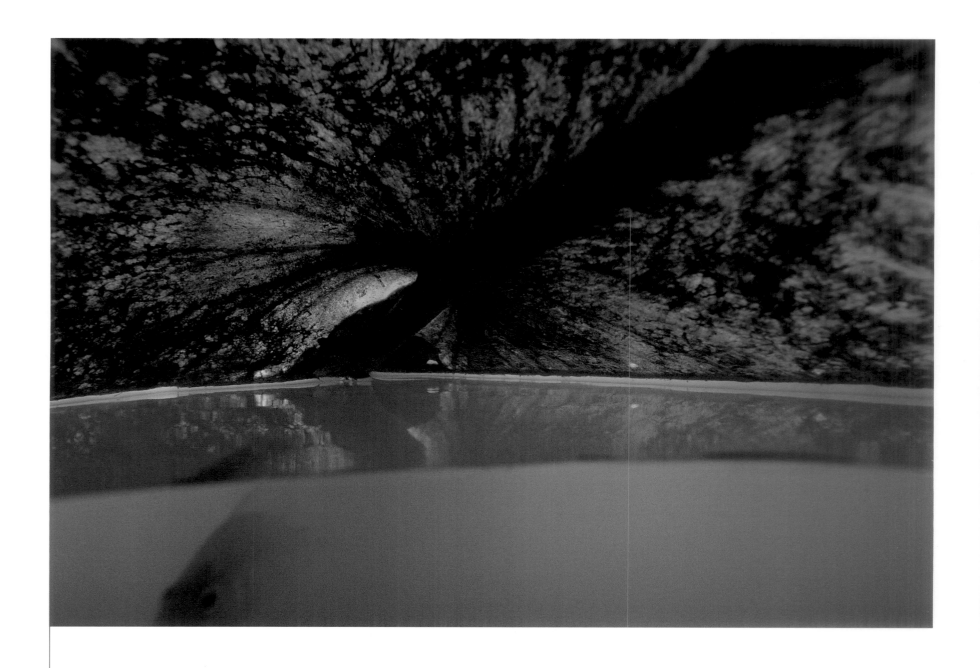

White perch under a cow lily, Calcasieu River, Louisiana May 23, 2003 / Depth 1ft. / Temp. 74F / Vis. 1ft.

The 200-mile-long Calcasieu River, by the Gulf Coast of southwestern Louisiana, has a rich history. In the early 1800s the infamous pirate Jean Lafitte, after raiding Spanish vessels, allegedly buried his treasure chests all along the river, which runs into Calcasieu Lake and then out to the Gulf of Mexico. As our boat followed the meandering wetland waterway through the dense swamp of cypress trees, I could see why both Lafitte and, it is believed, Napoleon, might have stashed their booty in this maze. A large expanse of cow lily pads caught my eye, and by aiming the camera towards the sun, I was able to backlight an individual bloom. A white perch, which probably had never seen a snorkeler before, conveniently appeared, as if to see what manner of pirate I was, poking around for treasure in its backyard.

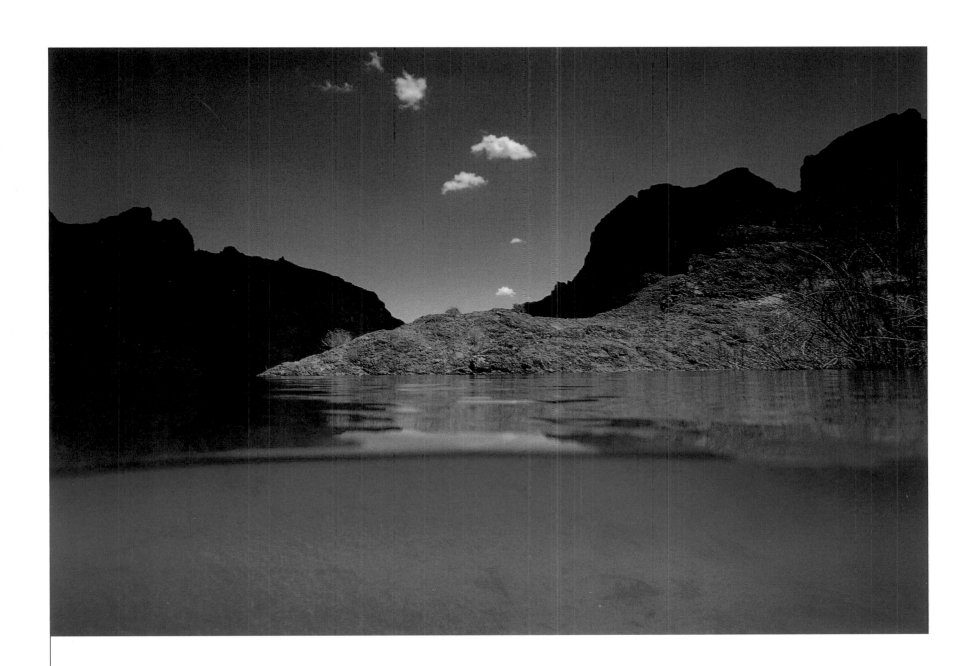

The Colorado River and the Black Mountains, Arizona-Nevada border July 1997 / Depth 1ft. / Temp. 53F / Vis. 20ft.

There's a tremendous river drift dive on the Colorado River south of the Hoover Dam. On a boiling hot day with the air temperature pushing 102°F, I reluctantly slipped on the thick underwear of my dry suit. A ridiculous exercise in such heat but the water was a chilly 53°F. The instructions from the divemaster were straightforward enough, "Drop down in the middle of the river. When you see the sloping sand bank on the left, kick to your right, otherwise you'll get sucked up into an eddy, which will swirl you up to the surface and pin you against the canyon wall. After that it's smooth but fast sailing in the eight to ten-knot current." OK, can do that.

It was easier said than done. I bypassed the rocks no problem. But the current that day, the divemaster told me later, had an unusual pull to the left side and, even though I was kicking as hard as I could when the sand bank appeared, I found myself being forced into the eddy. In my determination to free myself from the whirlpool I desperately kicked downward, breathing far too fast and hard. Just as I was about to accept defeat, my final frantic kicks liberated me and I was off, skimming past boulders, enjoying the ride of my life.

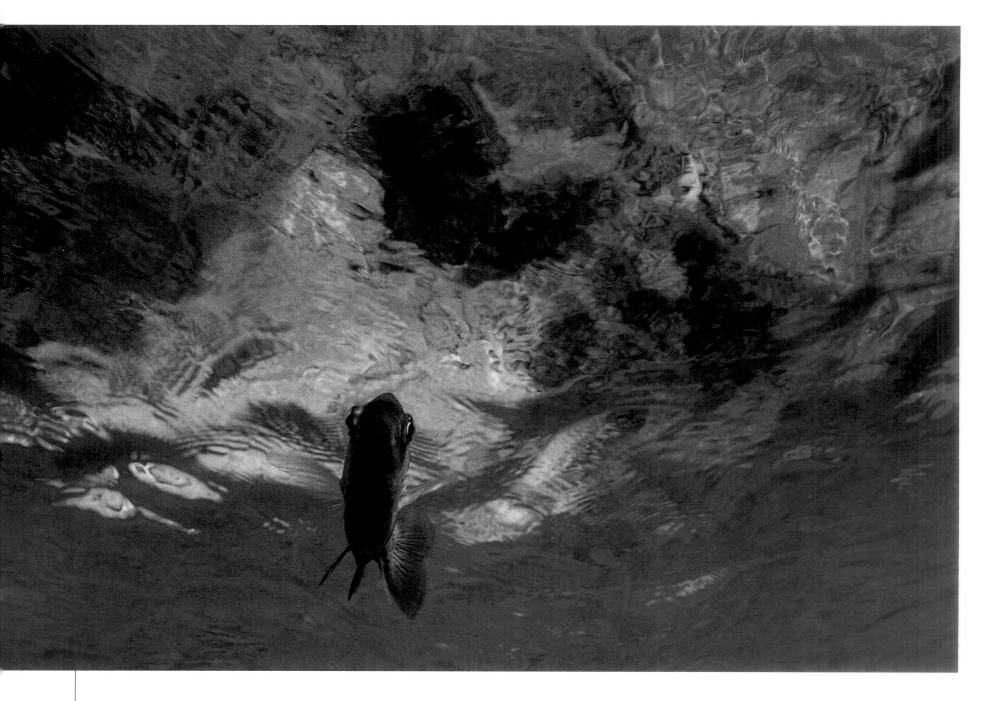

Bluegill, Martha's Quarry, Lebanon, Tennessee April 22, 2003 / Depth 5ft. / Temp. 57F / Vis. 25ft.

When I worked as a divemaster at Rum Cay in the Bahamas, I was very fortunate to meet and dive with the famous German photographer and filmmaker Leni Riefenstahl. I was learning my craft at the time, and she taught me to use a low camera angle and "shoot up." I've been doing it ever since.

This image, 25 years later and in very different water, is a perfect example. My assistant Andy Warren and I had spent a couple of difficult rainy days at the enormous flooded quarry; we returned two weeks later when the weather had improved. By late afternoon I had finished diving the four-story rock-

crusher building and snorkeled over to the cliff, where I caught sight of an inquisitive bluegill at the surface. It's an homage of sorts to Leni, who was a huge influence in my development.

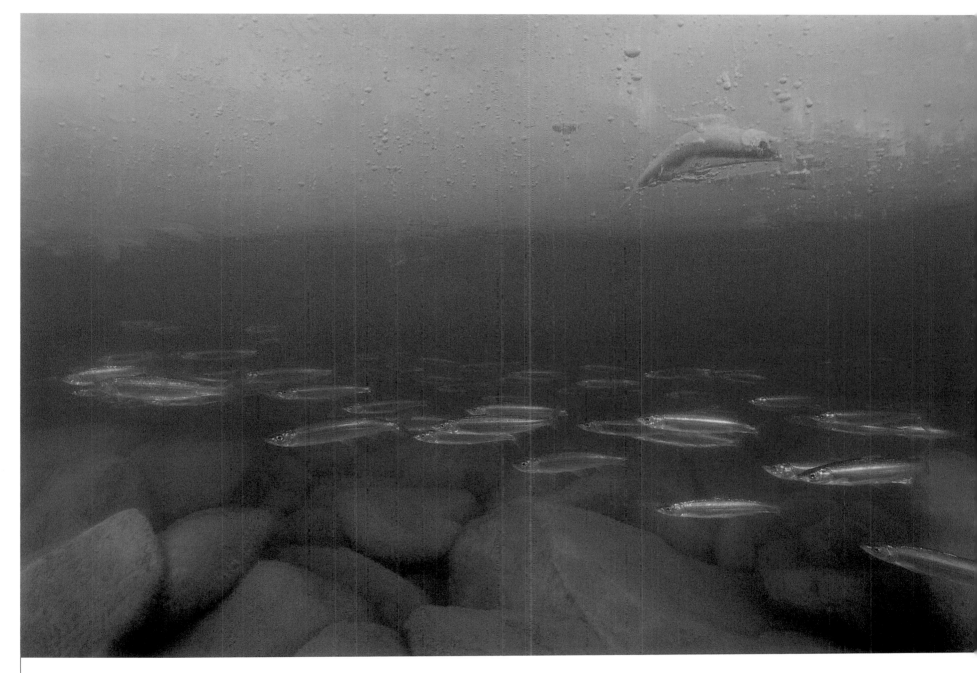

Spawning Bonneville cisco, Cisco Beach, Bear Lake, Utah / January 25, 2004 / Depth 4ft. / Temp. 33F / Vis. 6ft.

The Bonneville cisco spawn is a major event in these parts. On weekends during the spawning period, fishermen and their families appear on the ice with their dip nets to catch cisco through ice-fishing holes. Only in the dead of winter for 12–16 days do these seven-inch-long endemic fish swim into dipping range; the rest of the year they lurk in the depths between 40 and 90 feet. Their mating ritual is strictly nontactile. A female is surrounded by multiple mates, who wait for her to drop the eggs over a rocky area. The female shimmies and expels her eggs, and the males drop their sperm into the water immediately afterward. This entire act of creation lasts only 5 to 15 seconds. During the week I had my choice of ice holes to pick from. I spent five mornings ducking under the ice; by noon the fish were inactive, and I was frozen stiff—literally. Every time I clambered out, my dry suit froze in the 2°F wind, and we had to use our thermos of tea to thaw the camera controls. By the last day the water was a milky soup from quantities of suspended sperm—not for the squeamish!

Flooded forest, Lake Ouachita, Ouachita Mountains, Arkansas March 10, 2003 / Depth 45ft. / Temp. 46F / Vis. 35ft.

The mountain air was freezing and not a soul was on the lake. Nobody except we divers, or, I should say, this diver, because Hazel and the captain weren't about to get wet. But the dive had to be done in the chill of March, before the summer's annual algae bloom caused the visibility to drop. Once Captain Larry tied the small boat to a protruding tree trunk, we all huddled together around the inadequate gas heater, and as I suited up, Larry gave us the lowdown on the lake. Lake Ouachita has one of the most extensive underwater forests—

a whopping 20,000 acres. Historically, the majority of woodland areas had been harvested in soon-to-be-flooded valleys, but the rugged terrain here made that impracticable. Besides, folks had their hands full urgently relocating five towns, a church and a cemetery so that the lake could begin serving its new purposes: flood control, hydropower and water supply. Very little of these sunken towns remain, though there are rumors that the Buckville gas station is still intact somewhere down there, offering regular leaded gas at circa

1953 prices. Dealing with the cold turned out to be well worth the shivers as I wandered through a haunting labyrinth of trees, catching a rare glimpse of a school of gar, which only gather in winter.

Workmen's tools, Lake McDonald, Glacier National Park, Montana August 18, 2003 / Depth 51ft. / Temp. 50F / Vis. 50ft.

In August 2003, Montana was ablaze with forest fires. There had been a drought for five years and everything was crackling dry: 176,038 acres of the state burnt that summer. Glacier National Park was hit pretty badly at the beginning of the month, but by the time we arrived the fires were almost extinguished, with only a few small areas smoldering at the top of the mountain close to Lake McDonald. However, just as we drove into the campground the winds picked up to 45mph and the forest caught alight again. We watched in horror as the sky filled with very dense smoke only a couple of miles away. Fortunately we didn't have to evacuate and no one was injured, but for days we lived in this smoggy environment, where the sun looked like a faint, burnt orange ball. Every morning, nursing an intense headache from the smoke, I went to the ranger's station and inquired when the park would reopen. Finally, on the sixth day the most southern part was accessible. I was one of the first people into the park. Smoke still filled the air until a light rain subdued it. I met Mike, who was going to show me a group of old tools at the bottom of the lake. We followed the old boat ramp down to 30 feet before we turned northeast. We passed over a collection of such memorabilia as a coffee pot and some metal plates. In the 1930s the Civilian Conservation Corps were working in the park and apparently left their tools and other gear on the winter ice to be disposed of in the lake once the ice melted. A few years ago a diver collected them and placed them upright, creating this tool sculpture.

Garibaldi, San Clemente Island, the Channel Islands, California
November 28, 2003 / Depth 28ft. / Temp. 56F / Vis. 40ft.

It seems quite fitting that the official "marine fish" of the state of California was named after the courageous nineteenth-century Italian general, Guiseppe Garibaldi, regarded as the founder of modern Italy. The fearless fish is a dauntless protector of its habitat and will become extremely aggressive when it comes to protecting its young.

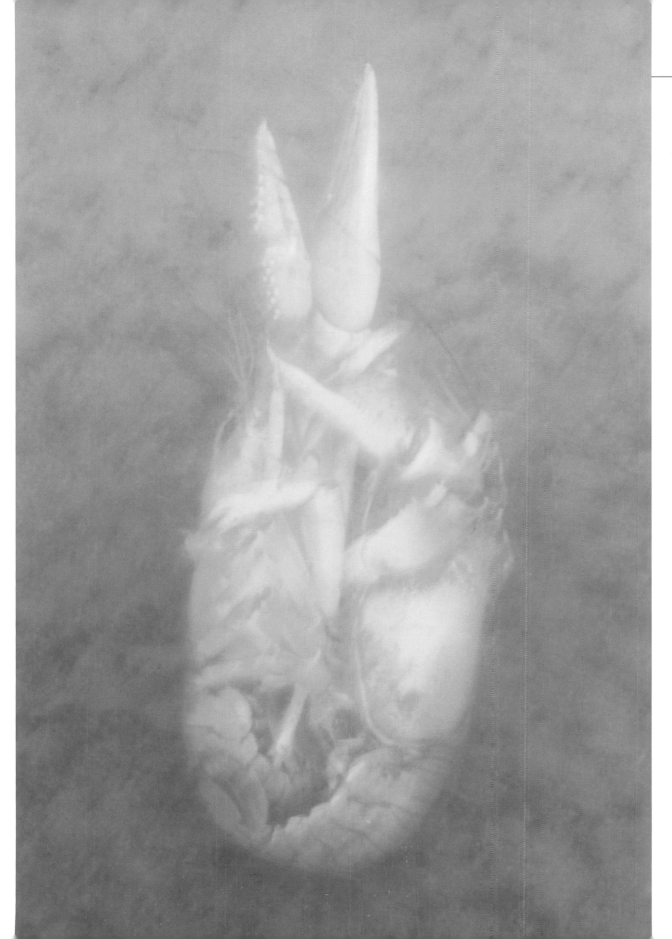

Mating crayfish, Spiritwood Lake, North Dakota May 2, 2004 / Depth 8ft. / Temp. 45F / Vis. 6ft.

The life of a crayfish is only about two years, and presumably scrappy too, considering its relatively massive claws. Rapid, high-volume reproduction is a must for the plated creatures, yet I found this Northern crayfish couple locked in a firm and long-lasting embrace near the lake's boat ramp. They seemed to be in no hurry, so I decided to experiment with a long exposure, curious to see what would happen with the color of the available light. The unusual yellow was more pronounced than I had expected and perhaps quite erotic—in a crayfish sort of way.

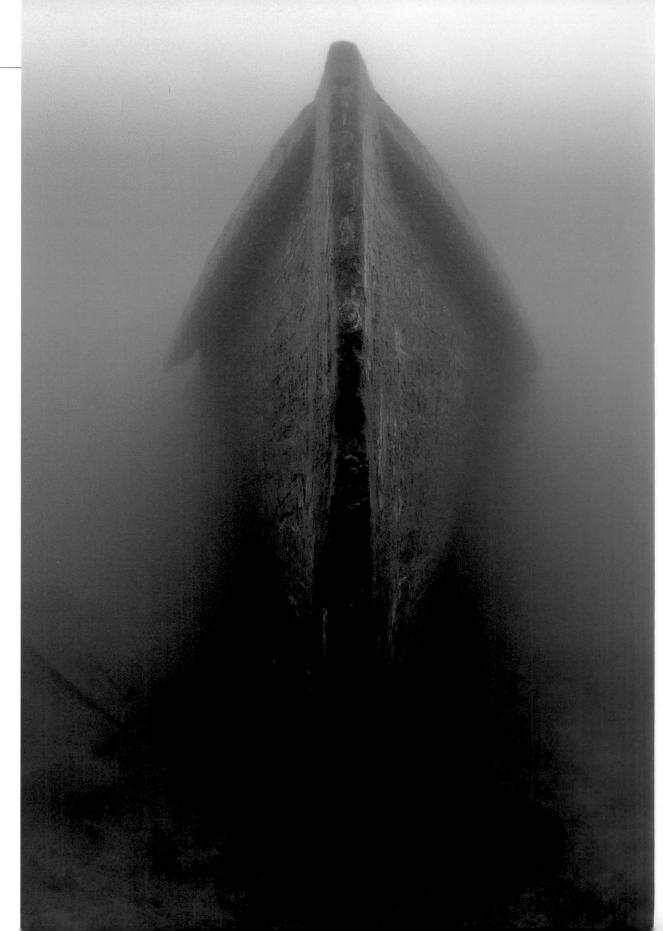

***The Lady of the Lake*, Smith Cove, Lake Winnipesaukee, New Hampshire**
September 11, 2002 / Depth 28ft. /
Temp. 68F / Vis. 15ft.

From 1848 to the Gilded Age of the 1890s, the streamlined *Lady* was the glory of Lake Winnipesaukee. A mechanical marvel, and at 125 feet one of the largest steamships ever built, she provided a speedy and reliable service along the 28-mile-long lake. Her races with competitors' ships were local legends—and the *Lady* always won. After her prime she served the railroad magnate Benjamin Ames Kimball, humbly now as a barracks for the Italian masons building his opulent castle. That work completed, she was slotted for a deepwater scuttling until an errant torch set her alight at dock. She managed a final brief cruise aflame, then settled onto the bottom close to shore—an unbefitting end for the classy *Lady*.

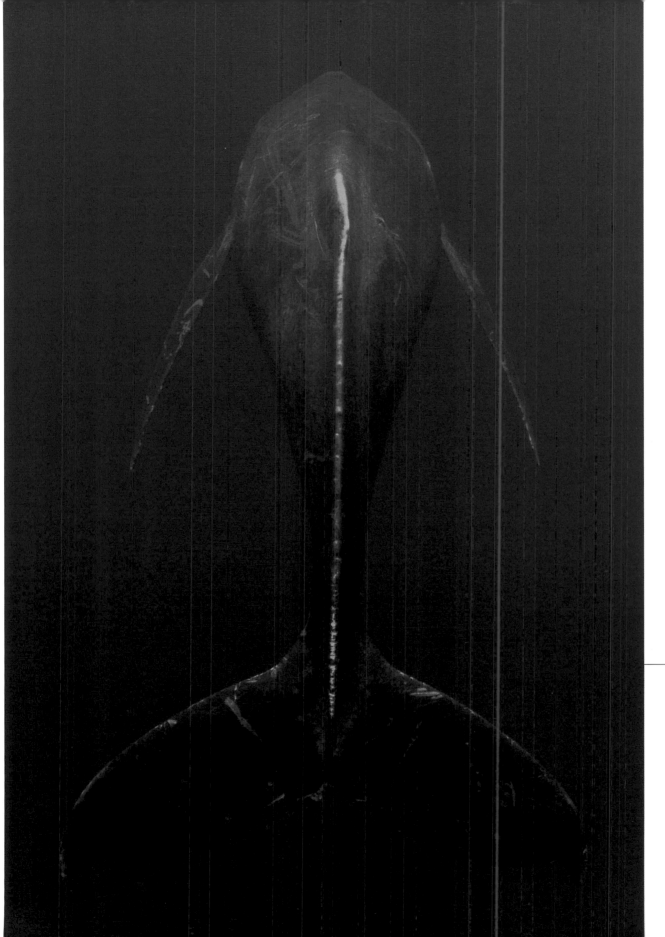

**Breath-holding Humpback whale, Auau
Channel, Maui, Hawaii**
February 22, 2005 / Depth 50ft. /
Temp. 71F / Vis. 100ft

One of the most awe-inspiring and
humbling times of my life was snorkeling
with humpback whales. At one point I
snorkeled down to visit one of the gentle
giants. It remained completely motionless
as it held its breath for thirty-one
minutes.

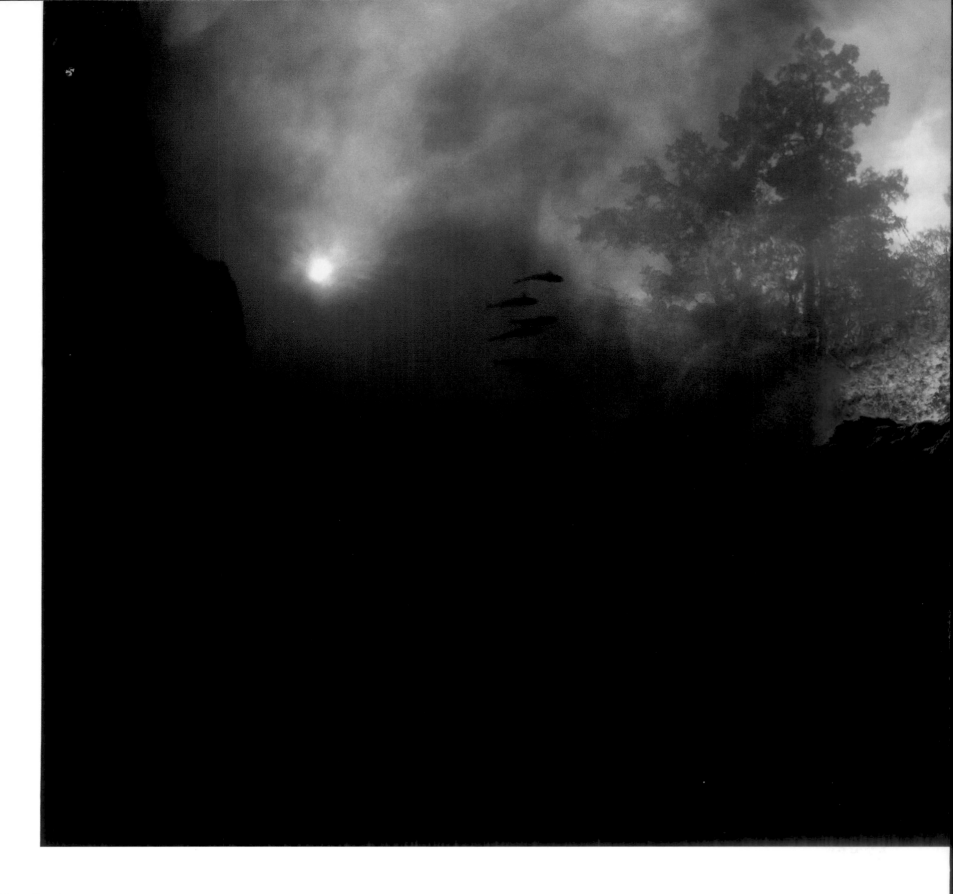

The Santa Fe River meets Devil's Eye Spring, Ginnie Springs, Florida September 2, 2004 / Depth 15ft. / Temp. 72F / Vis. 80ft.

Although I had already been to Ginnie Springs, an inland spring system in north central Florida, I wasn't entirely satisfied with my results. Two years later I unexpectedly returned while dodging hurricanes, and was very surprised when I looked into the water. All the hydrilla, a fast-growing invasive weed that plagues southern rivers, lakes, and springs, had been vanquished by the dark tannin riverwater of the Santa Fe. After five years of drought, the river had suddenly overflowed into the springs and had strangled the sunlight-loving weed. It was like photographing a new site.

I was the first person in the water the next morning, getting the jump on the cave divers who have mapped several miles of this cave system with a maximum depth of 110 feet. Minus the hydrilla, the bedrock was exposed to the morning light. I could see six western painted turtles eating in the distance. I swam over a banded water snake, which shimmied towards the bank. As I dropped down into the funnel-shaped opening of Devil's Eye cave I felt a strong upwelling of 72°F water—42 million gallons pulse to the surface every day. At 15 feet I grasped a large tree trunk that had wedged itself in the cave entrance, and let my legs hang free to be gently moved from side to side by the surge of water from the earth's core.

Looking up, I saw one of the most unusual and spectacular underwater visuals in the country. The sepia brown tannin-rich water was mixing with the clear spring water, creating a variety of warm orange colors. Then the spring water overwhelmed the tannin and I could clearly see the trees above the surface—a weird ebb and flow. As I waited for the right mix of river and spring water, a turtle swam overhead. A few minutes later the resident school of mullet followed suit. Just then the morning sky seemed to burst into flame.

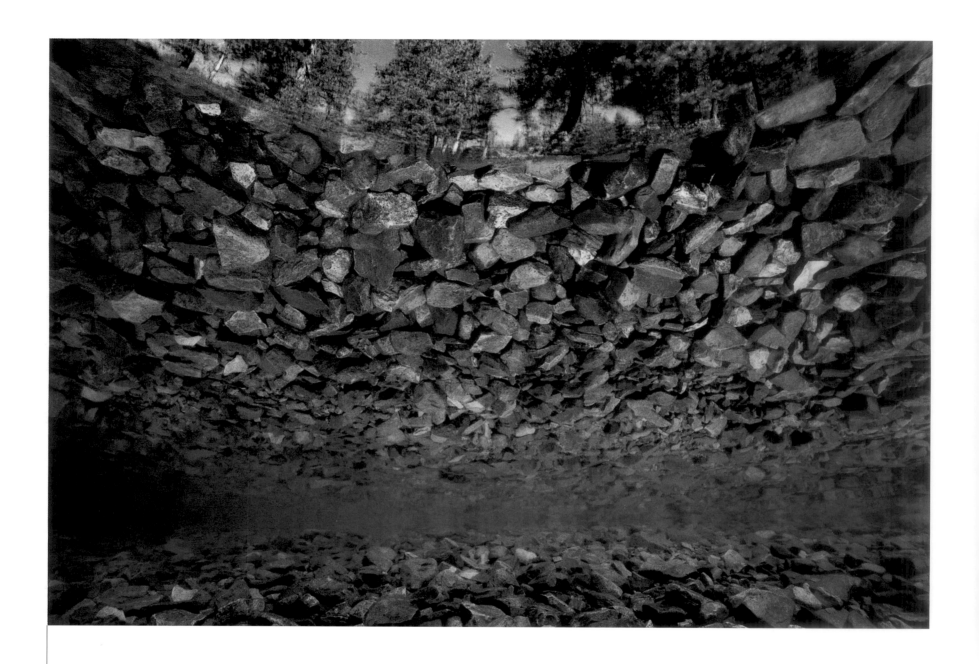

Reflected glacial rocks, MacGregor Lake, the Rocky Mountains, Montana August 19, 2003 / Depth 6ft. / Temp. 64F / Vis. 60ft.

As forest fires smoldered in Glacier National Park, we drove south to Lake MacGregor. It was a huge relief to be out of the choking smoke, and diving in cool, clear water, breathing bottled air. The sixty-feet visibility in the lake made it easy to spot loads of crayfish, which they call "crawdads" in these parts. After our time in the hazy fire zone, the clarity seemed wondrous, all the more so since the lake lies in a high mountain pass where the wind can whip up the surface at any time. However, it was an unusually calm day, and I was able to capture a wide-angle image of the reflected rocks —a visual I had been looking for all year.

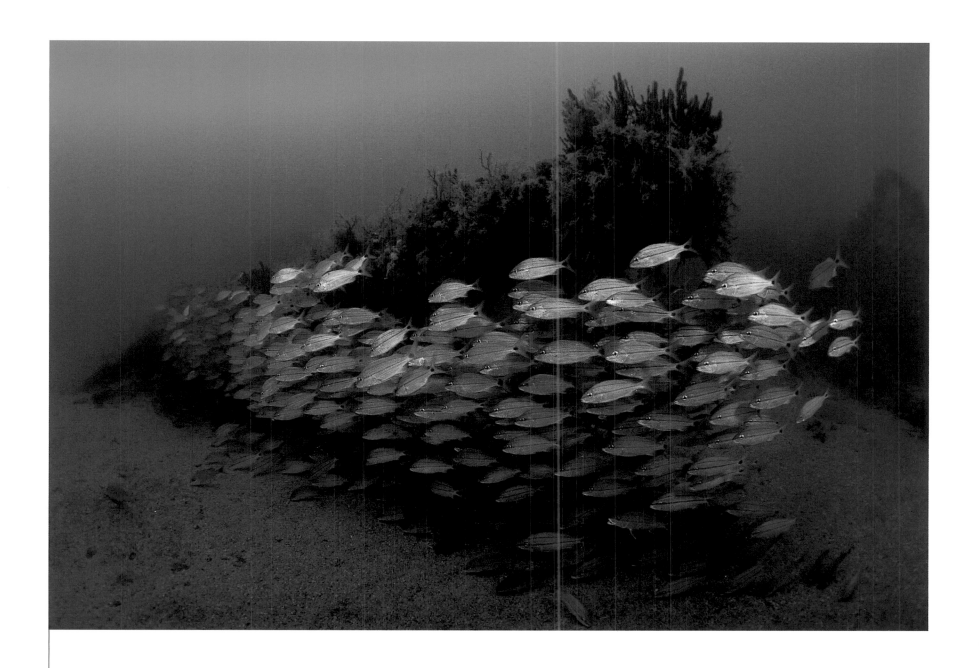

School of tomtate, wreck of the *Schurz*, Atlantic Ocean, North Carolina August 9, 2004 / Depth 106ft. / Temp. 75F / Vis. 50ft.

The World War I USS *Schurz* was originally a 255-feet German gunship called the SMS *Geier*. In 1914 the United States seized the ship when she put into port in Honolulu for repair. Just before war broke out between the two countries, the German crew tried to scuttle the ship without success.

When the U.S. finally declared war in 1917 the ship was repaired and renamed the *Schurz*. The Germans, resenting this fact, specifically targeted the ship for destruction, but it was an accident that sank her. On the foggy night of June 21 1918, approximately 25 miles south of Cape Lookout, the

Schurz collided with the tanker Florida. Nowadays a heavy concentration of baitfish and amberjack typically engulf the wreck, and at the stern the tomtate have made one of the cannons their home.

**Workman's boots, Lake McDonald,
Glacier National Park, Montana**
August 16, 2003 / Depth 38ft. /
Temp. 50F / Vis. 50ft.

Who knows who once wore these leather
boots? Certainly the gentleman in question
served in the Civilian Conservation Corps,
part of the New Deal's grand depression-
relief program, which began working at
the park in 1933. The crew at Glacier
constructed new buildings, created trails and
fought forest fires in a gloriously beautiful
but extremely isolated wilderness. While
exploring the southern part of the lake, I
found the boots beside an old iron ore stove,
and could easily imagine a hard-working
ghost rubbing his hands together, seeking a
bit of phantom warmth.

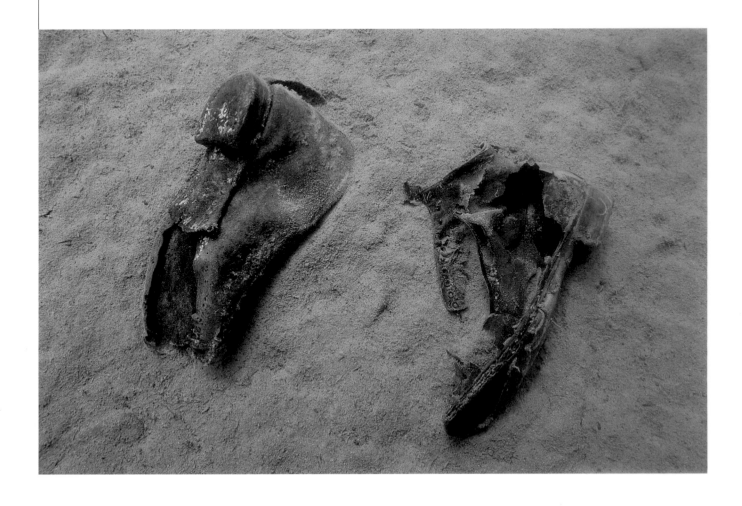

American Paint horse, Adios Ranch, Kenney, Texas March 22, 2004 / Depth 1ft. / Temp. 65F / Vis. 1ft.

The opportunity to photograph the Paint horse came through a chance meeting in a bed and breakfast in Steamboat Springs, Colorado. Over bacon and eggs, Hazel and I chatted to Bob, a Texas cattle-ranch owner. We exchanged addresses but at this point I didn't know he owned any horses. A couple of months later we were on the Texas coast for a three-day boat trip to the Gulf of Mexico, which was cancelled due to heavy seas. The unexpected free days prompted a call to Bob and I asked him if he had any horses. "Yes, I have four painted horses, come on up and camp on my little island on the lake."

We drove six hours north into Hill Country and maneuvered the rig over his fields and across a rickety, wooden bridge to the island—a wonderful place to park the Airstream. The following morning, while we got the cook's tour of the ranch, Ken gave us a history lesson. Initially the Paint was introduced by Spanish conquistadors and then became part of the herds of wild horses that roamed the Western deserts and prairies. In the 1800s, the peculiar spotted horse became a favorite of the Native American. The Comanche tribe considered by many authorities the finest horsemen on the Plains, believed

the horse to possess magical powers. Once the Paint had been domesticated, the cowboy cherished the breed because of its working ability and heart.

Near the end of the ranch tour, the horses trotted over to the truck and introduced themselves. I must say they were very impressive and we spent two days working with these magnificent creatures, and enjoying some good 'ol Texan hospitality.

Caddisfly, Flathead River, Flathead National Forest, Montana August 20, 2003 / Depth 2ft. / Temp. 56F / Vis. 10ft.

The caddisfly builds a protective case of gravel or sticks around its soft white body, in its aquatic larval stage. This serves as both protection and ballast to keep it from being swept away in the current. I was very curious about this little creature, and finally encountered it among the colorful pebbles lining the shallow Flathead River. As a result of the forest fires in and around Glacier National Park, just getting in the water had been an ordeal. We drove for miles through scorched forest along unpaved roads only to be stopped at our turn-off for the Flathead by a barricade and a state trooper. Every single tree was blackened on either side of the road, which the fire had jumped in 45mph crosswinds. Only the river had prevented the fire from continuing its rampage. It was an eerie sight.

When the road to the Flathead dive site finally reopened, it was a little disturbing driving through the charred forest. It certainly reaffirmed my belief in the power of Mother Nature.

Surrounded by all that scorched earth, I was relieved to jump into the cold river. Among the most spectacular river pebbles I had seen in the whole country was this small beetle-like creature peering from its protective casing. While the fires raged, it had snuggly gone about its business, prowling among the jewel-like stones, turning itself into a tiny Art Deco masterpiece.

Two weeks later I was in a fishing-tackle store near the Blackfoot River, where I noticed a fishing fly that resembled my bug. The owner, Kathy, told me the new adult emerges from the water as a very drab little moth. Caddis adults feed by sipping water and nectar from streamside brush, often forming huge mating swarms, battalions of flies that move en masse upstream, bouncing on the water surface to drop their eggs. These August orgies of caddisflies drive trout and trout fishermen quite wild.

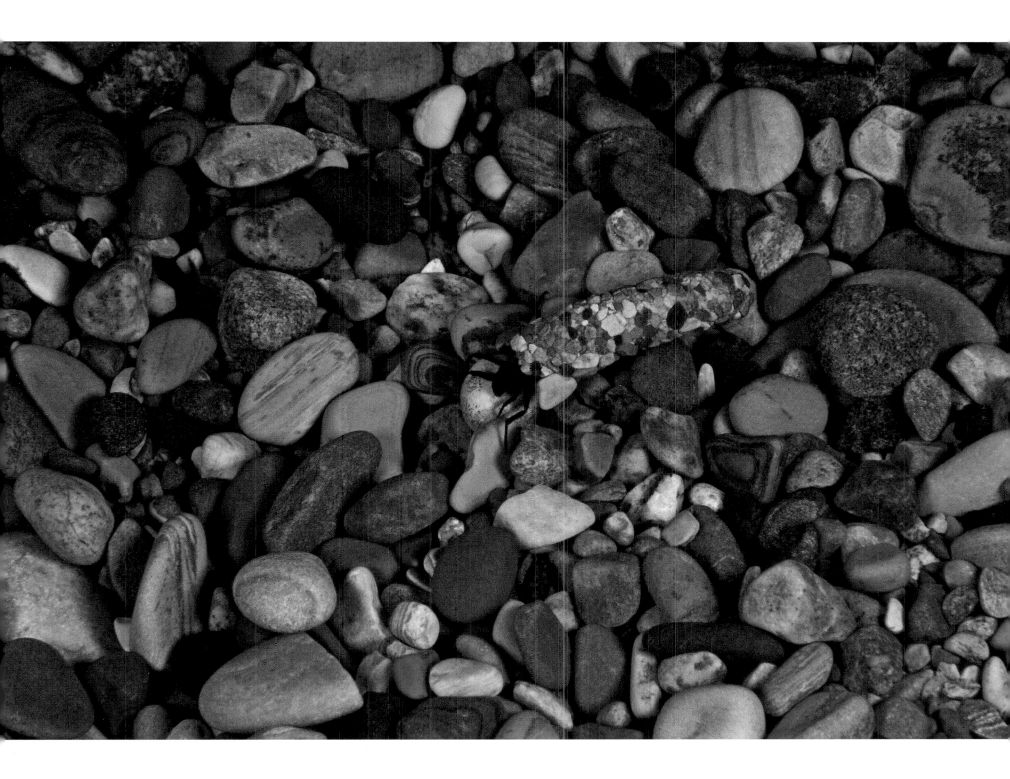

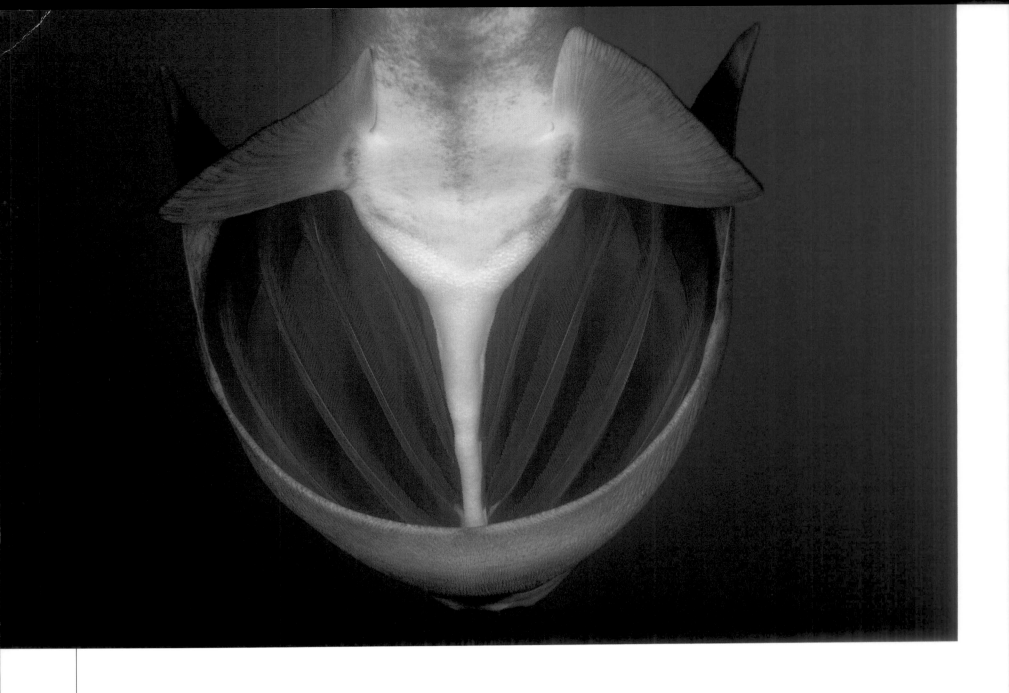

The gill rakers of a spoonbill, Mermet Springs, Illinois September 17, 2004 / Depth 24ft. / Temp. 72F / Vis. 12ft.

Spoonbills, relatives of the sturgeon, are filter feeders, and zooplankton are their main source of food. So to locate a spoonbill, you need to find these microscopic morsels, most densely present at the thermocline, where warmer surface water and colder deeper water meet. Because this invisible line was only down at 25 feet in September, I was able to spend a fascinating if sometimes frustrating 20 hours in the water over a four-day period. It was a real challenge to sneak up behind the elusive fish. I had to hover midwater for long periods of time, seeing nothing but green murk and faint moving shadows, even when the fish approached as close as 12 feet away. On a few occasions though, I was able to locate the school and during one incredible 88-minute dive I enjoyed 42 encounters. Even with these statistics I could count on one hand the amount of times I managed a favorable position for only a split second. The exception was one cooperative individual which allowed me about six seconds just below its tail. I loved working with this animal, watching it swiftly cruise by with its mouth agape, when it looked entirely deserving of the title "freshwater whale."

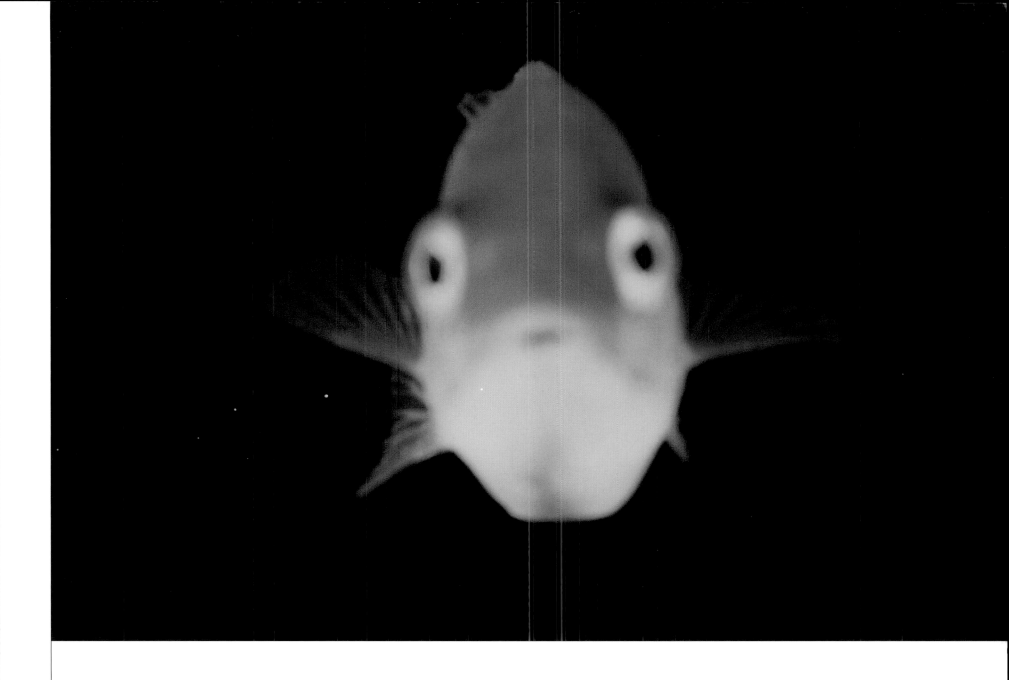

Cunner fish, Duck Island, Isle of Shoals, Maine September 28, 2002 / Depth 60ft. / Temp. 59F / Vis. 25ft.

Even before the Pilgrims landed in 1620, the Isle of Shoals, a group of nine rocky islands along the border of Maine and New Hampshire, was a key destination for European fishermen. The name "Shoals" reflects the abundance of fish these hardy souls encountered in the surrounding deep, cold water of the Atlantic. In 1614, the explorer Captain John Smith wrote that a dozen fishermen caught 60,000 fish in a month off the "remarkablest isles." Such prodigious feats are long past, but certain fish, such as the small cunner, still thrive in the seaweed-blanketed shallows. This little chap would not leave me alone, sticking his face against my macro dome port, insisting I take his picture. When I moved away, the frisky fish would follow and eventually I succumbed to my new friend's humorous advances.

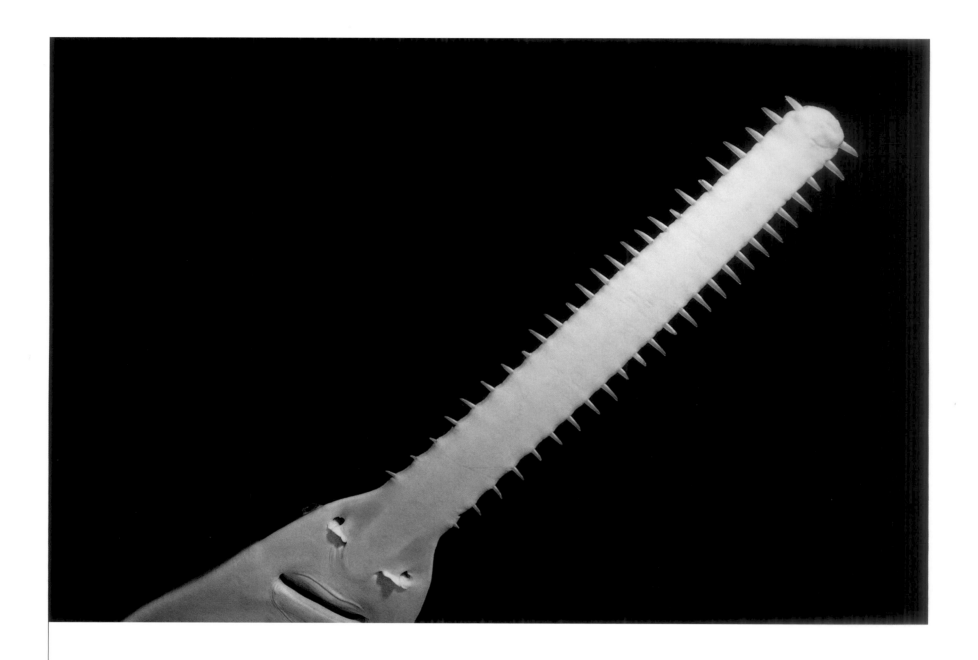

Smalltooth sawfish, Living Seas Pavilion, Epcot Center, Orlando, Florida / January 1986 / Depth 27ft. / Temp. 74F / Vis. 50ft.

After 56 million years, the sawfish is in danger of extinction. Biologists estimate that the U.S. population of this majestic animal has been depleted by 95–99 percent. They once ranged from the Gulf of Mexico to North Carolina but now are found only in Florida. Ironically, the main reason for their demise is the same reason they have survived for so long— their tooth-studded snout, called a rostrum. In the marine world of shallow coastal waters, estuaries, and lagoons, the rostrum has proved the perfect adaptation for the sawfish, not only as a weapon to attack and stun, but also as a sensor to locate hidden prey in murky waters with its motion and electro-sensitive pores. When wielded like a broadsword, the versatile snout is also an effective defense mechanism. But, confronted with the sweep and reach of commercial fisheries, the studded rostrum has proved an unmitigated disaster. Sawfish, which can reach twenty feet, easily become accidentally entangled in nets designed for other species. This misfortune of evolution, compounded by loss of habitat and low rate of reproduction, has caused the serious decline of this prehistoric survivor.

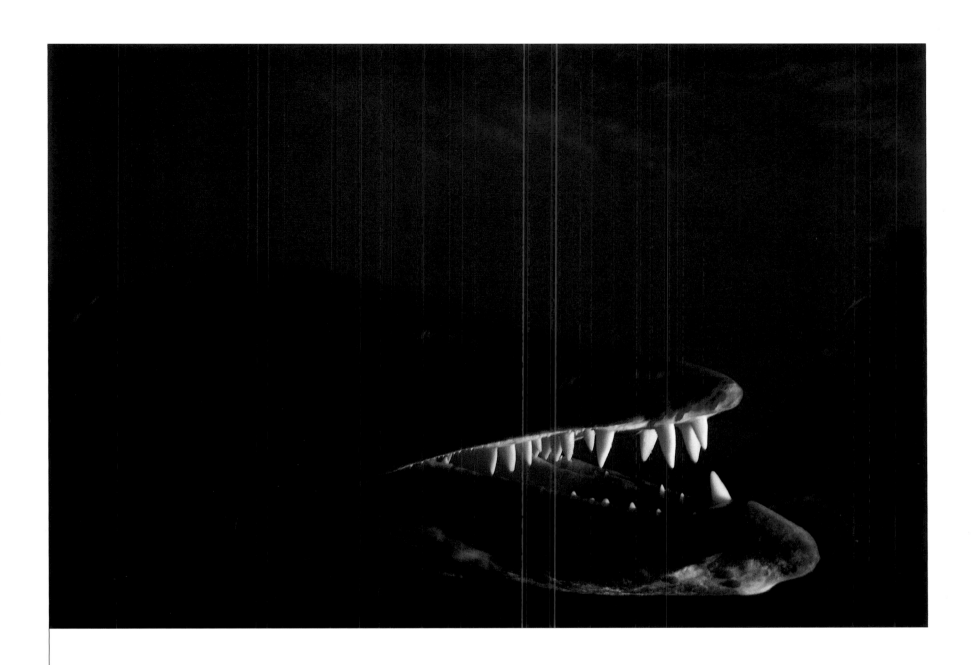

Barracuda, Key Largo National Marine Sanctuary, Florida / August 1988 / Depth 20ft. / Temp. 81F / Vis. 50ft.

The barracuda has been around for 50 million years, and has a reputation for being dangerous to humans. In 25 years of diving I haven't found this to be the case. They sometimes follow divers around, but this is curiosity rather than an aggressive act. Like most creatures, they are harmless unless provoked. Nevertheless, with its savage appearance, fang-like teeth, and ability to move up to 27mph in short bursts, the Tiger of the Sea is unlikely to shed its unjustified image.

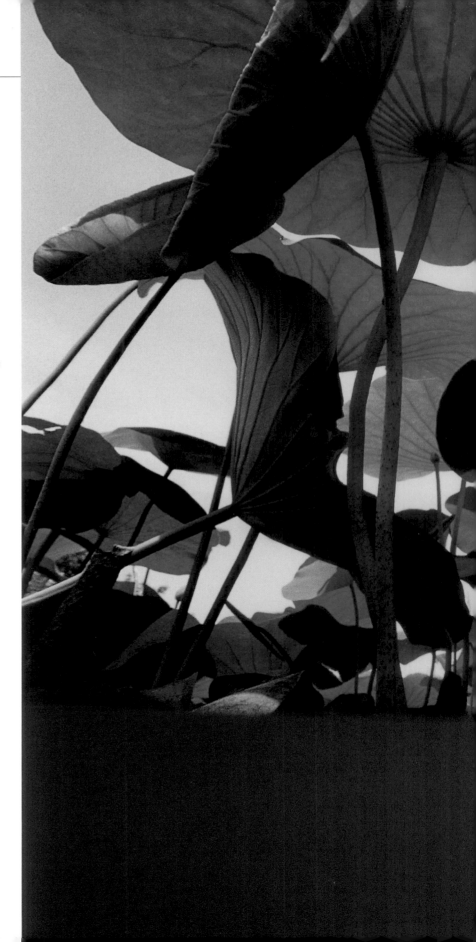

Lotus plants, Cameron Prairie National Refuge, Louisiana
May 24, 2003 / Depth 1ft. / Temp. 80F / Vis. 1ft.

Hazel and I found the vast area of lotus plants on one of
our "let's just drive around and see what we can find" days.
At this time we were camped near Lake Charles to explore
the Calcasieu River and the ecologically important Louisiana
wetlands, which constitute about a third of America's coastal
marshland. Driving along the Creole Nature Trail on Route 27,
we passed "Alligator Crossing" road signs. So I was of two
minds about entering the water where we discovered the lotus
plants. But they did look wonderful, irresistible, even. During
the ten minutes I scouted for reptile activity, we spied only
one small gator. I thought I could deal with junior, and trudged
through the mud, which swallowed my legs up to my knees. As
I lay in two feet of murky water, I was so involved in the image
I almost forgot about any potential danger. However, when we
drove off, Hazel saw a whopper of a gator lunge violently out of
the water and swallow a blackbird whole. The sneaky behemoth
had slid unnoticed close to the spot I had been minutes before.
Hazel turned to me and said, "You're not doing that again"!

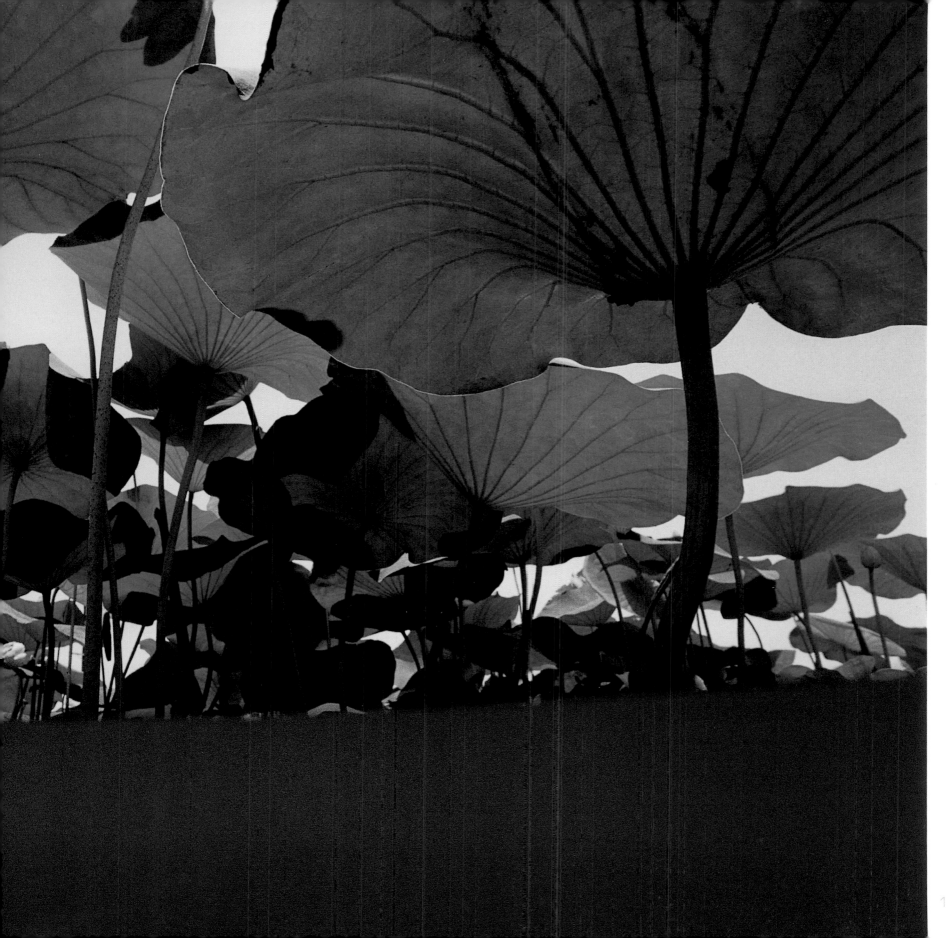

Breaking wave, Honolua Bay, Maui, Hawaii February 21, 2005 / Depth 3ft./ Temp. 72F / Vis. 25ft.

We were on the boat about to leave for my last day photographing whales when Archie Kalepa, the head safety lifeguard for Maui County called. "Surf's up!" he blurted excitedly. "We've got 12-feet waves, but they're going to die down this afternoon. Now's your opportunity".

We loaded the gear into the car, burned up the west coast and found the dirt road down to the bay. Suddenly we were deep into surf culture—the road was lined with bronzed teenagers, and cars with racks on their tops. I looked over the cliff and saw dozens of surfers sitting on their boards, waiting patiently for the next set. A heavy shore-break wave broke not far from the rocks below. Just getting in the water looked a bit risky and I realized I was in for a tough physical day. The surf was indeed powerful and a couple of times I was swept backwards in three feet of water, tumbling and desperately trying to keep the dome of my camera-housing from being smashed against the rocks.

Eventually I worked my way through the surf. Now I was among the waiting surfers. A wave broke in front of me and I was forced to duck down. As I looked up a surfboard glided over my head—a close call! To capture a wave as it broke put me in a precarious position. If I mis-timed my move, the wave would suck me in and I would be hurled underwater "over the falls" as surfers say. As I was thinking about how to best avoid this danger, another photographer appeared with a crash helmet on, making me feel even more vulnerable. I stuck with it, though, dodging bullish breaking waves until I felt I had captured a couple perfectly. It was great fun but I was one tired "surf-dog" by the end of the day.

"Never turn your back on the ocean." Old Hawaiian saying

Spanish moss on bald cypress trees, Blind Slough, Caddo Lake, Texas March 7, 2003 / Depth 1ft / Temp. 50F / Vis. 3ft

According to legend, a Native American chief was warned by the Great Spirit to move his village from the low lands. He ignored the advice, and when an earthquake jolted the Red River from its banks, forming Caddo Lake, the chief's village was engulfed. History tells an even more uncanny tale. Around the turn of the nineteenth-century, a massive 100-mile log jam, known as the "Great Raft", forced floodwaters to back up into the Cypress Bayou, forming the largest freshwater lake in the south, half in Texas and half in Louisiana. This is not usually a diving destination, so Peanut, a fishing guide, took me around the 20-mile-wide lake, a giant maze of ponds, bayous, and sloughs, while I searched the murky water for the 40-pound gar fish, which huddle together during the cold winter months. As I had suspected, the gar were a wild-goose chase. Instead I turned my lens toward the other reason for my visit—the most dense and dramatic Spanish moss I had witnessed anywhere in the South.

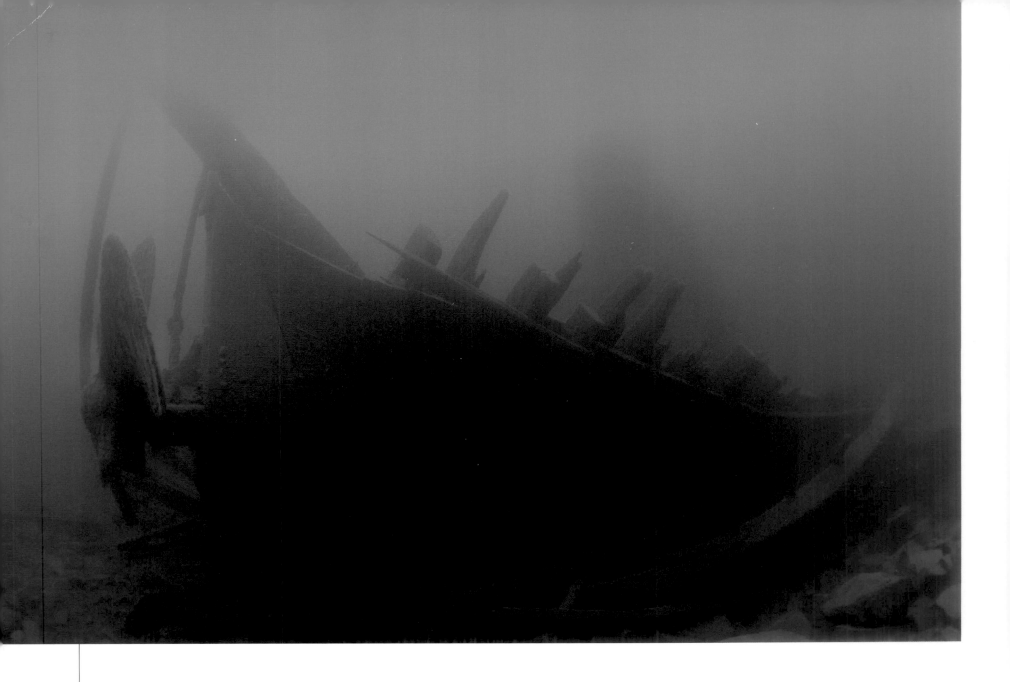

The stern of the *Henry Chisholm*, Isle Royale, Lake Superior, Michigan June 19, 2005 / Depth 142ft. / Temp. 38°F / Vis. 80ft.

Even in June and July, when the weather is calmer, Lake Superior can yield choppy seas, making the 19-mile crossing from Grand Portage to Isle Royale a potential five-hour journey in a small craft. So my dive buddies, Al and Todd, and I were thrilled that the lake was flat and we could zip across in only 50 minutes, which allowed us to make a quick dive on the *Chisholm's* engine before dark. Yet even with all the modern nautical instruments, it was still tricky to maneuver around the Rock of Ages reef to the site buoy. I could see why the shallow rocks, two and a half miles off the western end of the island, were such a danger to mariners, especially at night and before the lighthouse was built in 1910. When the vintage-1880 *Chisholm,* a wooden steam barge 270 feet long, tried to enter Washington Harbor on the night of October 20, 1898, it plowed full steam onto the reef. A salvage crew tried to remove the ship but the pumps were no match against the incoming water. After a couple of storms, the pounded ship sunk into a ravine in the reef.

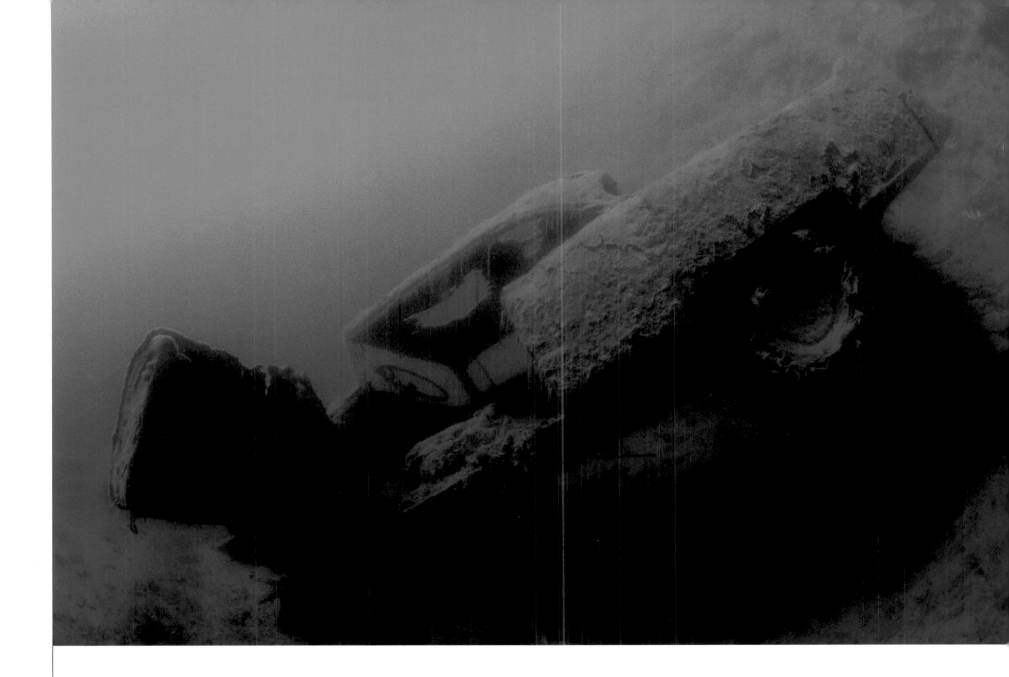

1959 pink Cadillac, Cerulean Quarry, Kentucky March 30, 2003 / Depth 25ft. / Temp. 48°F / Vis. 40ft.

The first time I visited Cerulean Quarry in October I was a week too late. The lake had just "turned over" and the visibility was poor. Freshwater lakes on average turn over twice a year. This happens when the seasons change. In the fall, the air temperature drops and the surface water cools. Cold water is denser than warmer water, so the cooler surface water drops to the bottom, pushing the warmer, sediment-filled water to the top. In my naïvety I arrived just after the fall inversion. Hazel and I returned the next year in March, with the water

clarity near its peak. What a difference. Now could see a huge rock-crushing machine, a battered old pick-up truck, and 60-pound catfish on the prowl. But I had come for the pink Cadillac, tucked away at the far end of the quarry. Now, who would dispose of a classic car in such a permanent and unceremonious way? The owner, after a few too many, had rolled it into the 16-acre lake to punish it for a flat tire, thus striking a blow for, well, he probably couldn't remember what!

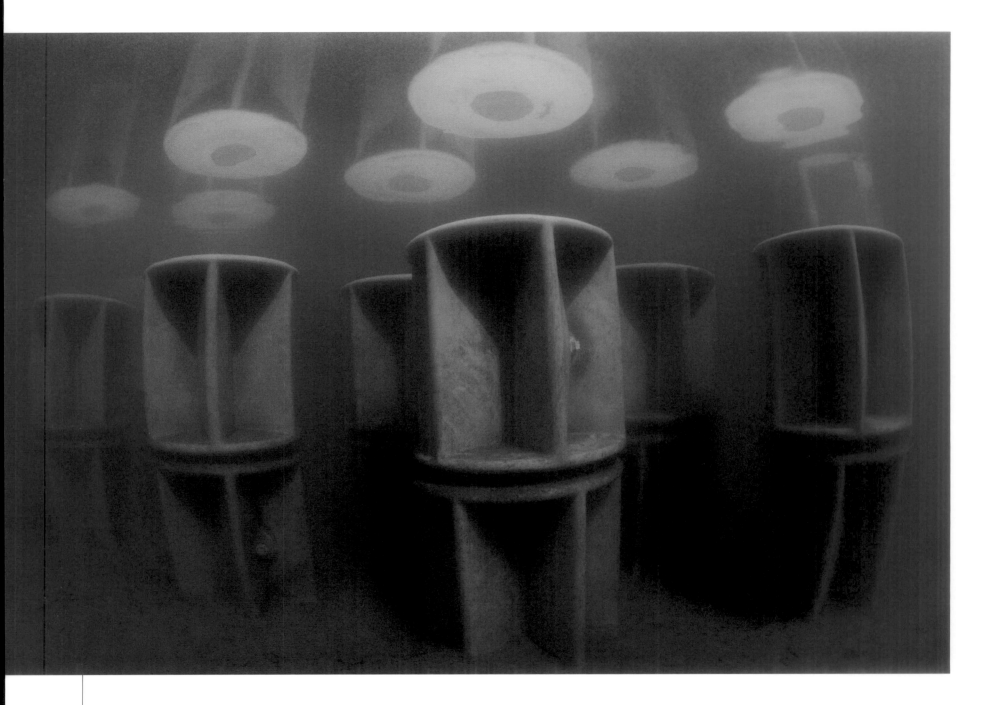

Breakwater drums, Lake DeSmet, Wyoming July 24, 2003 / Depth 14ft. / Temp. 62°F / Vis. 25ft.

These plastic drums were positioned on the western side of the lake in an attempt to stop the counter-clockwise current from depositing sand into the entrance of the new marina. I liked the striking symmetry of these practical objects, and their incongruity in a body of water where myths abound.

In Native American folklore it was a source of gold to make arrowheads. The Sioux tribe believed the lake had healing powers and the ability to prompt visions. My favorite Lake DeSmet tale is of "Smetty," a Loch Ness type of monster possessing "a bony ridge along the back, with a resemblance to a horse's head coming out of the water in a swimming motion." The theory now is that when the large native carp move together at the surface, it creates the appearance of a large beast.

Rainbow trout, D.C. Booth National Fish Hatchery, Spearfish, South Dakota July 21, 2003 / Depth 4ft. / Temp. 58°F / Vis. 12ft.

What glorious mayhem! I was in the middle of thousands of trout being fed by tourists from a bridge above the pond. The tourists, thinking I was part of the attraction, entertained themselves by throwing trout food pellets right on top of me so the fish would swarm around my head, occasionally

mistaking my fingers for their dinner. This crazy shoot took place in one of the oldest fish hatcheries in America, originally constructed in 1896 to establish trout populations in the Black Hills of South Dakota and Wyoming. Today the hatchery serves as a living fishery museum as well as continuing to rear

fingerlings. From a photographic standpoint the situation was so ridiculously out of control I just kept pushing the button until I felt confident something was on film.

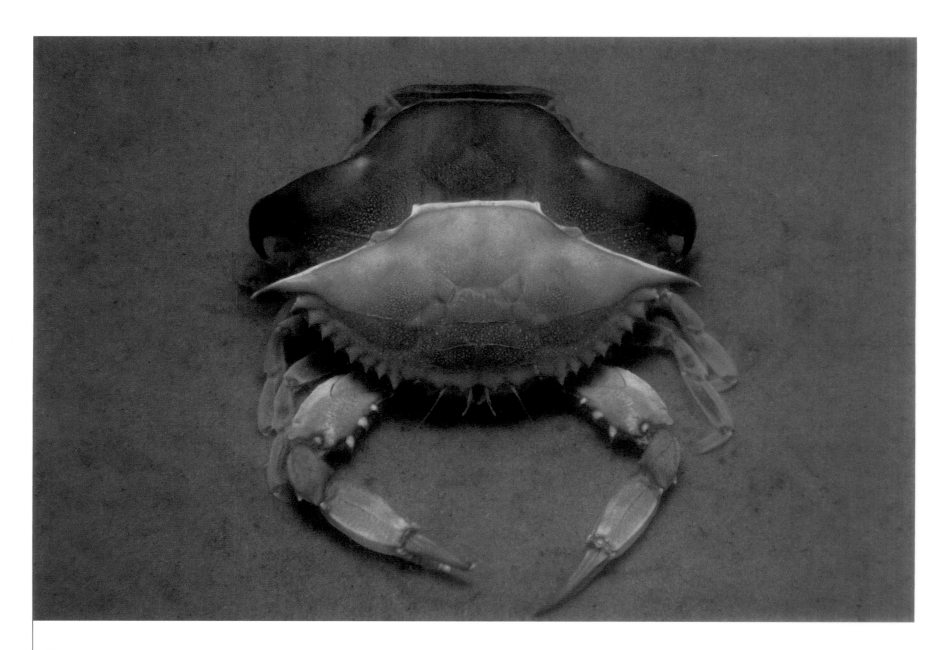

Blue crab molting, Lower Machodoc Creek, Coles Point, Virginia July 22, 2004 / Depth 4ft. / Temp. 68°F / Vis. 4ft.

James Allen has been crabbing in the Chesapeake Bay and the Potomac River since he was twelve years old. I met him when he was 87 and still crabbing, leaving his house every morning at 4 a.m..James was a wonderful old salt whose eyes lit up when he began to talk about his beloved blue crabs, which are an institution in these parts: "Back in the old days, the water was crystal clear and I could look down over my skiff and see the crabs on the bottom, 20–30 feet down. Nowadays, I can't see a thing 'cos of the pollution in the bay and the crabbin'

ain't what it used to be. I still go out because it's my life but I catch less and less crabs, and I'll cry like a baby if I can't do it no more." James showed us his catch of the day. "I keep them until they shed their hard shells, which they do 15 times in their first 18 months, and that's the soft shell crab people love to eat," he explained.

I spent a memorable day with this kind Southern gentleman. Most of the time we just watched and waited for the crabs to molt, until two of them finally did their thing at 8 o'clock in the

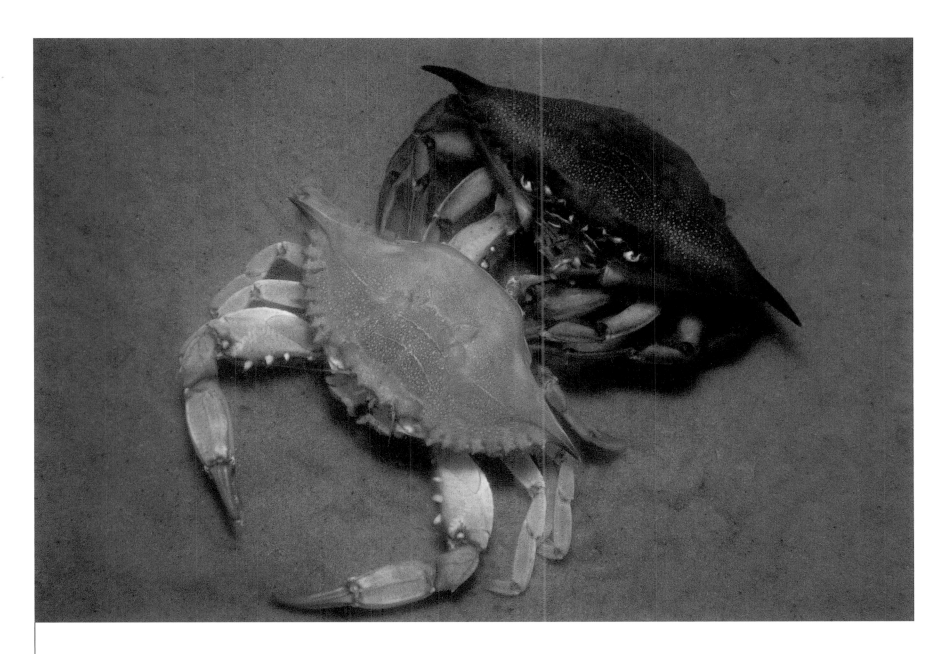

Blue crab molting, Lower Machodoc Creek, Coles Point, Virginia July 22, 2004 / Depth 4ft. / Temp. 68°F / Vis. 4ft.

evening. Within three minutes the crabs had shuffled out of their old shells. I photographed them in a holding tank four feet deep connected to the creek via a pipe. While we'd been waiting for the molt, James and I chatted. He told me some wonderful stories but this one took the biscuit. A friend of his was out fishing when he accidentally caught a crab, which for some reason he took a liking to and brought home. At first he placed it in the bathtub with an old washboard. The crab loved to walk up and down the board and jump off it. After a

while he and his wife decided to take the crab for a walk. They carefully placed a string around one of its legs and marched it down the street, much to the delight of the neighborhood—and the crab, apparently. At this point the blue crustacean had become a pet, so the couple named it Oscar, who was now allowed to wander around the house. When it came time for the morning walk, Oscar would always be waiting by the door. One day the man brought home some fellow blue crabs for dinner, and one fell out of the bag and dropped onto the

floor right in front of Oscar. That must've aroused suspicions, which were confirmed when the aroma of boiling crab began to waft from the kitchen. Oscar, who naturally didn't like the fact that his friends were on the dinner menu, began behaving differently after that traumatic experience. A few days later he had clawed his way through the screen door and was last seen scampering down the small pier before he jumped into the water, never to be seen again!

Decaying chinook salmon, North Umpqua River, Glide, Oregon October 22, 2003 / Depth 35ft. / Temp. 48°F / Vis. 8ft.

I literally stumbled across this group of decaying fish. Returning from the mountains, where I'd attempted to photograph some skittish trout, I stopped at the Roseburg dive shop. I asked Brian, the owner, where I might find some dead salmon—an odd request, you might well think, but death is a big part of the spawning drama.

Brian recommended I investigated the Colliding Rivers, where the deep waters of the North Umpqua River funnel into a natural water chute and meet the rapids of Little River head-on. He warned me, however, to stay close to the rocks on the east side when I jumped in, otherwise I would be going for a little ride down the chute. "You don't want to do that because you'll never work your way back up the strong current. You'll be stranded," he said, smiling.

The dive was indeed tricky. I had to clamber down a steep escarpment, cross a shallow, slippery creek, and then climb over a huge rock separating the creek and the river before sliding into the ferociously bubbling chute just below a small waterfall. No wonder some salmon never made it past this point.

I carefully slipped in and kept to the east side of the river as best I could. All along, though, I could feel the powerful waters pushing me to the west side. Not being able to see anything but bubbles, I surfaced to get my bearings. Sure enough, I was rapidly going in the wrong direction. In one quick frantic movement, I turned to the direction of the east side and dived back down. I hit the bottom beside the rock wall, just out of the current, exactly where I needed to be. And there, right in front of me was my prize—a group of perfectly arranged 40-pound salmon, brave but defeated.

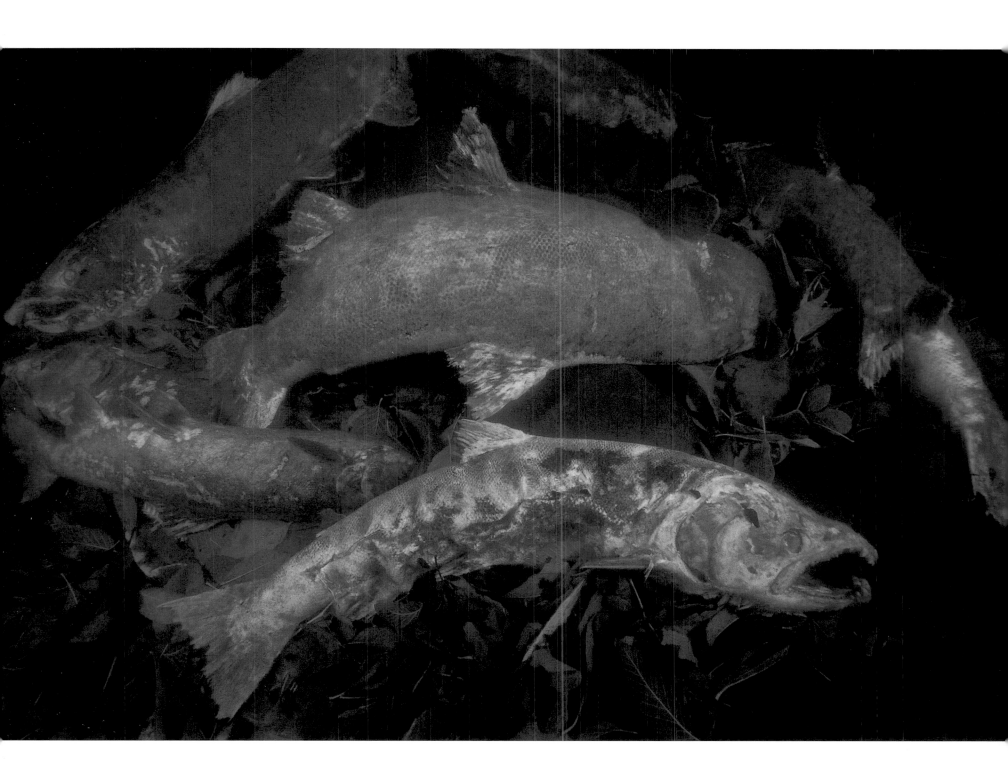

a photographer's

**Using the lighter tripod in
a Tennessee pond**

THERE IS NO GREATER pleasure for a photographer than capturing a one-of-a-kind image. For an underwater photographer, this can mean overcoming both poor light and bad water conditions. To have a chance at that rare shot, when skies are cloudy and there is sediment and floating plankton, you often need a heavy tripod and somewhere solid to park it, especially if using slow 100 ASA film. You might even find yourself in mud or silt, trying not to stir a grain as you plant your portable platform. In addition to the tripod, I usually carry two camera housings, which made me wish for three hands or a diving assistant—alas for this shoot neither were available. With all that weight you might imagine I would sink like a stone. However, because I was spending well over an hour in the water, if it was shallow enough, I would invariably be wearing a drysuit plus layers of undergarments for warmth during long periods of holding perfectly still, all of which made me buoyant

as a cork. To even things out, I wore 45 pounds of lead. Thus encumbered, I would carefully descend, and very gently sink my tripod into two feet of mud, all the while trying my best not to waft up the muck with my fins.

Sometimes, though, you can't help but make a mess setting up, and then you either have to wait, if you have the bottom time, or exit the water, take a surface interval, and return. Trying to make an available-light image inside a silty, deep-water wreck, where time is extremely limited, presents its own set of problems. You have to set up the tripod, compose the photograph, return to the boat, wait for everything to settle, and only then can you go back down and finish the shot. But all of the above form just part of the game, and when you actually come home with the image you had in your mind's eye, it is incredibly satisfying and rewarding, more so than any other type of photography I have done.

journey

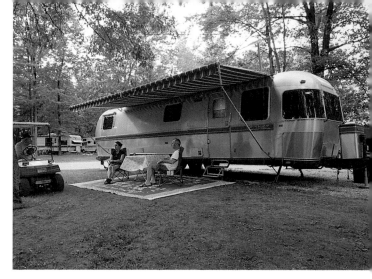

Chatting with Jesse at Sunset Lake, Indiana

Constantly attempting new techniques and following leads to unknown places inevitably meant that many ideas simply did not work. The great surprise was that these apparent nonstarters sometimes led to the best experiences, as when we attempted to find a hidden waterfall in the Cascade Mountains in Oregon. A park ranger gave us directions down a steep hill through dense brush to a trickling stream, which we followed through a fairyland forest covered in moss. It was the greenest green I'd ever seen. Even the ranger didn't know exactly how far it was to the falls, and as the afternoon faded to gloom, we were forced to turn back for fear of getting lost in the dark. Although the photography didn't pan out, it was one of the most phenomenal walks of the trip. At Cumberland Falls in Tennessee, we set out in quest of a "moonbow"—literally a white rainbow seen only at night when the Moon is full and the sky is clear, and there's enough spray at the top of the falls to catch the light. Sadly, the moonbow turned out to be moonshine that time, but who could regret such a night beside a raging river in the dark, waiting for the wonderful apparition to appear? I spent another magical night camping beside the Little Bighorn River with a view to capturing a split-level at dawn near the spot where General Custer met his demise. It was a long and thoughtful vigil while the wind howled through the trees all night—a wonderful experience even if the image didn't quite make the grade.

While the photography was consistently fraught with the possibility of failure, one of the great compensations was making new friends. We met such a diverse cast of characters across the land. What amazed me the most was the extraordinary kindness of strangers. Many a time I was calling people out of the blue and asking them if they would direct me to one of their local water spots. These strangers shared their time, and, on many occasions, their boats, and sometimes—the best times—would even dive with me. More than once we were invited home for a meal, which Hazel always loved because this meant she had a night off from cooking. In Pierre, South Dakota, the local dive-shop owner Tom asked us what we had planned for the Fourth of July. We could only shrug, because we'd just arrived. We spent that evening with Tom and his family, listening to tales of the olden days before the Oahe Dam was built and a sudden rise in the Missouri meant everybody had to close up shop and flee to the hills. After the stories, we all piled into Tom's boat and putted out into the middle of nearby Lake Oahe where we were treated to the town's fireworks display. A wonderful evening.

Without a doubt this book would never have been possible without all these people helping and sharing personal knowledge of their local areas. I am extremely grateful to all of you.

In the flooded forest at Lake Ouachita, Arkansas

Sea lion colony, Santa Barbara Island, Channel Islands National Park, California
November 25, 2003 / Depth 28ft. / Temp. 58°F / Vis. 35ft.

The only way to reach Santa Barbara Island in the middle of the week in the month of November was to hire a 30-person live-aboard dive boat for a day. This extravagance destroyed the monthly diving budget but I had no choice: it was "the place" to photograph sea lions. We boarded at midnight for the 46-mile crossing of the San Pedro Channel.

After a bumpy night running directly into the swell, I awoke to the clanking of the anchor chain and to the sun rising over the uninhabited—but hardly deserted—island. Directly in front of us was the rookery, a protective cove covered with some 2,000 sleeping, groaning, and barking dogs of the sea, most of them half-grown pups, the "teenagers" of the colony. One young sea lion was already circling the boat; it surfaced and looked my way as it passed by.

The Captain interrupted my momentary nirvana with the disturbing news that the tide would change in an hour and the visibility would drop considerably. Suddenly my four-hour shooting window had been cut to 45 minutes. I shifted from my sleepy bliss to overdrive. Within minutes I was in 30 feet of morning-blue Pacific water swimming toward the sea lions' "daycare center".

I decided to kneel in the sand and wait. At first the occasional sea lion swooped down to check me out. It stopped, blew bubbles, and took off to tell its buddies they had a visitor. Slowly but surely, more of these playful creatures appeared until there must have been a hundred around me. It was wonderfully chaotic. They darted, turned circles, hugged each other, and came right at me, only turning away at the last second. I had a blast, enjoying their exuberance and mischievous sense of humor.

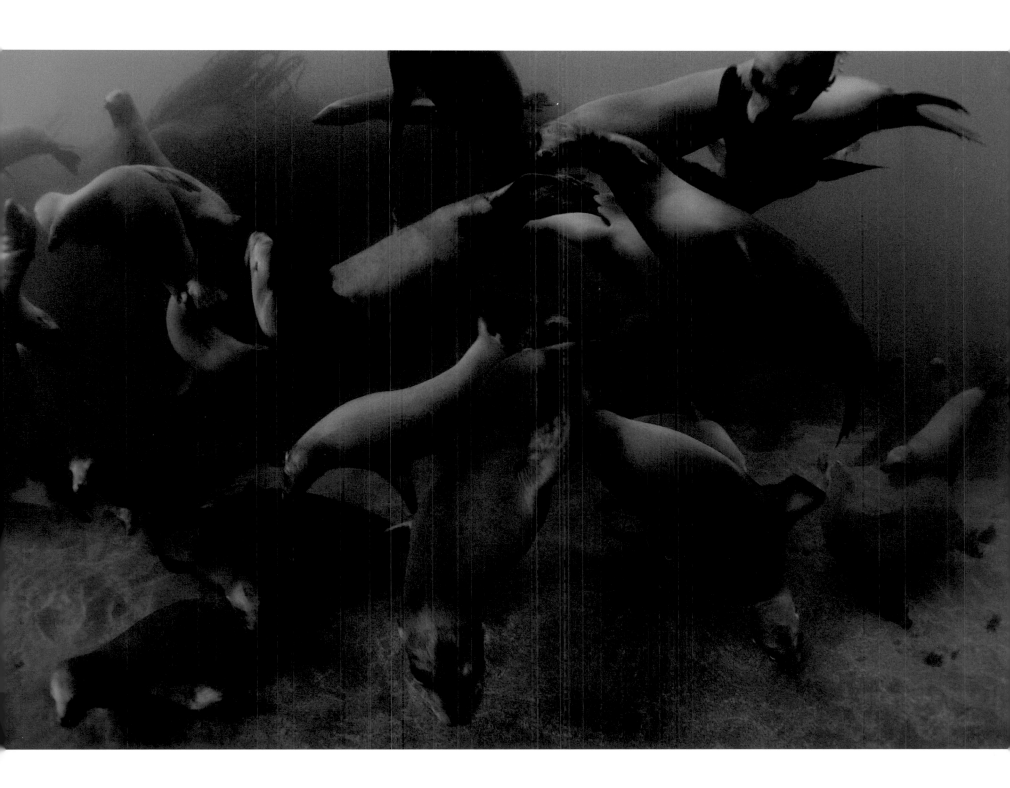

Giant kelp, Point Lobos, Monterey Bay, California November 6, 2003 / Depth 62ft. / Temp. 54°F / Vis. 25ft.

Along with Sergeant York, giant kelp is another, lesser-known American hero of World War I. Between 1911 and 1919, the high cost of potash induced many companies to feverishly harvest the "redwoods of the sea" from Santa Barbara to San Diego. Copious amounts of explosives were produced by extracting potash and acetone from the kelp—a great boon to the war effort. Today kelp harvesting is strictly regulated, an absolute necessity for the well-being of California's coastline, since the forests have decreased by approximately 80 percent in the last 30 years. Those that remain, though, remain magnificent—mysterious in their shaded gloom, and pulsing with life because they are home to more than 800 species. There is nothing quite like diving in a kelp bed, sheltered under the tangled canopy of fronds floating at the surface, then navigating the towering, thick stalks, which can grow as much as 18 inches a day and up to 200 feet in height. When the Pacific Ocean's swell is so powerful it reaches down to the seabed floor, the blades by the holdfasts, or roots, can be seen rhythmically swaying in an ancient water dance.

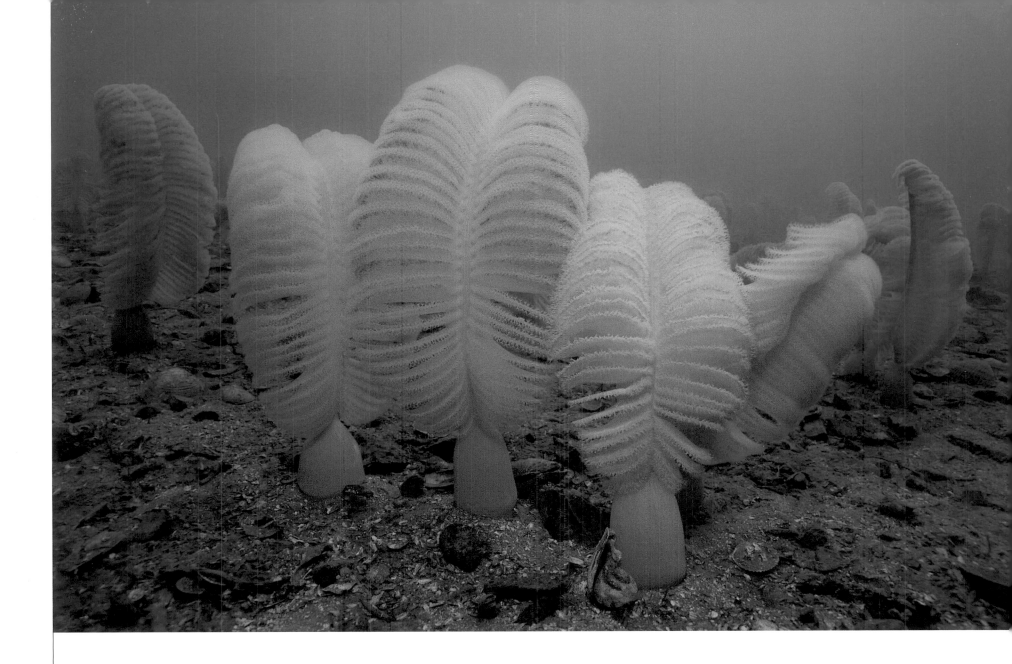

Sea pens, Excursion Inlet, Icy Strait, Alaska March 14, 2005 / Depth 51ft. / Temp. 37°F / Vis. 30't.

With more coastline than the rest of the United States combined, Alaska is the perfect place to adventure dive. When my Far North dive buddy, John Lachelt, suggested we stay in a log cabin at the north end of Excursion Inlet and do some exploring, I jumped at the chance—there's nothing I enjoy more. Besides the opportunity to see mega-fauna such as a 400-pound halibut, the aquatic flora is so other-worldly an entire dive could be spent gaping at the growth on a sloping mud bottom. After a full morning of dives, John and I were freezing, having spent two hours in the 37°F water, which sucked the warmth right out of our bodies. The thought of a third dive was unappealing, but during our surface interval a humpback whale cruised on by which stirred my emotions, and restored my circulation. We hit the finger-numbing water for the final time, and after 30 minutes, stumbled across a cluster of quill-like sea pens around two feet tall. It was the most extensive garden of sea pens I had seen anywhere in all my Alaskan dives.

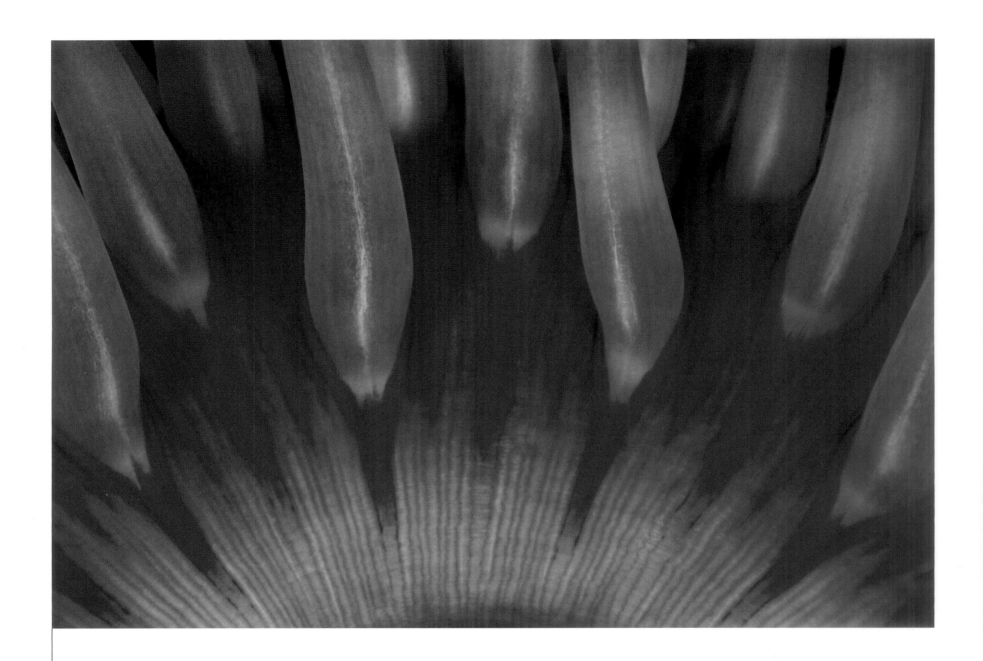

Sea anemone detail, Waddah Island, Neah Bay, Washington October 5, 2002 / Depth 60ft. / Temp. 45°F / Vis. 35ft.

This flowerlike relative of the jellyfish can vary in size depending on what food is on offer. At Waadah Island the rocky reef was so healthy and rich with life that the anemones were ten inches across and eight inches tall. Lovely as it may appear, the anemone is a proficient predator whose sturdy tentacles are capable of paralyzing small fish and shrimp with their stinging capsules, called nematocysts. After I finished my roll of film I saw a fish nestle into the circular disk. It must be suicidal, I thought. Didn't it know this was a fish-eating carnivore? I was waiting for the inevitable but it never happened. I realized there must be some kind of relationship going on, and later discovered that the painted greenling is the only fish on which the anemone bestows the privilege of its hospitality.

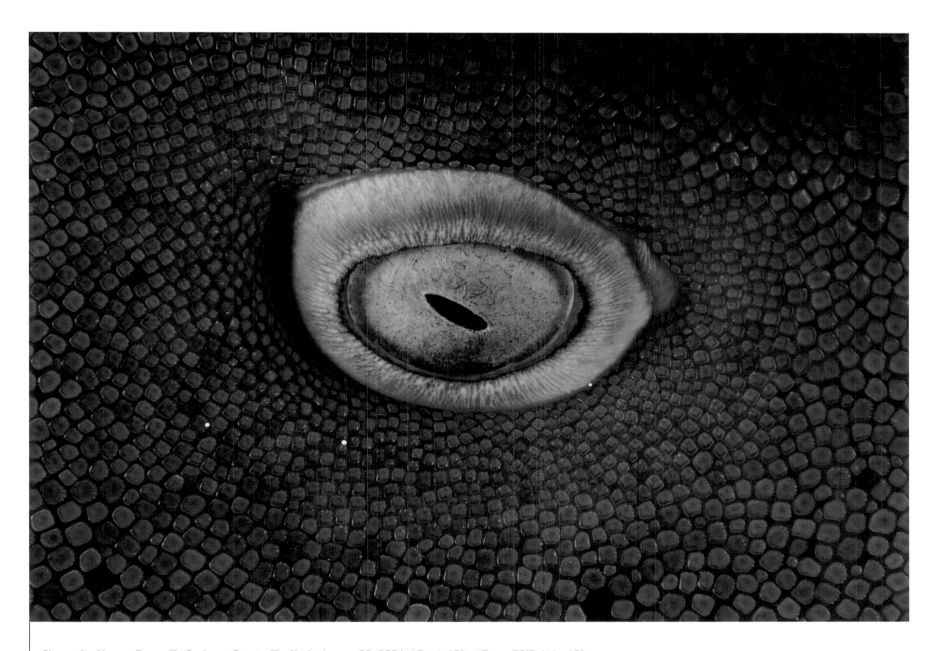

Nurse shark's eye, Bonneville Seabase, Grantsville, Utah January 23, 2004 / Depth 15ft. / Temp. 70°F / Vis. 10ft.

If someone had told me I would be photographing nurse sharks in the west desert of Salt Lake Valley, almost a thousand miles away from the nearest shoreline, I would have thought they were pulling my leg. But there I was in a natural hot spring, 4,293 feet above sea level, looking at three large nurse sharks. How did they end up here? In the late 1980s, Linda Nelson and George Sanders, the owners of a Salt Lake City dive shop, had grown tired of hauling their students all the way to Blue Lake, a three-hour drive away. The couple began searching for an alternative location closer to home and found a series of saline hot springs outside the small town of Grantsville, an area which eons ago formed the bed of giant Lake Bonneville. The ponds were enlarged for diving and, because the water was almost as salty as the sea, became an orphanage for unwanted aquarium fish. Since then the marine menagerie in Utah's "inland ocean" has steadily grown, and now nearby divers don't have to travel far to see tropical fish or to stare into the mysterious eye of a nurse shark.

Elvis Presley's swimming pool steps, Graceland, Memphis, Tennessee March 25, 2003 / Depth 4 ft. / Temp. 50°F / Vis. 25ft.

When I contemplated Tennessee, Graceland kept popping into my head. No wonder, of course: other than the White House, Elvis's pad is the most famous home in America, with more than 700,000 visitors each year. Like those pilgrims, I too have been enthralled by the history of rock and roll, and seen many photographs of Elvis chilling in his colonial-style mansion. Apparently he spent a lot of time in and around the 1939-vintage swimming pool. With his frenetic life, the pool must have been a miniature oasis for the King and his family. Lying submerged in the personal watering hole of the most important rock and roll artist of the twentieth century, I remembered something Bruce Springsteen had said: "It was like Elvis came along and whispered some dream in everybody's ear, and somehow we all dreamed it." I imagine a lot of that dreaming took place right here in the pool.

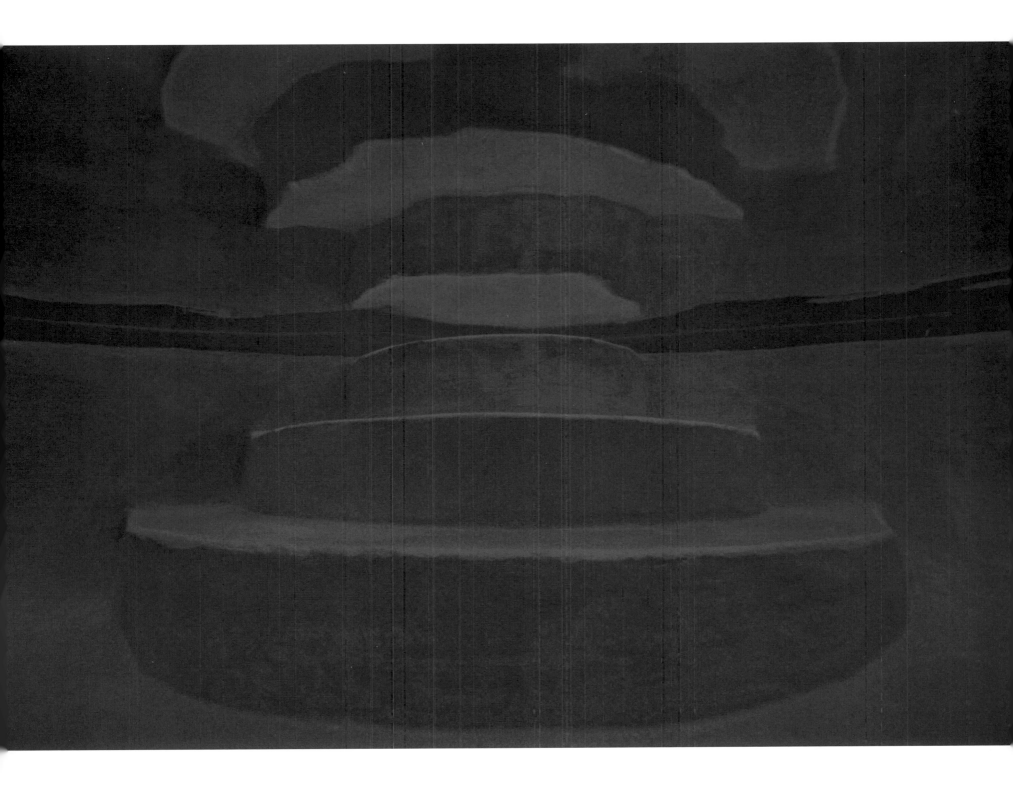

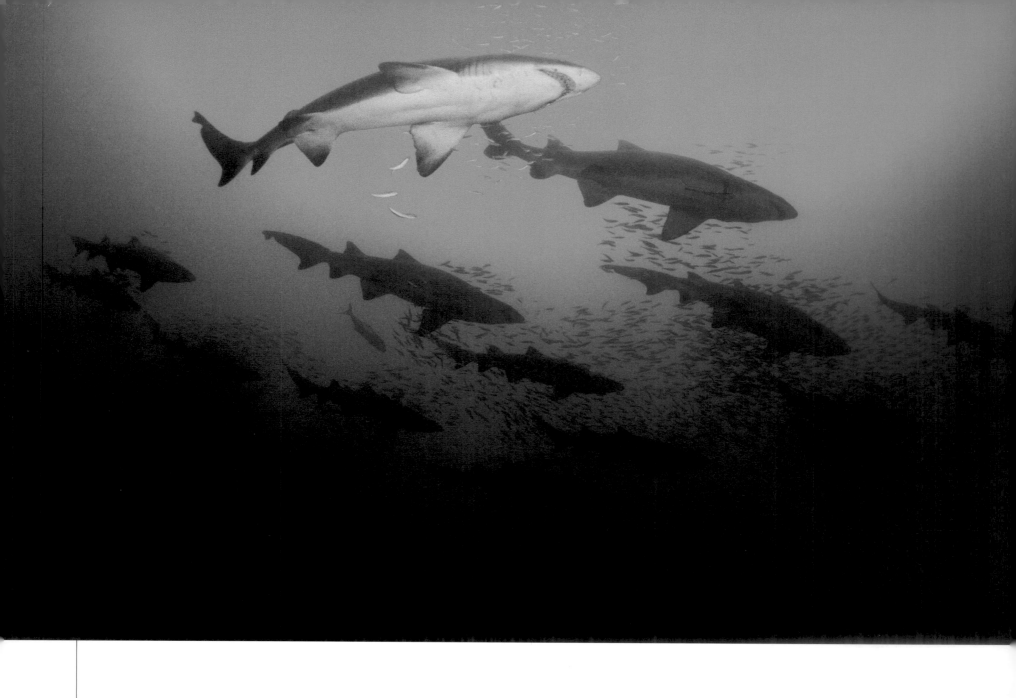

Atlantic sand tiger sharks, the *Proteus* wreck, Atlantic Ocean, North Carolina May 28, 2005 / Depth 121ft. / Temp. 73°F / Vis. 70ft.

The coast off North Carolina is called the "Graveyard of the Atlantic" and for good reason. Since records began in 1526 more than 2,000 ships have been lost due to Nature, war, and piracy. The *Proteus* was a World War I casualty. On the night of August 19, 1918, the *Proteus* and the SS *Cushing* were observing the recommended practice of running without

any lights so as not to attract the lurking German U-boats. Both captains saw the other ship too late and the *Cushing* rammed into the side of the *Proteus*. The *Cushing* survived and picked up the crew and passengers of the *Proteus*. No lives were lost. The wreck is now one of the sites in the vicinity to encounter an impressive school of sand tiger sharks. On

the dive I went straight for the stern, where the beauties usually hang out. Sure enough there they were, moving lazily around. There had to be at least 80 of them—as many as 200–300 have been spotted here at one time. Imagine being in 121 feet of water surrounded by sharks. It is an underwater photographer's heaven.

Blue-eyed darner dragonfly, the Blue Hole, Santa Rosa, New Mexico
August 17, 2005 / Depth 3ft. / Temp. 61°F / Vis. 60ft.

On our way from Arizona to Texas, we stopped at the Blue Hole. New Mexico was already "in the bag," so this brief side trip was really more of a pilgrimage to one of my favorite desert watering holes. I really didn't expect to find any new images, just needed to do some documentary video for future lectures. At the end of the dive, I came across a dragonfly floating on the surface. Hazel quickly passed me the macro setup and I honed in on the world's fastest insect. To my surprise it didn't fly away. I kept shooting. It still didn't budge. I couldn't believe it—this dragonfly was one cool customer. When I had finished shooting, I gave it a very gentle nudge to see if it was in trouble. Well, it was more than in trouble. The poor creature was dead.

Red mangrove, Tarpon Basin, Everglades National Park, Key Largo, Florida
October 8, 2004 / Depth 2ft. / Temp. 82°F / Vis. 30ft.

Mangrove forests contribute to the overall health of Florida's southern coastal zone. The "walking trees" provide a nursery for a wide variety of marine species and protect upland areas from flooding and eroding waves. This tranquil environment was the first National Park (1934) preserved primarily for its abundance and variety of life, as opposed to scenic or historic values.

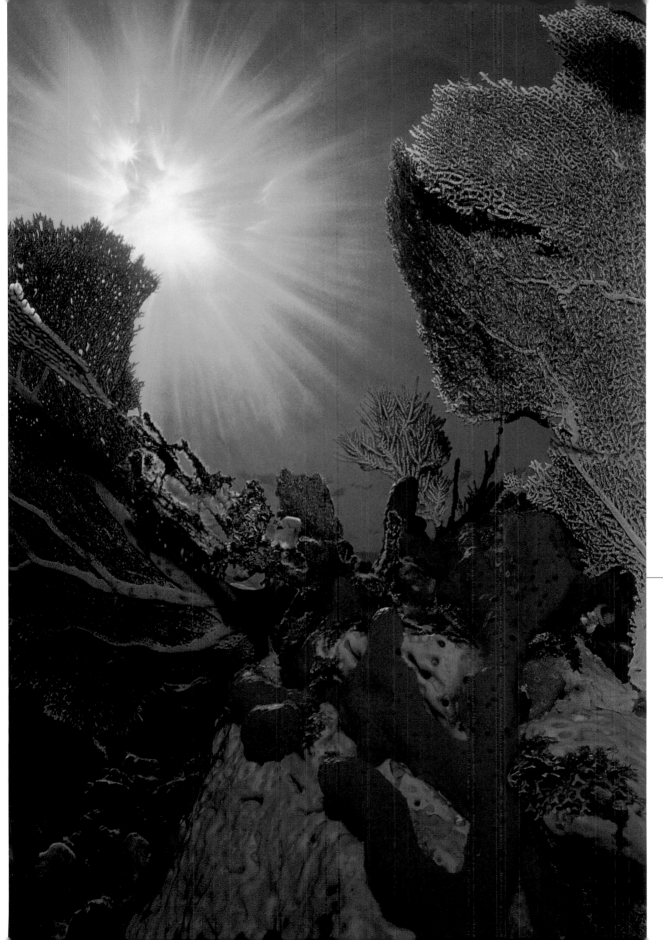

French Reef, John Pennekamp Coral Reef State Park, Key Largo, Florida
August 1988 / Depth 22ft. /
Temp. 82°F / Vis. 80ft.

My very first ocean dive was in John Pennekamp, America's first underwater park. I was 21 and it absolutely overwhelmed me. I just couldn't believe there was something as beautiful on Earth as a coral reef. This photograph was taken years later, while I was down in the Keys for a weekend break, on one of those special days when the weather was absolutely perfect—a flat calm sea and a brilliant sun, without a cloud in sight.

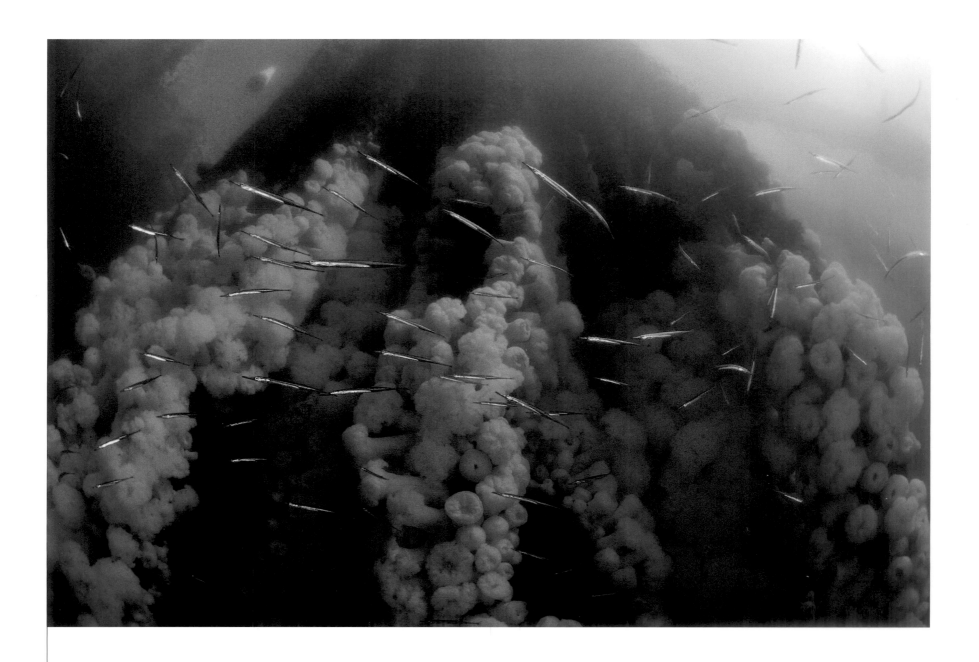

Tube snouts and plumose anenomes, the Pilings, Titlow Beach, the Tacoma Narrows, Washington September 24, 2003 / Depth 20ft. / Temp. 54°F /Vis. 20ft.

Call it an urban beach dive. From my parking space by a small park, I had to cross several railroad tracks and then navigate slippery concrete steps to the rocky beach. I had to hurry, too, to catch the slack tide and avoid rush hour—the vicious tidal current. After a brief swim, I found myself among old ferry dock pilings covered in plumose anemones basking in the morning sunlight. A school of perch cruised calmly past, and scuplin sat on the rocks staring indifferently at me, while a seagull slowly drifted along on the surface above. For a location that did not look particularly inviting from the shore, it turned out to be a real walk in the park, with all sorts of sub-aquatic citizens of the Northwest, such as these tube snouts, which thrive in the nutrient-rich water of the Puget Sound.

Tractor tires with largemouth bass and its young, Sandy Channel State Recreation Area, Nebraska June 15, 2003 / Depth 17ft. / Temp. 64°F / Vis. 15ft.

A few miles from the Platte River, which crosses the entire state of Nebraska, are 47 acres of shallow lakes. These serendipitous pools were inadvertently created in the 1950s by the construction of Interstate 80. The great gaping holes gouged by earthmovers soon filled with natural spring water and have become a natural habitat for wildlife like beaver, fish, and turtles. They have attracted divers, too, who have placed sunken boats, a concrete turtle, and the regionally appropriate tire tractor sculpture into one of the lakes.

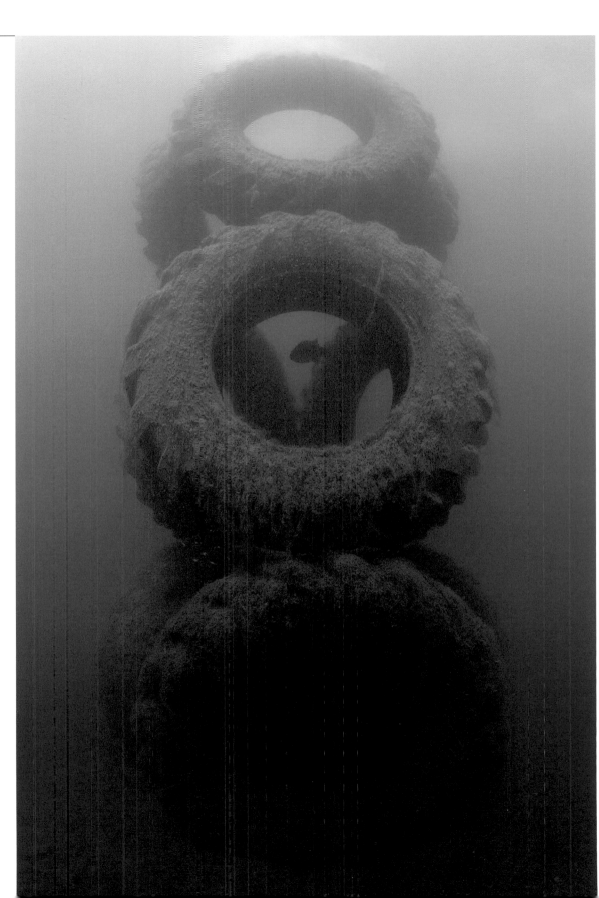

Wild pikeral, Spitfire Lake, The Adirondacks, New York July 2001 / Depth 1ft. / Temp. 60°F / Vis. 1ft.

My first experience of American water was as a six-month-old baby, when my parents placed me in my great-grandfather's old Garwood boat. The gentle rocking water of Upper St. Regis Lake instantly put me to sleep, no doubt allowing my mother a much needed break. Many years later I returned as an adult to discover a special place in the Adirondacks. Now I go whenever I can. My last visit was during preproduction for the project, when I found a colony of wild pikeral in a winding channel that joins Lower St. Regis Lake to Spitfire Lake. Both my great-aunt Alicia and my godmother Christina would have been pleased I had managed to include a place very dear to their hearts.

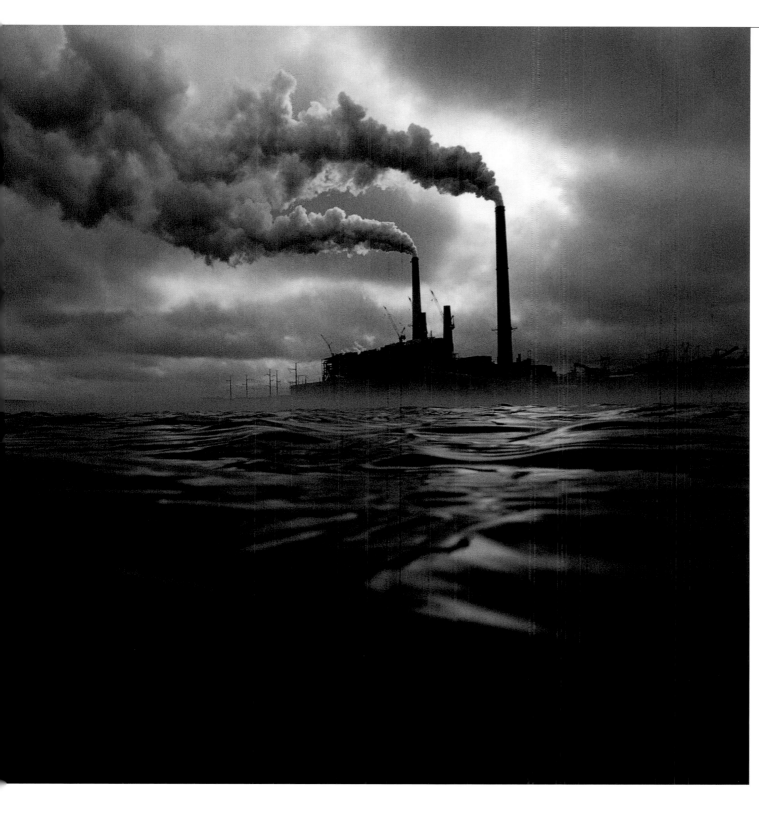

**Hydro and fossil power station,
Mt. Storm Lake, Allegheny
Mountains, West Virginia**
October 20, 2002 / Depth 1ft. /
Temp. 80°F / Vis. 20ft.

Mt. Storm Lake lies 3,244 feet above
sea level in the Allegheny Mountains.
In 1962 the Virginia Electric and
Power Company created a lake
132 foot deep on the Stony River
to serve as a "cooling pond" for the
power station's massive generating
units, which provide electricity to
more than two million customers.
These units, which use limestone
scrubbers to keep the air quality
within legal limits, are so powerful
and become so incredibly hot they
require 234,000 gallons of water per
minute pumped through the plant to
keep them cool. All this sophisticated
technology provides a surprisingly
warm recreational area. However,
because of the altitude there is an
annual 35° temperature shift from
60–95°F. Therefore, only the hardiest
of fish, such as catfish and bluefish,
live here. I knew the water would be
comfortable but I was so accustomed
to wearing my drysuit I instinctively put
on the unnecessary garment, much to
the bewilderment of onlooking divers.

Quarry steps, Dutch Springs, Bethlehem, Pennsylvania July 1997 / Depth 60ft. / Temp. 60°F / Vis. 30ft.

It seems that every quarry really wants to be a lake when it grows up—some more so than others. The National Portland Cement Company experienced these growing pains from the beginning with their Bethlehem pit. As soon as they began mining limestone in 1935, the quarry stubbornly began to fill with spring water, which the company stubbornly pumped out. When operations ceased in the mid 1970s, the quarry, at 100 foot deep, had no trouble becoming a 50-acre lake. Today it is one of the largest freshwater diving facilities in the country, complete with such *de rigueur* accoutrements as a Sikorsky helicopter, Cessna airplane, and a trailer truck, where the bass play. These once high-and-dry steps used to take the miners up the quarry wall to the plant; now they lead divers back to the surface of the lake.

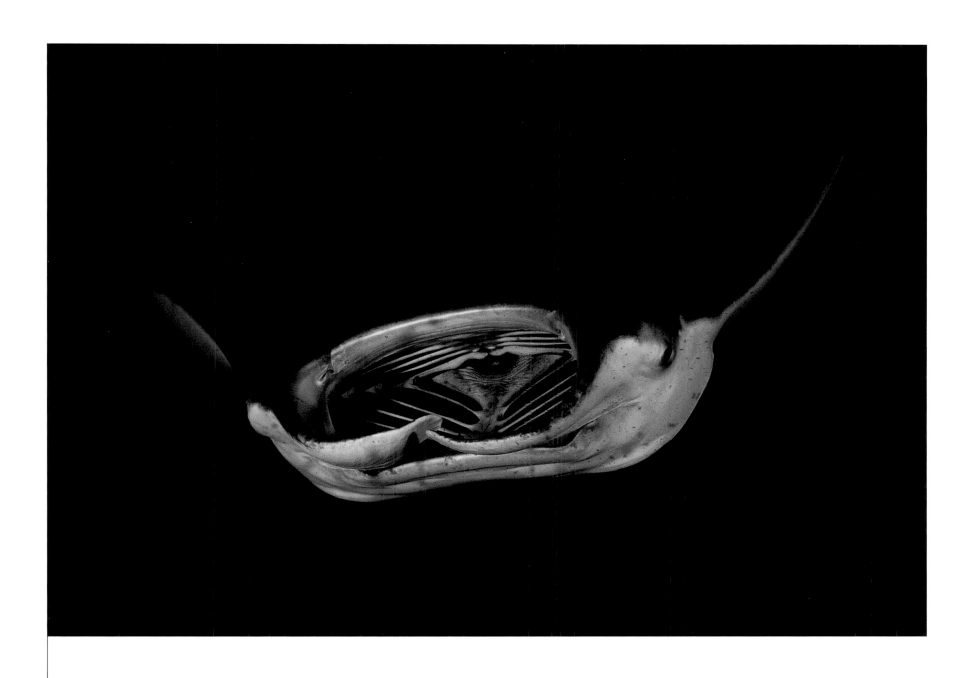

Manta ray feeding, Garden Eel Cove, Nr. Kona, Hawaii / January 28, 2005 / Depth 25ft. / Temp. 78°F / Vis. 40ft.

In the early 1980s the Kona Surf Hotel had a large, bright light shining into the water. Without realizing it the hotel had created a manta ray feeding station. The lights attracted the plankton, which in turn attracted the mantas, and by 1984 the manta night-dive was born. By the time I jumped into the dark water of Garden Eel Cove on my birthday, the dive had been finely tuned with the aim of protecting the animals. A group of strong lights are placed in a plastic basket on the bottom before the dive, allowing the plankton to accumulate. Then divers circle the lights and wait for the natural show to commence. On my first night one manta appeared early, just beneath the boat. I eased into the blackness and had a phenomenal one-on-one experience, mesmerized by this animal with a 10-feet wingspan doing somersaults in front of me. Then the acrobatic Hahalua (the apt Hawaiian name) circled around and swooped down with its cavernous mouth wide open. It was a great birthday present.

Rainbow trout, Gilboa Quarry, Ohio
June 16, 2004 / Depth 35ft. /
Temp. 58°F / Vis. 30ft.

On our way to Ohio from Indiana, we drove through one picture-perfect farm town after another on Provincial Route 114. As we drew close to Gilboa, we noticed cornfields flooded by the Blanchard River, courtesy of the recent, torrential rainstorms. Not a good sign for an underwater photographer who needs decent water clarity. However, I was pleasantly surprised to find visibility at the old limestone quarry to be still pretty good. The first five feet were milky, which ruled out a search for the paddlefish and the imported koi, but beyond that depth I could see 30 feet down to the school bus, my rendezvous point with the rainbow trout. "Just tap on the bus and they'll appear," were my instructions from Judy, who owns the quarry with her husband Mike. I kneeled on the top of the bus and banged. Within a minute I was surrounded by hungry fish, circling like sharks, waiting for a handout I didn't have.

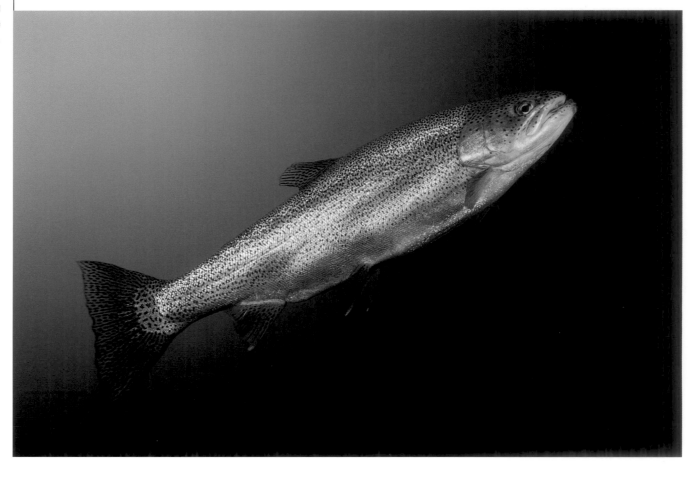

Striped bass, Seneca Lake, New York August 17, 2001 / Depth 22ft. / Temp. 74°F / Vis. 25ft.

By the middle of summer, the hydrilla grows so dense and high it creates a formidable green barrier for anything less nimble than a snake wanting in or out of the lake. Local dive instructors Pam and her husband Steve have to hack through it like *macheteros* to create a path for their divers. But just beyond the hydrilla line there's a sunken couch where they can kick back and conduct scuba lessons. Fish, such as this striped bass, use the path as their own personal highway to and from the shoreline of this glacial lake, which stretches 38 miles in length, and drops to 618 feet deep.

American lobsters, Iron Bound Island, Frenchman's Bay, Maine September 17, 2002 / Depth 55ft. / Temp. 50°F / Vis. 20ft.

As if about some urgent business, the lobster scurried over green sea urchins, past northern sea stars, and across the rocks, which were encrusted with purple coralline algae. For a second the crustacean stopped, giving me just enough time to move in for a close-up.

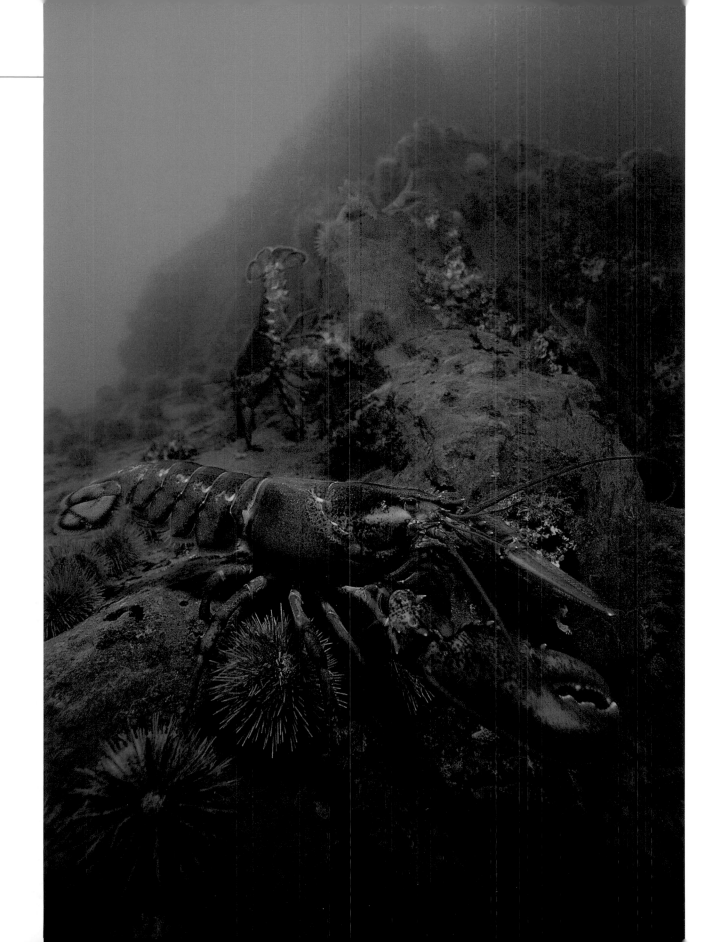

**The scroll figurehead of the *Sandunsky*
wreck, Straits of Mackinac, Lake
Michigan, Michigan**
June 13, 2005 / Depth 72ft. /
Temp. 46°F / Vis. 40ft.

Of the hundreds of discovered shipwrecks in
the Great Lakes on which diving is permitted,
the *Sandunsky* is the oldest, and one of the
most tragic. It went down on September
20, 1856, in a violent storm; all seven men
on board lost their lives. The rare ram's-
head figurehead is quite magnificent to see,
even though it's a replica. Some unsavory
characters damaged the original when they
attempted to steal it, and that carving is now
in the Michigan Maritime Museum in South
Haven for safekeeping and conservation. The
replica—thanks to the Ford Seahorses Club—
offers divers a view of the craftsmanship of
yesteryear.

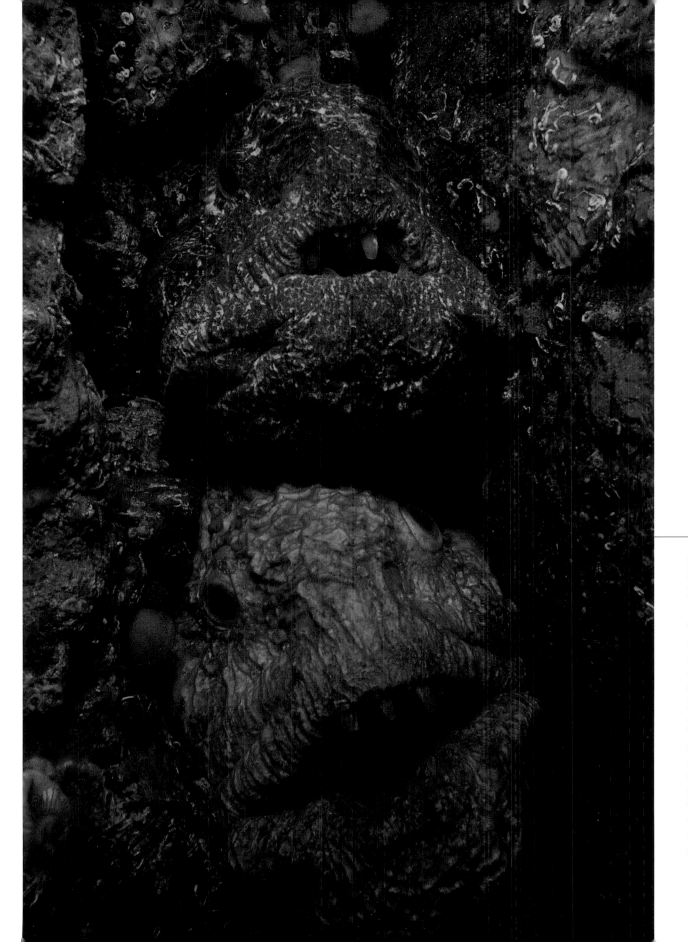

Male and female wolf-eels, Corrine's Reef, Kamishak Bay, Alaska
August 1994 / Depth 91ft. / Temp. 40°F / Vis. 15ft.

These fierce-looking fish are actually quite docile and shy. They spend their days peacefully in their cozy den and venture out at night in search of crabs, mussels, and sea urchins to crunch with their powerful jaws and large canine teeth. A wolf-eel pair appear to mate for life. Two form a bond at about four years of age, and the happy young couple find a convenient dark crevice in the rocks to slide their slender bodies into, sometimes remaining for their entire lives. So who's who here? Both genders are orange when young. As they mature toward a length of seven feet, the male will turn gray and the female brown.

SAFETY FIRST

THINK BEFORE YOU ACT

The pilot house, *Chester A. Congdon* wreck, Isle Royale National Park, Lake Superior, Michigan June 17, 2005 / Depth 109ft. / Temp. 41°F / Vis. 40ft.

At 2:28 a.m. on November 6, 1918, the *Congdon* left Fort William, Ontario, Canada, with a cargo of wheat, destined for Port McNicholl. A heavy sea was whipped up by a southwestern gale, and at 4 a.m. Capt. Autterson was forced to retreat 8 miles and anchor in the calmer water of Thunder Bay. By 10:15 a.m. the wind had diminished and the 532-foot-long steel bulk freighter ventured out again, only to be engulfed by thick fog. At 10:40 a.m. the captain decided to continue cautiously, if blindly; he set a course for Passage Island, off the eastern end of Isle Royale, with the intention of running for two and a half hours, and then stopping if the fog persisted. However, these mental calculations proved incompatible with the rock-hard realities lurking within the fog. The *Congdon* eased past Passage Island without hearing the fog signal and steamed toward the shallow reef of Canoe Rocks, where she ran aground. The gale force winds of the next two days broke the *Congdon* in two. The stern with the pilot house sank into deep freshwater, where it is well preserved to this day.

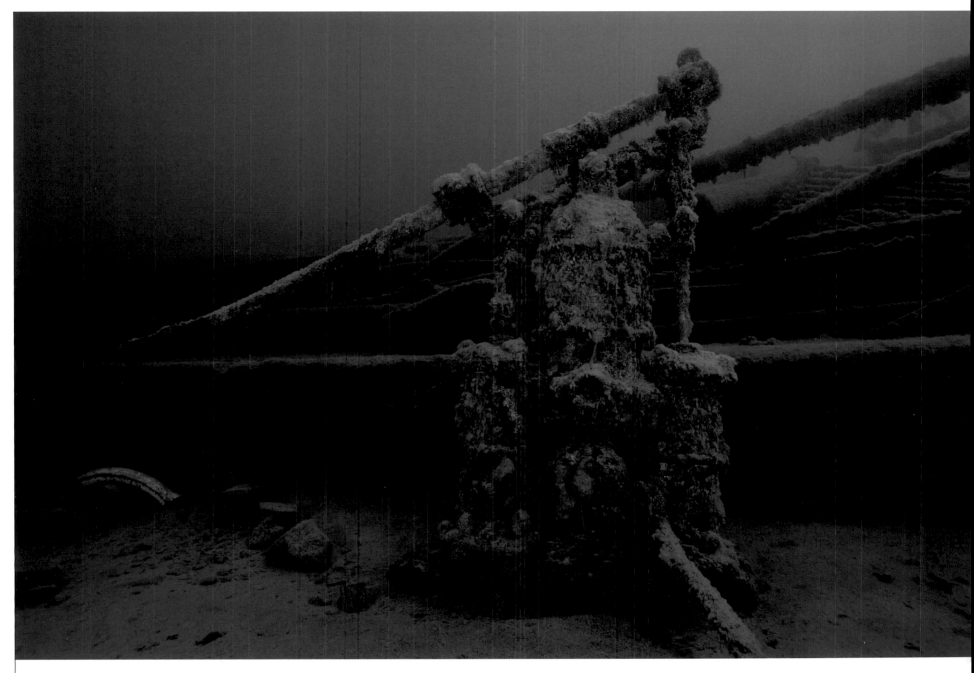

Water pump, the *Monarch* wreck, Isle Royale National Park, Lake Superior, Michigan 18 June, 2005 / Depth 64ft. / Temp. 40°F / Vis. 40ft.

The 1890-vintage *Monarch*, loaded with cargo and passengers, departed Sarnia, Ontario, for Fort William at 5:25 a.m. on December 6, 1906, on her last trip of the year. She was heading straight into the face of a northwest wind, a blinding snowstorm, fog, temperatures below zero, and heavy seas. About four hours later the 259-foot-long vessel plowed full speed into the solid rock cliff of The Palisades on the northeastern side of Isle Royale. The cause of the calamity was never firmly established, but it most likely was a combination of the abominable weather and a frozen taffrail log, which indicated an incorrect distance traveled. For the crew and passengers, the worst was yet to come. They had to endure freezing conditions for four days before they could be rescued. Nowadays the shipwreck lies in 50–70 feet, with many such artifacts scattered about as a bathtub, china, a pitcher, and this manually operated water pump.

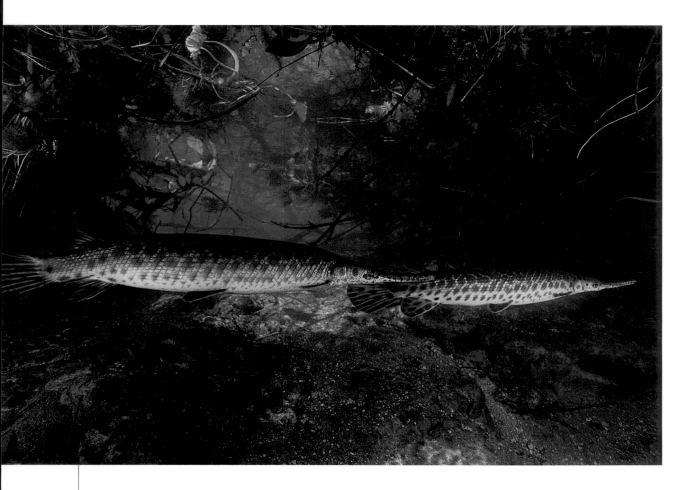

Spotted gar, San Marcos River, Texas February 22, 2003 / Depth 5ft. / Temp. 72F / Vis. 20ft.

Even before the trip began, this distinctive-looking fish that grow 3–4 feet long was on my "shoot list." In Lake Ouachita, Arkansas, a school of gar swam above me, but I saw them too late and once they caught my movement, the skittish fish took off. That missed opportunity just made me more determined to capture them on film. During my first day of diving in the San Marcos River, I found the odd one ensconced deep in the vegetation but there was no way I could creep close to

it. I returned to the same area the next day to photograph the Texas wild-rice. Just as I was setting up, two spotted gar swam upstream in the half-knot current. I turned but again was too late. I quietly followed them from a distance, even though I felt it was a lost cause. To my amazement they stopped swimming and glided back in the current, directly in front of me. There was time to push the camera button twice before they resumed their journey upriver.

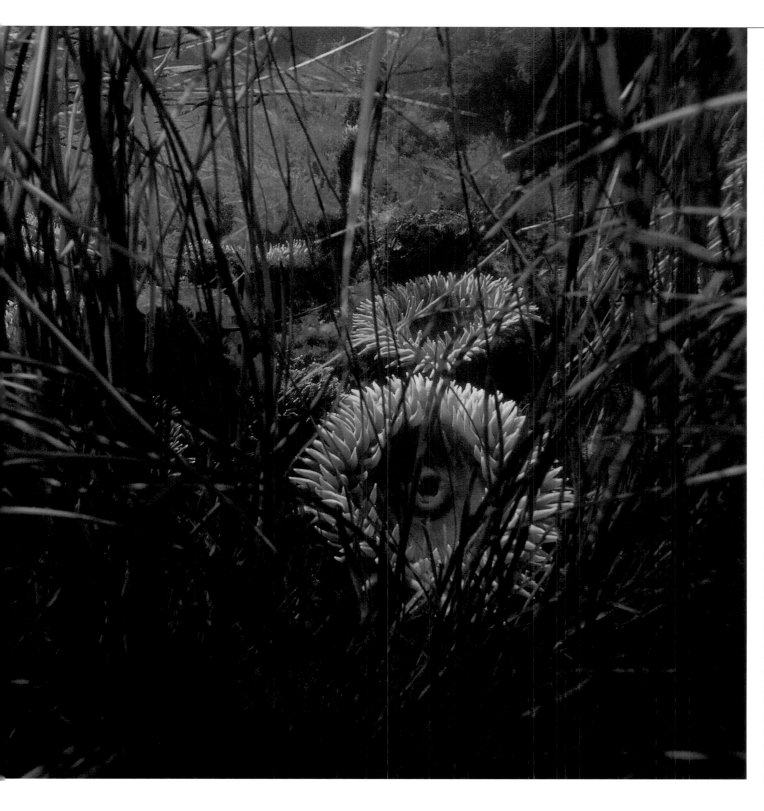

Tidal pool, Seal Rock, Oregon
July 4, 2005 / Depth 2ft. /
Temp. 64°F / Vis. 7ft.

When I arrived in Newport, Oregon,
I had just finished one of the most
intense months of the entire project.
In 33 days I had driven from the east
to the west coast, traveled more
than 8,000 miles (2,300 by plane
from Minnesota to Georgia and back),
worked in six states including many
days of deep, cold-water wreck dives
in the Great Lakes, and in the previous
15 hours I had hauled the rig 800
miles from Montana to Oregon, which
was the longest nonstop run of the
expedition. I was in the zone and it was
exhilarating.

Reaching the west coast for the
final time was a major milestone for
Hazel and me. It meant the beginning
of the home stretch with only two
months on the road to go. After
traveling for 26 months was I tired? Of
course, but I was enjoying myself far
too much to let this interfere with my
quest. And at this point it was to find
the finest tidal pool, one vibrant with
life, something the northwestern coast
is renowned for.

I chose Seal Rock, a classic
Oregonian beach, wide and sandy
with a series of rocks jutting out of
the water near the shore producing a
small bay. The bedrock was exposed in
the shallows, which created a prefect
habitat for a tidal pool ecosystem.
When I stuck my mask into the first
pool, I was thrilled to see a thriving,
pristine environment, probably still
as rich as when the Chinook tribe
found their plentiful sustenance in
these coastal waters. Surf grass
was prevalent, swishing back and
forth over the giant green anenomes
as water surged through the rock
crevices. The Native Americans called
the area Seal Illahe, meaning seal
home. And yes, there were plenty of
seals lolloping around the rocks.

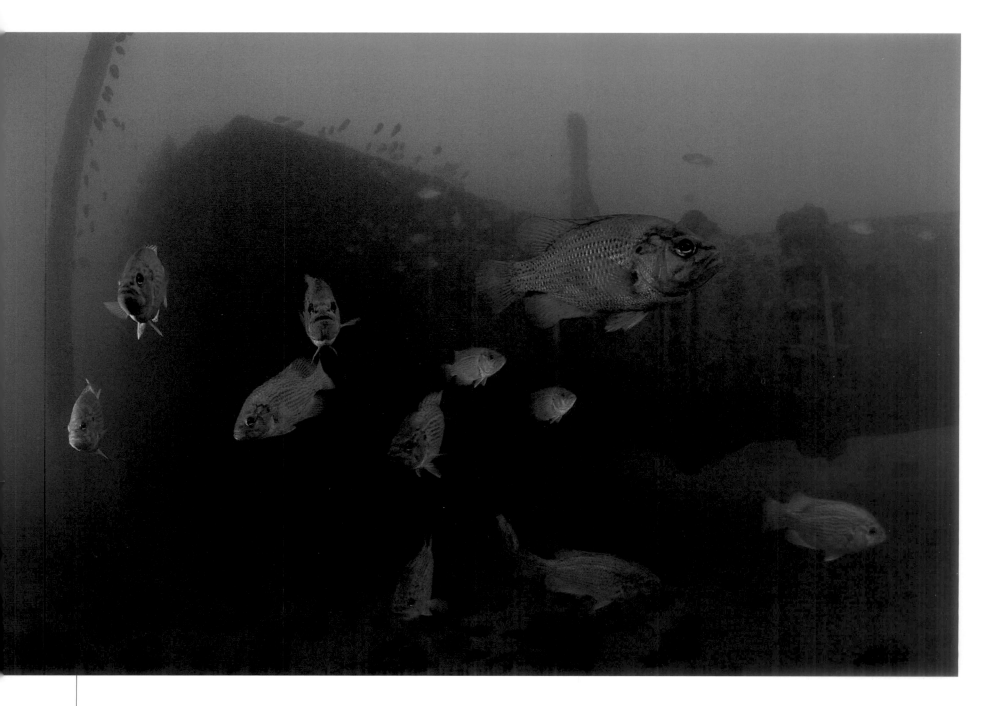

Rock bass by water intake pipe, Skaneateles Lake, New York August 15, 2001 / Depth 28ft. / Temp. 70°F / Vis. 50ft.

Skaneateles Lake is one of the 11 Finger Lakes in upstate New York. At 14 miles long, and averaging just three-quarters of a mile wide, it is a classic narrow glacial lake courtesy of the most recent Ice Age. Apparently Skaneateles, meaning "long lake" in the Iroquois tongue, is one of the cleanest lakes in the world, holding water of such high quality that the city of Syracuse and some nearby villages use it unfiltered—hence the massive pipe in the photograph. A school of rock bass always congregate near the intake valve where the slight suction brings food toward the waiting fish.

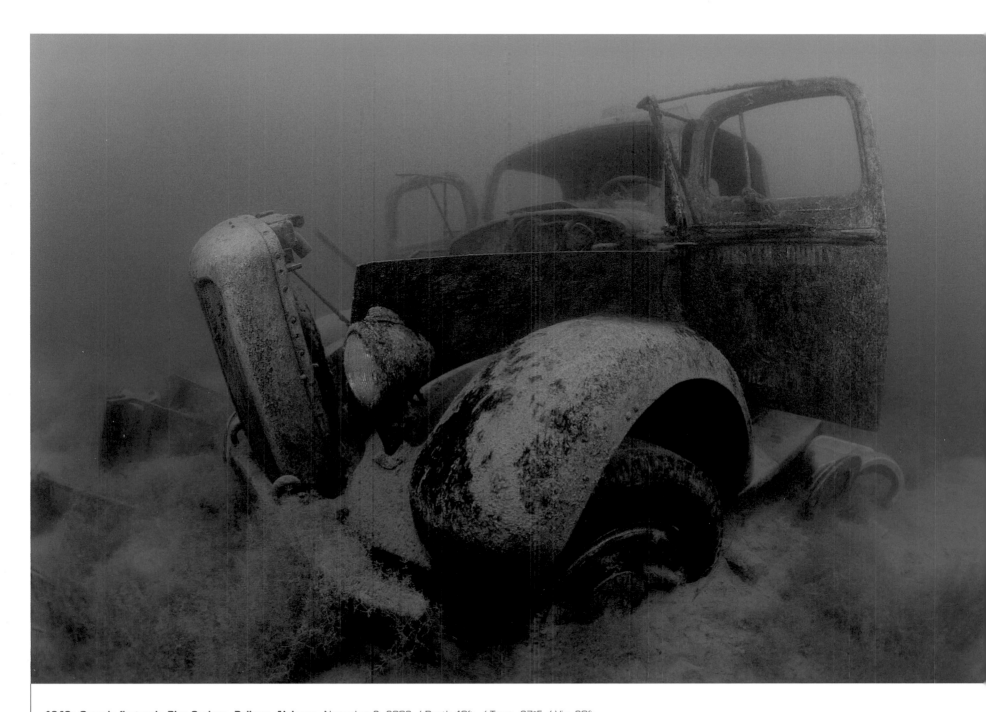

1940s Georgia firetruck, Blue Springs, Pelham, Alabama November 3, 2002 / Depth 40ft. / Temp. 67°F / Vis. 20ft.

When my research turned up a couple of antique firetrucks plunked down in an Alabama quarry I was curious to see what they looked like. It was a busy weekend at this popular diving hole, despite the rain, and I was sure the visibility had been disrupted. Quarry bottoms are usually silty and easily disturbed: one misplaced kick and the game can be over for photography. So even before I jumped in I anticipated this would be just a scouting session. Instead it was my lucky day. One of the trucks was sitting upright in 40 feet of water with its doors open and one front tire only half buried. The visibility, around 20 feet, was acceptable, but I knew I had to work quickly before other divers appeared. I found the most dramatic angle, which I hoped would best suggest the bulk and dignity of the machine, and very gingerly eased my fins into the mud.

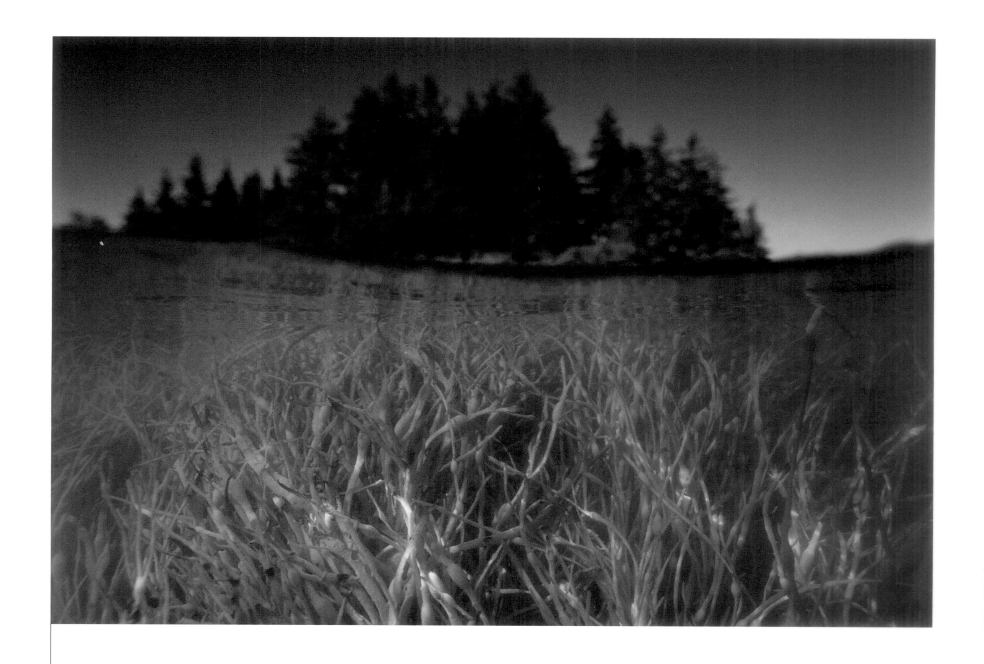

Yellow rockweed, Clark Cove, Mt. Desert Island, Maine September 17, 2002 / Depth 1ft. / Temp. 52°F / Vis. 5ft.

At low tide the rocky shores of Clark Cove are draped with thick, tangled blankets of yellow rockweed. The incoming tide gently refloats this unruly mass, transforming it into a lush undersea meadow that sways gracefully in the surge. Albeit high or low tide, rockweed is home to many a creature. Barnacles and mussels hide behind the wet blanket of vegetation, which protects them from predators.

Invertebrates such as sea urchins and periwinkles feed on the younger part of the plant. Juvenile fish like herring and pollock use the rockweed beds as their nursery and refuge, eating the abundant tiny shrimplike amphipods. When low tide returns and the rockweed is again exposed to the air, seabirds forage among the fronds in search of sea snails and crabs.

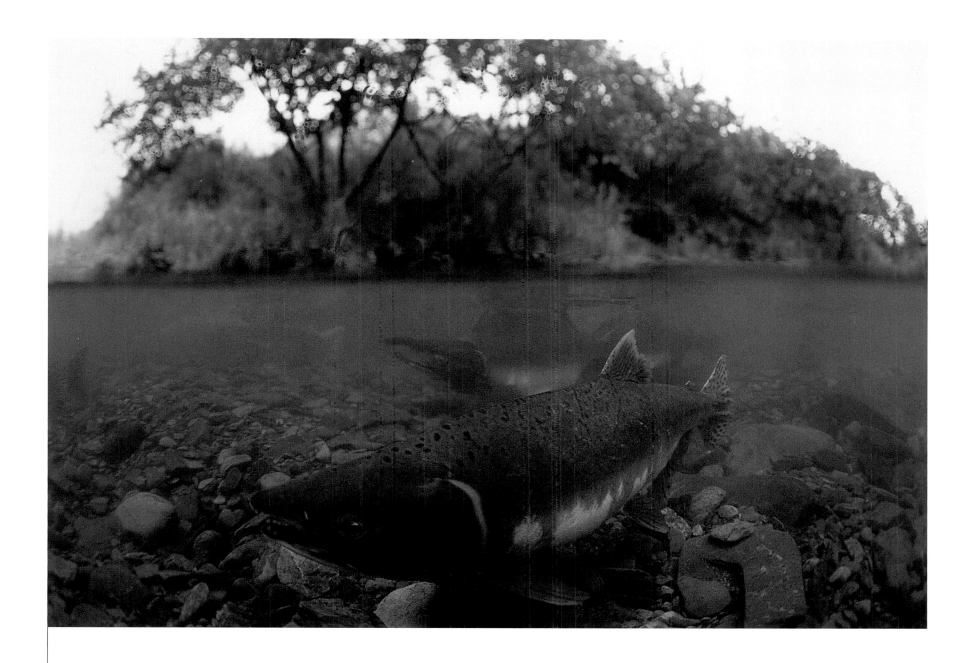

Female and male pink salmon, Buskin River, Kodiak Island, Alaska August 1994 / Depth 1ft. / Temp. 52°F / Vis. 10ft.

The Buskin River was a hive of activity. There were salmon everywhere in all stages of life and death. In the middle of the river the strongest pinks were slogging forward against the current with a sheer determination that only comes with an instinctive sense of destiny. Whatever the cost, they knew they had to migrate up the river to their place of birth to spawn. Just out of the mainstream were the exhausted pinks, the ones that had stalled—I could almost see them panting—and I knew they were not going to make it any further. By the edge of the shallow river, the fish that had run out of fight and energy were lying dead in various stages of decomposition. The ebb and flow of a salmon's life was staring harshly at me. Only two years ago these same fish had swum downstream as juveniles, on their way to the sea. As I mused on the brevity of life, out of nowhere I heard a voice. It was a Park Ranger beckoning me over to the riverbank. He calmly informed me that any minute now the resident Kodiak brown bear would be marching down the river to tuck into his evening meal of fresh fish, and that it would probably be a good idea to vacate his dining room. I wholeheartedly agreed and thanked the ranger for extending what might have been the all-too-brief life of a photographer.

Rain pond, Housatonic Meadows State Park, Housatonic River, Connecticut
November 5, 2005 / Depth 1ft. / Temp. 52°F / Vis. 3ft.

I always knew there were going to be a few states that would prove photographically challenging. But somehow opportunities always seemed to arise, and by September 2005, I had shot 49 out of the 50 states. By this time Hazel and I had sold our ever-faithful Airstream and we had returned to New York. The remaining state on the list was Connecticut, only a two-hour drive away.

After waiting three weeks for a couple of intense cold fronts to pass, we moseyed on up to the Housatonic River. It had been three glorious years since we had begun the trip and I could hardly believe the entire country had been traversed (and re-traversed) in that time. That day we stopped at a park beside the shallow river and found a miniature valley in the forest, a perfect catchment area where the heavy rains of the past weeks had accumulated. Having found no potential images in the river, my instinct told me this was my best chance for the final state. Returning at dawn the next morning, I waded into the three-foot-deep "rain pond" and experimented with the trees directly above. The idea worked and I left the pond shocked, not so much from the cold but because the last state had been completed.

After traveling about 108,000 miles in 848 days, and jumping into a wide variety of waters a total of 945 times, spending a total of 732 hours in the water, I had come to the end of the project. I felt elated that I had achieved my goal, but at the same time overwhelmed and a little sad, since the greatest journey of my life, with so many unbelievable memories, had finally drawn to a close.

Treat the earth well
We did not inherit it from our ancestors
We borrow it from our children

Native American saying

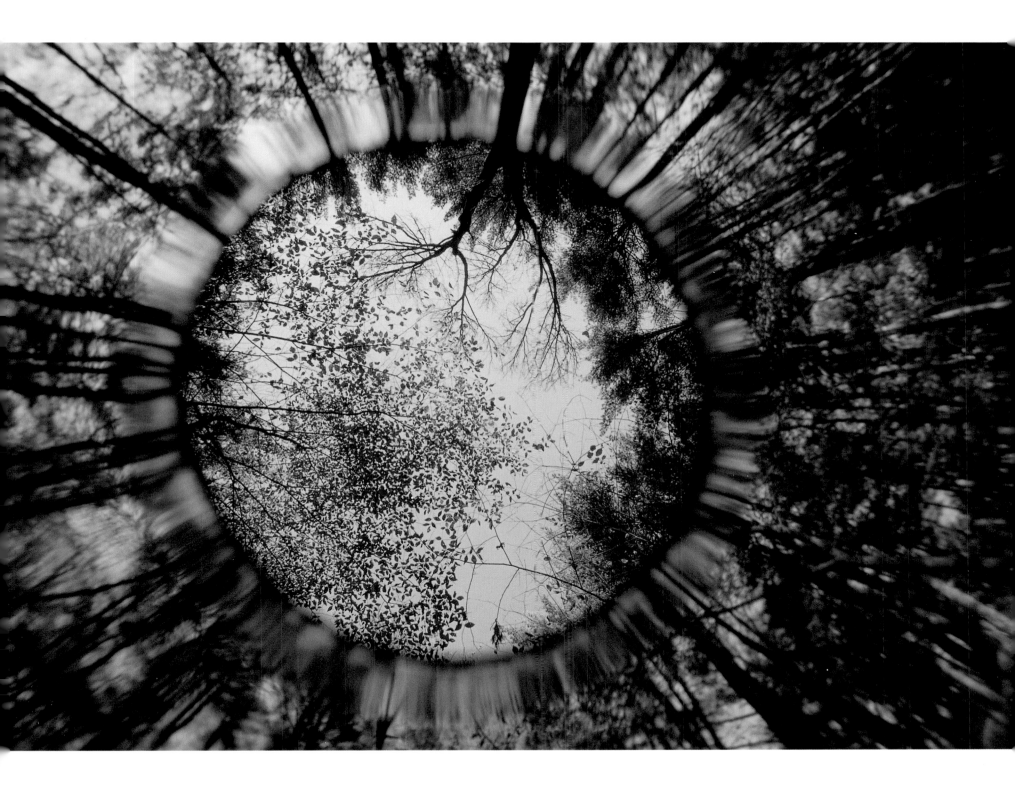

Acknowledgments

My sincerest thanks to Jean-Michel Cousteau for the more than flattering Foreword and to David Doubilet for his generous words.

My deepest gratitude to my sponsors: Kodak, and the late Inder Mahendru at L&I Color Lab. All the images were shot on Kodak 35mm film, which were digitally drum scanned for reproduction.

For their belief in the project I am forever indebted to Iris Temple, Audrey Jonckheer, Andy Bellin, Christopher Spaulding, Jim Leary, Francesca Paolozzi and Michael Elefante.

Many thanks to my assistants: Sebastian Thaw (1997 trip), Andy Warren (April 2003) and Caspar Giri (August 2003), for their sheer hard work and companionship on the road.

A big thank you to Madeline True for her extensive research, which proved invaluable.

A special thanks to the following: The Aggressor Fleet, Tiffani Addington, James Allen, Matthew Armand, Archie Arnt, Baboo, Jesse Bedwell, Howard Bellin, Makesh Bhatnagar, Tom Bowers, Stephen Brimm, Al Bruton, Vic Burri, the late Dick Byam, David Byrd, Mike Chapin, Robert Clark, Russ Clark, Ron Coley, Jim Cooke, Pam and Steve Crandall, Stuart and Susanne Cummings, Bobby Davis, Diver Ed, Chip East, Debbie Edwards, Glen Faith, Mark and Debbie Ferrari, Al Finlayson, Gene and Susan Fruscher, Bob Garrison, Mike Giles, John and Sarah Glaster, Lesley Avery Gould, Larry Harness, Rob Holm, Archie Kalepa, Brian Keller, Mike Keel, the late Greg Kidder, Julie Kidder, Nicholas and Maggie Kirkbride, Rick Kruger, John Lachelt, Scott Lopez, Fred Messie, Todd Matthies, Terence McArdle, Bucky McMahon, Steve Meier, Ken Mortinson, Barbara and Charles Moseley, Erad Nelson, Phil and Marianne Parsons, Don Peterson, Jim Peterson, Lee Peterson, Joe Pirello, Pete Renschler, Mary Rose, Bill Routh, David Scarborough, David Sipperly, Andy Talbot, Len and Jean Todd, David Westerfield, Nicholas and Harry Williams, and Susan Yanok.

Thank you Pat and Randy at RV Dallas for keeping the Airstream in great condition.

My gratitude to the Department of Fish and Wildlife, the Marine Sanctuaries and National and State Parks in a variety of states, the National Oceanic & Atmospheric Administration (NOAA), Florida Keys National Marine Sanctuary and the Florida Keys Land & Sea Trust.

The whale images were taken under NMFS Permit No. 393-1480, issued under the authority of the Marine Mammal Protection Act and the Endangered Species Act. Anyone without such a permit must remain at least 100 yards away from these animals.

The quotation on page 56 is from *Lost Woods: The Discovered Writing of Rachel Carson*, Copyright 1998 by Roger Allen Christie, reprinted by permission of Frances Colin, Trustee.

I thank my Editor, Neil Baber, for his enthusiasm and the gift of creative freedom.

Thank you to Demelza Hookway, Assistant Editor, for all her hard work and dedication, Prudence Rogers for her excellent design and Beverley Richardson for her attention to production detail.

The entire list of all the organizations and dive shops who helped me along the way is posted on my website www.alexkirkbride.com.

My family and friends have been so supportive throughout the journey and I would not have been able to accomplish my goal without them. Thank you all so very much indeed.

Finally, and most importantly, I'd like to acknowledge my wife Hazel's immeasurable contribution to *American Waters*. For five years she was the backbone of the project and many of the production photographs were taken by her. I am eternally grateful for her encouragement and constant support.

state index

abbreviations

ft. feet

Temp. Water temperature

Vis. Water visibility – how far you can see horizontally underwater

The temperature and visibility will vary depending on the depth and time of year